T0150598

BURNE-JONES TALKING

ALSO EDITED BY MARY LAGO

Imperfect Encounter:
Letters of William Rothenstein & Rabindranath Tagore,
1911–1941

Max & Will:
Max Beerbohm & William Rothenstein
Their Friendship & Letters,
1893–1945 *(with Karl Beckson)*

Men & Memories:
Recollections of William Rothenstein,
1872–1938

BURNE-JONES TALKING

*His conversations 1895–1898
preserved by his studio assistant
Thomas Rooke*

EDITED BY MARY LAGO

 PALLAS
ATHENE

For Lovat Dickson

✱ Contents

❧ Illustrations

ILLUSTRATION SOURCES

1 Mary Lago; 2 Lance Thirkell; 7, 8, 13 Fulham & Hammersmith Lib-
raries; 4 The Tate Gallery; 6 Museo d'Arte, Ponce, Puerto Rico; 9, 15 Celia
Rooke; 10, 11 Sotheby Parke Bernet & Co; 12 Princeton University
Library; 14 National Portrait Gallery

p. viii and p. 205 (self-caricatures), Humanities Research Center, University of Texas at Austin; p. xii (B-J and his cleaning lady) and p. 114 (Morris reading to B-J), Sotheby Parke Bernet & Co; p. 26 (B-J in his studio), Lady Burne-Jones: *Memorials*; p. 43 (self-caricature), private collection; p. 111 (Chaucer thanking Morris and B-J for completing the Kelmscott Chaucer), whereabouts of original unknown; p. 158, (self-caricature), Lady Mander and the National Trust, Wightwick Manor.

❧ Preface

Thomas M. Rooke's original notes and notebooks do not survive. For this edition I have used the text closest to them: Lady Burne-Jones's holograph transcript made from Rooke's text. That transcript consists of 416 foolscap pages written almost solidly, with nearly every line of the dialogue transcribed as a run-on line. There is now no way of knowing what deletions and changes she may have made during that process of transcription; it is certain, however, that she quoted only a tiny portion of the whole when writing her *Memorials of Edward Burne-Jones*. For a few additions and corrections to her holograph copy, I have drawn upon a later typescript copy made, with a number of emendations, deletions, and variations, from the holograph copy and used by Lady Burne-Jones in the writing of that biography.

Since her holograph transcript is as close as we are likely to come to Rooke's original text, itself a second-hand source, how then, in the interests of historical accuracy, may I justify this edition as a true representation of the man talking: Burne-Jones in his own words? There is confirmation, I think, in his letters, of which many hundreds survive in many public and private collections. Again and again in his letters, he echoes opinions, and describes persons and events with the vocabulary, the nuances of meaning, the syntax and cadences that appear throughout Rooke's record of the conversations. All confirm that if Burne-Jones's authentic voice is to be found in his letters – and their great spontaneity certainly suggests that this is the case – Rooke has captured it with great faithfulness in these journals. One marvels at his devotion and his skill.

I include here approximately one-third of the entire holograph text. In the remaining two-thirds, historians and biographers will find a wealth of new and interesting information and comment. I have selected for this edition passages that illustrate vividly the personalities, interests, and activities of

Burne-Jones and his circle in the 1890s. Where I have included only a part of a day's entry, my choice is indicated by means of spaced ellipsis points, as: . . . An ellipsis indicated in the holograph version as the speaker's (or Rooke's) is indicated here by means of unspaced ellipsis points, as: ... With respect to punctuation and paragraphing, I have kept as faithfully as possible to what seems indicated in the holograph text, although this is by no means always entirely plain. I have made silent corrections only where these seemed essential for preserving the meaning.

Omission of some names in the holograph text is indicated there by a space, sometimes with a question mark to indicate a lapse of memory on the part of Rooke, or by a line, indicating omission on the grounds of delicacy or caution on the part of Rooke, or Lady Burne-Jones, or both. Such of those names as I could supply are enclosed in square brackets.

I have regularised some inconsistencies in the arrangement and form of Rooke's date lines and 'stage directions'. To identify his own comments, he sometimes wrote 'I' but more often wrote 'Me'. For the sake of grammatical purity, I have used his 'I' throughout.

It is plain from the text that as the daily recording of the conversations proceeded, Rooke recalled past comments by Burne-Jones. These were inserted at various points in the journals, with approximate dates provided by Rooke, or with the heading 'Anytime' or 'Long ago'. For the sake of a more orderly chronology, I have gathered these inserted passages (with one exception, pp. 69–70) and have arranged them as nearly as possible in the correct order at the beginning.

Notes to the Introduction, Interludes, Conclusion, and Rooke's Apology will be found at the back of the book.

One may speculate whether Burne-Jones, who had serious reservations about publication of letters and other personal papers, was actually the instigator of Rooke's journal-keeping. In 1894 this exchange with Rooke took place:

E B-J: You will let people know what I feel about the things I have at heart, you have heard me say often enough here.

Preface

I: Mr Mackail will be your Lockhart.

E B-J: Yes, he will.

In the event, it was Rooke, not Burne-Jones's son-in-law John Mackail, who acted, not so much as biographer in the tradition of Lockhart's *Memoirs of the Life of Sir Walter Scott*, but as a Boswell to Burne-Jones's Johnson.

Columbia, Missouri MARY LAGO
April 1981

✒ Introduction

Picture, if you will, a garden studio in West London – not one of the showplace studios of the Victorian artist grandees, where fashionable ladies call on Sunday afternoons, but a true workplace, cluttered, congested, tidied up only for rare special occasions and then only over the loud protests of its owner and principal occupant, Sir Edward Coley Burne-Jones, Baronet, painter and designer, sometime Associate of the Royal Academy, disciple of Rossetti and Ruskin, business associate and devoted friend of William Morris.

The time is 1895. Ned Burne-Jones, born in Birmingham in 1833, the only son of a gentle, obscure and rather ineffectual frame-maker, is now an eminent late-Victorian. Because he has ceased to hold open house in his studio, strangers who gain admittance there feel distinctly privileged. His family circle, through the marriages of the sisters of his wife Georgiana MacDonald, already is accumulating an aura of distinction. Alice MacDonald is the wife of John Lockwood Kipling, of the Indian Educational Service, father of the rising young writer, Rudyard Kipling. Agnes MacDonald has married Edward Poynter, Royal Academician who is later to be Director of the National Gallery, and, still later, President of the Royal Academy. Louisa MacDonald is the wife of Alfred Baldwin M.P., father of the future Prime Minister, Stanley Baldwin. The Burne-Joneses have a son, Philip, who intends to become a painter like his father; and a daughter, Margaret, who is married to John Mackail, the promising classical scholar. The Mackails have two children: Denis, who will become a novelist, and a daughter who will become known as the novelist Angela Thirkell. Besides the Grange, the house in North End Road with a house studio and a garden studio added, there is another house with still another studio, opposite the minute village green in the seaside village of Rottingdean.[1]

1

Introduction

They are a pleasant sight, this family circle, a late-Victorian vindication of the century's emphasis upon earnest endeavour, all nicely distributed here among art, literature, and service to the nation. But one must note the year of this portrait: it is 1895. In 1900 the new century will begin; in 1901 the old Queen will die. Ned Burne-Jones will not live to see either event. He is a last survivor of a great tradition, and he is possessed by a sense of many endings. Rossetti, who had set him on his way to becoming a painter, is long dead. Ruskin's ideas of beauty and his views of the relation between art and society had shaped Burne-Jones's own, but Ruskin's extravagant levies upon his own intellect have bankrupted mind and body and have exiled him to Brantwood, his house overlooking Coniston Water. William Morris is still at hand, seemingly as rumbustious as ever, having emerged in 1890 from a seven-year involvement with militant Socialism, but Burne-Jones, who refused to follow into that alien enterprise, still grieves over that interruption in their friendship, begun in student days at Oxford; stubbornly, he defines Morris's Socialism as only a 'parenthesis' in his career (p. 118). These three friendships are for ever a part of Burne-Jones's association with the Pre-Raphaelite Brotherhood and its followers.

Observe now a third picture: Burne-Jones at work in the studio. He is literally surrounded by pictures and designs, some new, some decades old, some being completed or revised, even painted out altogether and begun again. For years he has joked about the failure of his brush to keep up with the fertility of his imagination. In funny little self-caricatures, with which he often signs his letters, he confronts whole phalanxes of unfinished canvases and goes down to abject defeat; in these caricatures his limbs, garments, and beard are as limp as seaweed, his expression bleakly, extravagantly dejected. Yet it is not a joking matter, for his pictures now sell more slowly. The subjects from legend and mythology, the stylised figures, the lapidary precision of detail are losing ground to encroaching Impressionism and are coming to be regarded as an acquired taste reserved for those who dote on period pieces. Burne-Jones increasingly regards himself as a period piece: 'A pity it is I was not born in the Middle Ages,' he

said in 1897. 'People would then have known how to use me –
now they don't know what on earth to do with me' (pp.
146–47).

How do we know, having advanced thus far into the Twen-
tieth century, that Edward Burne-Jones said that – *said*, not
wrote? Since 1869, his studios had had another regular occu-
pant, who in 1895 began an almost daily record of conversa-
tions with Burne-Jones, whom he called the Master, and bet-
ween the Master and his family and friends. This secret scribe
was Thomas Matthews Rooke, nine years Burne-Jones's
junior, a painter principally in water-colour, who excelled at
historical architectural painting and drawing. In 1869 upon
application to Morris and Company he had been assigned to
help Burne-Jones with his designs for the Firm's projects. Also
in the 1860s, Burne-Jones had begun to paint on a larger scale;
it became Rooke's task to transfer designs from original draw-
ings to the large canvas or cartoon. His technique, meticulous
and jewel-like, was ideally suited to the task of helping to fill in
the minute details of Burne-Jones's large pictures. While they
worked, they talked. Everything under the sun, past, present,
and future, was their subject. The conversations started from
the picture in progress, or from a leader in that morning's
Times, or from a bit of visitor's gossip, or from a reminiscence
of the Pre-Raphaelites. The talk was a free-flowing stream, a
harvest of recollections, a palimpsest of allusions, opinions,
historical record. As Rooke explains in his 'Apologia', it
occurred to him, with regrets for past opportunity now lost
for ever, that these conversations must be preserved. He there-
fore began 'this attempt to preserve the sayings of an artist all
of whose friends hope and believe may remain always interest-
ing to the world, as well as his work' (p. 19). Consciously and
conscientiously, impelled by Burne-Jones's wish that Rooke
'tell' him episodes from the beloved novels of Dickens, Scott,
Thackeray, and Dumas, whom Burne-Jones called 'his-
torians', Rooke resumed a discipline begun (and abandoned)
in childhood, when retelling of stories previously read had
been both family entertainment and deliberate memory-
training. Hesitantly at first, then more confidently, he began to
make notes on whatever bits of discarded paper came to hand

in the studio. At the first opportunity for privacy, each set of notes was converted to a verbatim record of that day's dialogue. In short, Rooke trained himself to be Burne-Jones's Boswell. The day after the Master's death, Rooke gave to Georgie – Lady Burne-Jones, 'the Mistress' – this record of nearly four years of 'studio talk'. Georgie quoted (very often inaccurately) some passages in her *Memorials of Edward Burne-Jones*, but in many of these Rooke becomes entirely anonymous; or he is merely a 'friend' or 'someone' to whom Burne-Jones addresses a question or a remark.

Thomas Matthews Rooke, who lived into his one hundredth year, was born in London in 1842. His great-grandfather, Philip Rooke, was a native of Harberton, Devonshire. Of his grandfather, another Thomas Rooke, we know little beyond his birth and death dates (1732–1806). Thomas's father, another Philip Rooke (1796–1874) was a Jermyn Street tailor, an enthusiastic amateur artist who would arise early in order to paint the sunrise before going to his shop. In 1872 T. M. Rooke married Leonora Jane Jones, a schoolmistress from the Channel Islands, whom Burne-Jones engaged as governess for Margaret. The Rooke children's lives would be shaped by their father's associates and by his painting expeditions to the Continent. Margaret (1880–1955) became Professor of Italian Medieval Classics at Smith College in 1909, and at her death was Professor Emeritus. Noel (1881–1953) became a painter, wood engraver, book decorator, and poster designer; a pupil of W. R. Lethaby and Edward Johnston at the Central School of Arts and Crafts, London; subsequently an influential and greatly respected teacher there; and throughout his career an artist in his father's tradition of reverence for excellence in all the arts.

What Georgie omitted from her biography of Burne-Jones, what scholars have largely ignored and Rooke himself did not realise, then or later, was that, in providing these journals, he had provided also an outline of his own appealing personality. It is only an outline. Infinitely more retiring than Boswell, he plainly tried to stay in the background while framing questions and comments that kept Burne-Jones talking along certain lines. This deliberate self-effacement, and Burne-Jones's

habit of addressing him affectionately as 'Little Rooke' or 'Rookie', together with a protective attitude that could seem patronising, have suggested to some historians a rather unpleasant condescension. One study of Burne-Jones describes Rooke as his ideal assistant, 'being of a mild nature prone to hero-worship'.[2]

In fact, Rooke had two heroes. Replying in later years to a Tate Gallery questionnaire, he wrote, under the heading 'Art Masters', that after his teachers at South Kensington (later the Royal College of Art), his masters 'from 1869 [were] Edward Burne-Jones and always John Ruskin by his works and influence'.[3] Burne-Jones was to him 'a Demi God or kind of Divine Creature' (p. 20). Ruskin was the Olympian mover and shaker, seldom seen by Rooke, who dwelt on high above Coniston Water and, always in kindly tones and with generous hand, dispensed the advice, commissions, cash, and encouragement that sent Rooke, on loan from Burne-Jones, about Ruskin's business on the Continent. In the 1880s that business was the making of a pictorial record of churches, cathedrals, and other precious old buildings threatened by time and irreverent restorers. To this end, Ruskin, whose precarious health had already curtailed his travels abroad, engaged a group of artists whose work would become the property of Ruskin's Guild of St George, in Sheffield.

Rooke's first assignment kept him in Italy from May 1879 until at least January 1880. This was a passionate effort, ancillary to Ruskin's 'Memorial Studies' of Venice, to depict St Mark's in what was left of its original state; the restorers' ravages upon the West Front were already far advanced. In 1873 Morris, Burne-Jones, and George Howard had seen these, and at that time Morris had flown into such a rage that he 'squashed up George Howard's hat, thinking it was his own' (p. 169).[4] Burne-Jones had been no less indignant, and in 1879 he had helped Morris to draft a petition to the Italian Minister of Works and also wrote repeatedly to Mary Gladstone, who was in Venice that Autumn, to beg her father's support: 'The best of us can scarcely draw the loveliness of that front – the clumsiest of us wouldn't stoop to, presently, when they have restored it – now no more – but tell me what help

your father would give . . . it would be shameful to sit down
and groan about it, and do nothing – and I'll talk of nothing
else till I weary mankind.'[5] Burne-Jones abhorred talking in
public, but he spoke at a protest meeting in Oxford. He helped
to mobilise for action the Society for the Preservation of
Ancient Buildings, fondly called Anti-Scrape. And, of course,
he loaned Rooke to Ruskin.

To mark their alliance, Ruskin sent Rooke the bound proofs
of Part I of *St Mark's Rest*, inscribed and corrected in Ruskin's
hand.[6] To Burne-Jones he sent Rooke's instructions: Rooke
was to copy the mosaics on the walls of the aisles of St Mark's:
the walls, not the floors. 'Alas,' Ruskin wrote, 'there is no floor
left! It has all been torn up and replaced . . .'[7] He appealed for
funds, warning the English public that the mosaics were 'now
liable at any moment to destruction. I have undertaken, at the
instance of Mr Burne-Jones, and with promise of that artist's
helpful superintendence, at once to obtain some permanent
record of them, the best that may be at present possible; and to
that end I have already despatched to Venice an accomplished
young draughtsman, who is content to devote himself as old
painters did, to the work before him for the sake of that, and
his own honour, at journeyman's wages. The three of us, Mr
Burne-Jones, and he, and I, are alike minded to set our hands
and souls hard at this thing: but we can't unless the public will
a little help us.'[8] The public's help amounted to £448.7.0, and a
letter from Rooke to Burne-Jones suggests the sources of a
disproportionate share: 'He [Ruskin] also kindly says that the
amount of subscription in hand shall be sent to me – from
which I imagine that Mr Morris and yourself have once more
repeated the action (which use has made so familiar) of putting
your hands into your pockets. And I wonder whether it will
have helped you to come to Venice or rather whether it is to be
instead of that pleasure.'[9]

Ruskin could be appallingly tactless, as both friends and
public well knew. In letters to Rooke he could not, of course,
resist lecturing, but if he was exacting he was also kindly, and
criticisms were carefully softened and qualified. On receipt of
a batch of Rooke's drawings from Venice, Ruskin wrote that
he was 'entirely pleased with them as documentary work: but

they still – and even more than hitherto, disappoint me in colour, to my own eyes, of the originals'. Rooke, he thought, habitually read 'on the sober – as I do on the gaudy, side of colour: but I want to get at the real difference of view between us, and therefore I am now going to ask you to make me a drawing, with especial reference to the effects of colour and gold with marble cornice . . .' He went on to say that he was asking Frank Bunney, also at St Mark's, 'with whom on points of colour I am very nearly one', to draw a subject already done by Rooke. Ruskin then hastened to add that Rooke must not construe this as an attempt to put him and Bunney into competition or opposition: he hoped only to 'obtain by his assistant agency facts of which I think he is more habitually cognizant. Your work – were it only in grisaille, would always be of intense value to me – but it will be of more, with the collateral aid.'[10] Rooke accepted these strictures with a good grace, and Ruskin's letters took up a steady refrain of admiration that was sincere even when it became extravagant. In 1884: '*Ev*erybody admires and delights in your Loire work', and again, ' . . . I am entirely delighted with all – but most of all, in *degree* of delight – with this last envoy – the large view of Brieg . . . hundreds of people can do mosaics approximately well for one that can do a cottage and a cloud . . .' In 1886: 'Let me congratulate you in the most solemn way on these glorious drawings – nothing since Turner's death has ever given me so much pleasure . . .' In 1887: 'Your French drawings are continually more and more a joy and wonder to me, your letters always a comfort'; and again, 'Your figures are the most perfect in truth and feeling that ever were put in landscape.'[11]

Ruskin's solicitude and subsidies for the comfort and welfare of his 'dearest Rooke' were as generous as his praise. He seems to have been well aware of the crucial role that he had assumed in Rooke's life, and he showed a touching sense of responsibility for it. Still, Burne-Jones was the more accessible hero-figure. Rooke admired him, not because he was 'of a mild nature prone to hero-worship', but because he and Burne-Jones shared a concept of ideal beauty and near-mystical devotion to art as a vocation. For Rooke, Burne-Jones was the supreme example of the artist who holds to that

concept and that vocation, no matter how contrary the behaviour of the art market. Burne-Jones's credo and his resolve was that 'I mean to spend all my hours loving beauty with all my heart – and have no leisure to hate – and at present feel inclined to say "Oh don't argue, or else I shall cry" – and I want people to like what they like – that is the meaning of the word. – You *like* what you are *like* – and the splendid like splendour and the glorious like glory, and the tender like tenderness, and the frozen like brass, and the timid pretend they like brass, and the nasty like nastiness, and the vague like vagueness, and the clean like cleanness, and the mean like worthlessness – as for me I have always painted pictures for my own sake only – if any others like them I am glad but it is for me I paint them . . .'[12] Rooke, accepting this credo, would have said, echoing Carlyle, but in the most transparent simplicity, that Burne-Jones was supremely 'profitable company', the great man upon whom one 'cannot look, however imperfectly . . . without gaining something by him.' He was quite simply Rooke's 'living light-fountain, which it is good and pleasant to be near.'[13]

In return, Rooke contributed much to his Master. He supplied an indispensable presence in the life of the studio, for Burne-Jones needed a great deal of sheltering affection. He invited it, indeed begged for it by assuming, as if playfully, the language of childhood. This explains, I think, the diminutives sometimes interpreted as condescension. 'Dear Rookie,' Burne-Jones would write, summoning Rooke to work, 'will you come today and play with me?'[14]

In addition, Rooke was a kind of mirror in which all of Burne-Jones's agitations and dissatisfactions were magically transmuted and given back as infinitely reassuring pictures of the artist's life in its ideal state. Burne-Jones oscillated between nervous backward looks at his own works and his worries about his reputation in the future; Rooke dealt serenely with the past and concentrated upon the work in hand. Burne-Jones's personal affairs had gone badly awry, never to be fully mended, at the close of the 1860s; Rooke's relations with his wife and children seemed – and were – idyllic, almost too good to be true. Burne-Jones hated travelling, and as he grew older

he hated it more; Rooke was at home wherever he found himself and consequently became his Master's eyes and ears, and eventually his designing hand in Italy. Above all, Burne-Jones dreaded old age and viewed its onset with disgust; Rooke, who after all was only nine years his junior, regarded the passage of time with equanimity. Burne-Jones, when he considered the even tenor of Rooke's professional and domestic life, was by turns admiring and astonished.

Let us examine in more detail this friendship between master and assistant, as set forth by themselves.

First, there is the difference between their attitudes toward their common vocation. Both had long ago surrendered utterly to art as an irresistible calling, but where Burne-Jones engaged in stormy exchanges with an adversary Muse, Rooke dwelt with his in modesty and contentment. Burne-Jones looked on with affectionate wonderment that Rooke should be so happily reconciled to the desperate uncertainties of the artist's life. When Mary Gladstone went to Venice in 1879, Burne-Jones told her that she would see there the George Howards, the Edward Poynters, Stopford Brooke – 'but none will be better than that little pupil of mine I asked you to see – though he will be very frightened of you and stammer with shyness and wait on doorsteps – of such is the kingdom of Heaven though – and he has a big soul in his tremulous little body . . . and you must introduce him to your father and he will faint at such an honour.' He urged Rooke as the ideal guide to Venice, because 'he is entirely unobtrusive and simple and good-natured and impossible to offend . . .'[15] After Miss Gladstone wrote in praise of the Rookes, Burne-Jones replied that he knew she would 'like to see such a pretty simple good life – an ideal artist's life: . . . his work is so excellent that people presently will notice it and then, and then – and he has no contempt in him to save himself by, no suspicion, nor any defence at all . . .'[16]

Most of Rooke's first decade with Burne-Jones had been a time of grave and prolonged stress in the Master's personal life. Much later, Burne-Jones described this time as 'the blissfullest years of work I ever had', but he called them also 'the desolate years'.[17] In 1870 his peace of mind was laid waste by

the uproar over his painting *Phyllis and Demophoön*, exhibited that April with the Old Water-Colour Society. After two weeks the picture was mysteriously removed, presumably because the critics judged it morbid, or because a lady or ladies had objected to the nudity. The disappearance was never adequately explained, and apologies to the artist were bungled. Burne-Jones, who, unlike Rooke, had plenty of contempt and suspicion for all concerned, found them no defence at all. Deeply wounded, he resigned from the Society, at the time his only public medium for exhibition.[18]

As Penelope Fitzgerald points out in her biography of Burne-Jones, criticism was no novelty to him, but much unpleasant publicity accompanied the banishment of *Phyllis and Demophoön,* because there was more to the affair than disagreement about a picture. The model for Phyllis's face was Mary Cassavetti Zambaco, a relation of the Ionides family, one of London's Greek merchant dynasties who had long been patrons of the Pre-Raphaelites and their followers. Burne-Jones's love for Mary was an open secret. For more than a year he had been trying to break with her, and there had been at least one semi-public drama, after which Burne-Jones and Morris had rushed off in the direction of Italy but had got only to Dover. In 1871 something crucial occurred, but the public (and biographers) were discreetly excluded from whatever agreements or disagreements prevailed at the Grange. Georgie behaved with great dignity throughout. Mary Zambaco eventually disappeared from the scene, and Burne-Jones clung more and more to the privacy of home and studio.

Even these were not the complete refuge. Mary Zambaco's shadow hung over them. For Ned Burne-Jones, suffering patiently and in silence was impossible. He must inveigh and expostulate aloud, and banter was his oblique means of recording and relieving the pressure of his feelings. Trivial matters stood proxy for his real perplexity, the dilemmas and contradictions of the married state. 'Webb is awful at present', he wrote in 1879 of Matthew Webb, another studio assistant who was assiduously courting a young lady, ' . . . and he won't talk any more in that wide minded way that used to characterise his speech but speaks of fidelity and duty and married happiness –

I do so miss the old manner which was much more advanced and liberal you know . . .'[19] About 1883, this exchange took place with Rooke:

E B-J: A painter ought not to be married; children and pictures are each too important to be both produced by one man.

I: Not married?

E B-J: No, the great painters were not married – Michael Angelo not married, Raphael not married, Fra Angelico not married, Signorelli not married (*etc. etc. more*). Del Sarto married! but we know what happened to *him*.[20]

And again to Rooke, about 1884: 'A woman at her best, self-denying and devoted, is pathetic and lovely beyond words; but once she gets the upper hand and flaunts, she's the devil – there's no other word for it, she's the devil. So look out, little Rooke, look out in time. Two people are so fortunate as to be quite happy with each other, but they mustn't be down on the unlucky because of their own good fortune. They ought to be all the more sympathetic with them, and not think their own success is all their own doing. There's a self contradiction in pitying a woman – the worst of it is that as soon as you've taken pity on her she's no longer to be pitied. You're the one to be pitied then, so beware.' In the typewritten version of Rooke's notes prepared for Georgie's work on the *Memorials*, the last three sentences have been omitted.[21]

This brings us, finally, to Burne-Jones's rebellion, so different from Rooke's serene acceptance of old age, against the passage of time. Burne-Jones's passionate distaste for ageing intensifies as he moves into the 1890s. 'I wish I was thirty-five,' he wrote to Helen Mary Gaskell, who was the last of his bittersweet friendships with women younger than himself, 'do you know I once was – isn't it strange and incredible? – but it's quite true – and stranger still I was once three and twenty!'[22] The years he mentions were landmarks in his life. He was thirty-five in 1868, when the Zambaco affair was approaching its crisis. He was twenty-three in 1856; in that year he abandoned his plan to enter the ministry, left Oxford,

and received Rossetti's encouragement. In 1856 Morris left the Oxford architecture office of G. E. Street and rushed up to London to devote himself to painting. In 1856 he and Ned had moved into Rossetti's old rooms at 17 Red Lion Square, and their true apprenticeship as artists had begun. In actual fact, that life had been often hectic, uncomfortable, and downright unhealthy, but Ned, looking back, saw it as their Golden Age. He had always loved to paint ideally youthful figures; how many homes and school-rooms contained – still contain – reproductions of his 1880 painting, *The Golden Stairs*, with its procession of willowy young women descending?[23]

Descending: that is the key word. Burne-Jones felt that ageing was an ignominious descent into oblivion. Like W. B. Yeats, he found comfort in the lapidary arts as a reassuring symbol of changeless beauty. He enjoyed designing jewelry. He loved mosaic decorations and designed those for St Paul's American Church, Rome; this was the work for which Rooke became his emissary in Italy, and which Rooke completed after Burne-Jones's death.[24] Stained-glass window designs were one of the most reliable sources of his income. He loved the precise and antique sound of the harpsichord. When he bought one for his daughter, he wrote that 'the sharp metallic tinkle of it I like – it's a pretty change on the muffled tones of modern instruments – and it recalls ancient times, and at some such instrument Glück and Mozart and even Beethoven played – it was good enough for them and so is too good for me – and then I like its sharp clear twang . . .' Soft edges, soft surfaces are mutable and mortal. Burnished surfaces, sharply forged edges last for ever – or as nearly for ever as to make no difference, and one thinks of the extraordinary care that he lavished upon the painted representations of armour, the miraculously luminous burnished greys of the knights' armour in his *Briar Rose* panels for the saloon at Buscot Park. His daughter at the harpsichord, he wrote, 'is living the wise and perfect life, and even to see it is good for me . . .'[25]

One thing that he had long known was not good for him was involvement in organised art politics. He had been able to avoid that game, for although he had left the Old Water-Colour Society, he had had patrons who were so faithful and

so generous that for many years he managed without the help of the London galleries. He exhibited again when the Grosvenor Gallery opened in 1877, and thus he came in for *Punch*'s ridicule of its 'greenery-yallery' complexion. When the managers fell out with their patron, Burne-Jones moved with them to the New Gallery.[26] But in 1893 he astonished and scandalised almost everyone by resigning from the Royal Academy, to which he had been elected as an Associate in 1885. He had accepted this 'with cordiality as a sign of sympathy from brother artists which it was impossible to reject.' But the Academicians had not made him a full member, and he felt that they regarded him as a left-over monument of Pre-Raphaelitism, not as a living artist. He felt that he was now too old 'to be able to carry on the tradition of a school in which I did not grow up. Today I am no longer a young man – too old a man certainly to spend time in competition which I neither sought nor desired, and which is deeply distasteful for me; yet for the past eight years I found myself involuntarily forced into competition at each successive election for the final admission which you have denied me.' Therefore he respectfully withdrew.[27]

To his old friend G. F. Watts, himself a holdover from the days of high Victorian art, Burne-Jones wrote with less restraint: 'I have been thinking and thinking many a day how to end my impossible position in the Academy – where I am no good to them, can't help them, am a source of bother and difficulty for them – and for myself, find myself just where of all places in the world I am least at ease . . . You see I'm like a man who has been asked into a house as he was passing by, and being beckoned to, he comes in good-naturedly and without much thought, and has been on the hall mat ever since . . . And you are not to be vexed my darling friend – these things don't matter really a bit – nothing in all the world matters one bit except making a beautiful picture.'[28]

Without a doubt, in the 1890's ideas of what constituted a beautiful picture were gradually changing. Impressionism was no longer just a horrid rumour; its principles and its pictures were being imported by younger artists who went regularly to France. In 1886 they organised the New English Art Club,

which became a rallying point for those who, for reasons different from Burne-Jones's, resented the Academy's power. But Burne-Jones could not join the N.E.A.C. In his view, Impresionists seemed obsessed with the mere sloshing of paint. Burnè-Jones shut himself up in the studio and doggedly painted away at Arthurian and Chaucerian subjects that he knew few contemporary buyers would want.

Here is one source of the notion of Burne-Jones as romantic anachronism, the man who 'led a double life', who was 'always to visualise the good life as something remote from the world'.²⁹ Certainly the archaisms in his pictures have nurtured the impression of a limp-minded misfit in the modern world – he himself encouraged this view, as we have seen – who communes in the studio with a misty Great God of Beauty, looking neither to left nor to right lest the outside world intrude and break the spell.

Rooke's Boswellian journals oblige us, I believe, to widen this view of Burne-Jones. His 'double life' was the dual life of every artist: the life of the everyday world and that of his imagination. When the two worlds balance each other, they become the ideal 'good life'. Burne-Jones's *participation* in both worlds seemed to be off balance because he spent what seemed a disproportionate amount of time in his studio. There are three possible reasons for this: first, he had shrunk from the publicity of the *Phyllis and Demophoön* affair; second, he was by temperament ill suited to artists' organisations, in part because their squabbles repelled him, and in part because, with the Pre-Raphaelites, he believed that art teaching is best done, not in an academy, but through personal exchange between artist and pupil; and third, he jealously counted the hours of every day. In 1897, after refusing to preside at a lecture, he said, 'There's nothing worse for an artist than to have anything to do with public life . . . an artist ought to keep himself clear of all that'. He was pleased (and had done some very adroit politicking) when Poynter became Director of the National Gallery in 1894, but he was less pleased when Poynter became President of the Royal Academy in 1896. 'No peace, no more quiet ever again in his life,' Burne-Jones said. 'Even for us who are not in all the turmoil of the world it's precious hard to get

inside one's picture and not to be standing outside of it all the time.'

There was no imbalance, however, in Burne-Jones's *visualisation* of the good life in both worlds. He had his Ruskinian vision of the world as it might be if society could be brought closer to an ideal state. If by the 1890s he had rejected many of Ruskin's ideas, he never rejected Ruskin's fundamental principle that the welfare of art and the welfare of society are inseparable. As he had written to Watts in 1893, 'nothing in all the world matters one bit except the making of a beautiful picture'. A beautiful picture matters, not because the artist can commune with it in private, but because, once sent out of the studio, it nourishes the life of the community by adding one more measure of beauty to the workaday world. This is the artist's justification for shutting himself up in the studio – with the *caveat* that he must not forget *why* he has done so.

Burne-Jones had a clear idea of the kind of good life that ought to be attainable in the workaday world. To this end, if not by Socialist means, he was very much William Morris's man. Society's correctible shortcomings and avoidable stupidities, which put him into states of acute and voluble indignation, are the subject of many of the studio conversations with Rooke. These are striking for the clarity of his perception of national and international events and for the accuracy of his then highly unpopular predictions. He viewed events of the 1890s in South Africa, and British reaction to them, with deepest pessimism, foreseeing death and destruction to come – as they did, and do. He deplored the pompous complacency of the Queen's Jubilee celebration in 1897 and was convinced that in time the Empire would dwindle – as it has done. He had only scorn for the British attitude toward the United States during the Venezuelan crisis of 1895, and he predicted that the day would come – as it did – when Britain would need American aid. He was nearly as fierce as Morris in his denunciations of industrial plundering of the landscape; he and his household rejoiced greatly when a gale wrecked the outlandish electric railway that Morris so furiously called the 'Rottingdean Humbuzzer' (p. 121). He stayed out of organised politics, but, he said, 'if I fought I'd fight to win. If I were to be

15

in the scrimmage I'd go on very different lines to what I would out of it. I'd stick at nothing' (p. 140).

His certainties sometimes faltered at times of weariness and stress. Then, without revising his priorities, he would weigh his inner world against the outer. In 1895, when he began to suspect that all was not right with Morris's health, and he knew (but kept to himself) that all was not right with his own, he recalled that 'there were eleven years that were bonny years and of those I love to think – years of the beginning of art in me – and Gabriel everyday, and Ruskin in his splendid days and Morris everyday and Swinburne everyday, and a thousand visions in me always, more real than the outer world – and eleven years is a great number of years to have been happy in – isn't it?'[30] And when Georgie took him to Malvern Spa in 1897 for a convalescence, he surveyed the human specimens who frequented such establishments and speculated about their worlds: 'After being there a few days I began to wonder if there were such an art as painting or whether it was a mistake of mine to suppose it ever existed. How can they be happy without painting – I don't know – or live without it or be happy. The two lives can't be both right, and which is the wrong one? But we [artists] are never happy. We can't enjoy any beautiful thing we see for wanting to paint it, and when we have tried to paint it what miseries we get into' (p. 145). Critics seem often to have drawn conclusions from comments such as this, as from the letter upon the death of William Graham, his patron and valued friend: Burne-Jones wrote that he had been 'very down in the depths for his death is a great and real loss to me, and the breaking of an epoch in my days . . . I have failed for want of some happiness to give life to the time, and have let myself feel dull and downcast for weeks together without making any effort to mend . . . perhaps soon things will mend, and the year will have done its worst and let us breathe again.' This letter was judged as proof of his 'lack of resilience, his *fin de siècle* yearnings, and, it must be said, his childishness . . . he lacked energy and maturity to produce an enduring master-piece.'[31]

Rooke's journals refute charges that Burne-Jones lacked resilience, or was becalmed by *fin de siècle* yearnings, or was

fundamentally childish. His view of life was fundamentally sombre, this being in part a legacy from his motherless childhood and his father's funereal behaviour.[32] But in the journals we see Burne-Jones, day after day, working and talking his way out of gloomy spells, enquiring with a most refreshing curiosity about contemporary affairs, trying to understand what makes modernity attractive to others. Again and again, he asks Rooke what it was that the Impressionists were trying to do. He shared Morris's hatred of industrialisation, but he was fascinated by imaginative inventions, such as Marconi's telegraphy. He was no less shocked than was any conventional late-Victorian by the downfall of Oscar Wilde, who in happier days had been a family friend, but as time passed he reflected more on the dreadfulness of prison for a man of Oscar's wit and intellect, until finally he could say – as so many of his contemporaries could not – 'I wish they could see their way to let him go' (p. 133).

Burne-Jones was a last survivor of a landmark movement in art, no doubt about it. His pictures are period pieces, no doubt about that either – but how much they tell us about that period. Whether he produced an enduring masterpiece I leave to the judgment of art history, but neither he in the 1890s nor his critics even a few decades ago could foresee the prices commanded by his pictures now.

Let us set aside, therefore, the idea of Burne-Jones mute and melancholy, dreaming his life away, solitary in the studio. Let us observe him at work among his regular associates, and a very engaging group they are. Rooke is there, of course, and Robert Catterson-Smith, who came to London as a silverworker and entered the Morris circle by way of the Art Workers Guild; he copies on the wood-blocks Burne-Jones's drawings for the great Kelmscott Press edition of Chaucer's works. William Morris surges in and out, flourishing his walking stick and addressing everyone in his path, including Georgie Burne-Jones, as 'old chap'. Sydney Cockerell, who began his career as a coal merchant, is there as secretary to the Press, an obscure budding antiquarian who will become the noted and knighted Director of the Fitzwilliam Museum; he does not appear often in the text of the conversations, but he

runs errands, turns up frequently at lunch, and keeps an invaluable diary in which he records everyone's comings and goings.[33] Georgie Burne-Jones is established as a decided personality, very feminine, very strong, and not silent. Friends turn up from all the quarters that one would expect to find represented in this studio: the Art Workers' Guild, the Arts and Crafts Exhibition Society, the Folklore Society, the Society for the Protection of Ancient Buildings: every one of them dedicated to the proposition that the chief end of man and of woman is to put something beautiful into the world and to help the world to appreciate it. The work pauses now and then, but the talk never stops, and Rooke preserves it for us, with love.

❧ T. M. Rooke's Apology

No excuse I hope needed for this attempt to preserve the sayings of an artist all of whose friends hope and believe may remain always interesting to the world, as well as his work. The bright, quaint tone of his talk, on subjects of widest interest varying perpetually but always glittering with vivacity I always felt was such a Complement to his work, and almost rivalled it, that to know one without the other was not to know him. The more so that it was both an intuition and a steady purpose with him to keep each to its own sphere. The one was as rapid and spontaneous as he made it a point that the other should be well considered and elaborately studied to the very bottom and pruned from unessentials and undesirableness before being given out to the world, to an extent that it would be quite impossible to deduce one from the other, and only when they are side by side is the common origin and aim seen and the complete man displayed . . .[1]

And for the means and manner in which I have done it, and the circumstantial evidence I have to offer in support of what is put forward, the following may be given. From very early days of my admittance to his Studio, after giving me directions to start the day's work with, he would talk about our day's work and then about the [word omitted] and tell me what new or old subject of interest or story came uppermost in his mind. Then to my dismay I would find that any [word omitted] I would try to make would be for the most part quite unintelligible. I remember he was always asking after new books to read, and I having one morning brought him a cheap edition of *The Autocrat of the Breakfast Table* [by Oliver Wendell Holmes] was re-presented with it next morning with a hole burnt thru' the middle with the red hot poker – his favourite method of execution on works deemed unworthy. However, when this preliminary difficulty was got over, and his tastes became intelligible to and accepted by me, he got me into the habit of

telling him during work what I could remember of any book that was being read to me at home, refusing to be put off with any excuses as to the imperfection in my way of remembering or repeating them – telling me that in time I should acquire a habit of doing both better, and that it would be to my own advantage in increased power of alternately remembering the books, which in some small degree happened, in spite of my especial deficiency in verbal memory. One of the earliest books that I remember undergoing this process was Boswell, and my attention was drawn by him as well as by the book to the taking down and storing up of things said that might be worth remembering.

I used at first to feel that I was being told more about himself and his friends than should be for my ear, but tried to wrap up these confidences as sacredly and safely as possible in my own self. Then at last I came to know that he was a Demi God or kind of Divine Creature who was never satisfied with less than the whole possession of the heart of whatever mortal he might happen to be with, however near to, or far removed from him, whether it were Angela just beginning to talk, or old Wass the gardener, towards the end of his days, and in the unceasing exercise of this Divine Right and Might of his, besides lavish giving, an intuitive habit was to talk of everything without the least sense (on the part of his confidant) of reserve for himself or for others . . . But a certain reserve was maintained by the gaps that were left in the communications to each one. The fulness of disclosure on one side of a subject was made up for by complete silence on another. For instance, while I was admitted to the completest intimacy with every process, material and method of his work and, as far as my ignorance made it possible, with the origin and motive of his designs, in which he educated me continually, never a word was said to me about the destination of his work after it had left the studio. And equally, those who had the most acquaintance with its subsequent history were not allowed to penetrate into the mysteries of its production. Hints as to methods of baffling improper enquiries into these may be seen in the course of the conversations.[2]

The friends most freely talked about I least saw. Rossetti and

T. M. Rooke's Apology

Mr William Graham never. Mr Ruskin after 15 years. Others after 20. And those friends I was in the way of meeting did not get talked about at all. In fact, his conduct in life was like his play at draughts: composed of such apparently reckless audacity (that, after the first 18 months of my acquaintance I believed and gave out that he acted purely on impulse), and of a reserve and prudence that was its steadying point and could stand if necessary quite motionless from one end of his life to the other. Nothing was more hopeless in playing at draughts with him than to get a man locked; the iron grip was on him, he never moved again. And each of his men till he was wanted stayed untouched; often one that I expected to come on at each move never budged. Nothing pleased him more than to win a game without having to move some of his men. 'Good little chaps,' he would say, 'quietly they've stayed there all the time.' Neither in draughts nor in life did he seem to make any deep laid schemes and always professed entire inability and disinclination for them – but, in both, depended on quick insight into position and taking the rapid advantage of accident. This may be seen in his exultation over the enquiry once made of him by the author of a critical book as to whether it was a friend of his who had inimically reviewed it (say 1871): 'Now hath the Lord delivered mine enemies into mine hands. I shall tell him "I never take any notice of what a critic may say about art, still less am I interested in what a critic may say about criticism." ' . . .

Bounds for himself and for others he always had, rigidly fixed, never transgressed, and fiercely guarded, but to the uninitiated quite unobservable, and the less disterning of his friends, myself among them at first, only discovered them to their surprise and dismay by tripping over them. The more, that it was his own pleasure to steer close by them, and brush past them with a delicacy, gaiety and daring surpassed I should think by few. He was equally adroit in threading his way through the mazes of perilously poised objects into which it was his habit and delight to convert his studio. The large teacup always brought up half full from breakfast – sometimes sipped from and usually converted, with but slightly diminished contents, into a cigar-ash tray (familiar sight to the

habitués of his studio), loved to sit on box or mantelpiece like a bird with its tail over the edge, as did any other cup, glass, or tray, in rapid accumulation, as the day went on.

Pictures, studies, books and other works, framed or unframed, ledged themselves against each other in the manner of more sacks on the mill and got piled into unfathomable stacks, until there was barely room to pass through, perfectly safe as long as they were untouched – but woe betide the too rapidly whiffed skirt, or imperfectly measured footsteps that ventured by them. Though any movements but his own among these beloved objects were an anxiety to him, there was never any change in the manner of their being placed. He wouldn't allow of an improvement in it; that was disconcerting to his memory of their position, which hung by threads invisible to most. Only a partial cleaning up took place when a picture was finished, or a new epoch in the life of any work was to be entered on. Nothing but the entry of workmen caused a thorough overhaul and revision. There was one gain he evidently saw in all this. It was an education in care and dexterity for his servants and friends and a bringing home to them of their imperfections. If they couldn't shew the utmost care and learn some adroitness they must give up any hope of being useful or agreeable to him. To me especially this was a great difficulty. Known at home as clumsy old Tom, I had been brought up by careful parents (who couldn't bear to see anything in an at all unsafe position), to assure safety to breakable articles by the opposite method to his, and I didn't get on without accidents from time to time. Notably I let down the dark blue sibyl, painted by way of experiment on a thick deal panel, from an anything but safe kind of easel made out of a trestle (remember his amusement with the report of the workman's 'Move up them trussels, Bill') and it had to go to Roberson's to have its corner patched.[3] For this I was mainly paid out by such remarks as that to Mr Morris when the latter said that to turn a dye into pigment 'You must precipitate it, you must throw it down, you know,' the Master answering, 'Oh, Rookie'll do that for you' . . .

There could have been no one more unfitted perhaps at the start, except by opportunity, than myself to do what is here

attempted. I listened with amazed delight to the flow of talk in the Grange studio when first hearing it, enjoying the sensation without the least ability of tracing it to its source, or remembering anything but the sensation. It flashed by me like the landscape seen from a railway train, *quite* as unseizable.

From the earliest school days my purely word-memory lessons were the most difficult and distasteful; they seemed to me poll-parrotty and the boys who got on best with them were often the stupidest. Afterwards, to tell a story, or repeat a joke was always beyond me, and dazzled amazement was inevitably mixed with my pleasure in any talk or reading.

But after a certain degree of intimacy was accorded me, began a course that made some change. When the Master's store of all kinds of talk was at the service of a new-made friend and began to run out I was made to tell as much as I could give account of from what used to be read to me at home, however lamely. And this was persisted in, on all occasions, in spite of my demurring, it being urged that there was in the practice not only a beguiling of our time but a cultivation of my memory, as indeed it proved to be . . .

It would come, late in the day, after we had got well to work and all had been said that might arise from that, or from passing events, public, or private to either of us. Boswell's *Johnson*, Carlyle's *French Revolution*, *Frederick the Great* and *Cromwell*, Dickens, Thackeray, Dumas and Scott were all gone over in this way, and in a few books more than once in the course of years. *Barnaby Rudge* last of all: and when the end came I had the death of the Maypole landlord ready for him, that was never to be told.[4]

At last after all the years this course of reading and retailing went on, it became slowly clear to me (especially in the repeated attempts to carry the spirit of some of Dickens' more astoundïng sentences to him, in the speeches, say, of Flora, Bunsby and Captain Cuttle) that nothing but the actual words and disposition of them, just as they had flown together crystallising into immortal sayings, in the busy mind, would do it.[5] And the same truth became evident when I tried to put down the Master's own talk, that by a note securing the significant words and arrangement of a phrase the whole of it might be

recalled. And when this was not possible the best way was to fix each essential in the memory before any thing new came on top of them, and in writing out any accounting on the first opportunity, to begin with the last, and least obscure, thus giving the best chance of getting them all off the mind one after the other. It was possible, especially after lunch, to get reminding notes made by leaving the lunch table early, and though not originally with that object incurring the Master's daily looked-for, and generally smiled-at warning that I was spoiling my digestion by so doing. Thus did he, by a course of practice, as well as by direct teaching, make me acquainted with one of the many open secrets of the literary art – as of so many other arts, and of the soul of all art – that now give me confidence to try and perpetuate, unknown to him, some of his own almost unconscious outgiving, as well as the faculty of observing where, in part by the charm of it, and (what before had escaped me) how by long culture and with the aid of acute senses his own sentences came in unfalteringly perfect cadence, with incisive accuracy of aim, unpremeditated from his life; or, with important utterances, just the slightest pause of consideration. Not, alas, until after nearly five and twenty years of lost and unintentionally neglected opportunity, but happy yet in time to attempt again, if I may, to give example of so much that has never been gathered up.

9 July, 26 November 1898

THE CONVERSATIONS

Conversations Recollected
Spring 1894 and Earlier

Often

E B-J: When things don't go well with you, or you're in a tight corner you come to me, and I'll always find you something to do. But if you can get on without me, so much the better – I don't like absorbing your life, don't want to take the responsibility of it – otherwise I should be glad to keep you going always. But I should like you to be independent of me – to do your own work.

Long ago

E B-J (*in reply to my remarking on the number of nativities and adorations he had done – no two alike*): I love Christmas Carol Christianity, I couldn't do without Medieval Christianity. The central idea of it and all it has gathered to itself made the Europe that I exist in. The enthusiasm and devotion, the learning and the art, the humanity and Romance, the self denial and splendid achievement that the human race can never be deprived of, except by a cataclysm that would all but destroy man himself, all belong to it.

At different times – long ago

E B-J: Belong to the Church of England? Put your head in a bag![1]

[1] Passages from two letters sum up B-J's religious prejudices and predilections. First, to Ruskin (21 July? 1889?, transcript. Fitzwilliam): 'My dear, we ought to belong to a church that writes its gospels in gold on purple vellum, every kind of purple that Tyre could devise, from indigo purple to rose purple – let's go, on condition that the Pope makes a great fuss over us and sings himself, in his finest cope. Georgie won't join us, needs reasons for things and in that way constantly imperils domestic peace, but if the Pope himself would chant a special mass for us (and I should like it in the Lateran, if it's all the same to him) will you come?' And

27

second, to Helen Mary Gaskell (postmark 4 August 1893. B-J:BL):
'A van has come out on the green opposite [at Rottingdean] – and
all over it is printed in enormous letters THE LUTHER PRO-
TESTANT VAN established to MAINTAIN A PROTESTANT
CHARACTER in the Church of ENGLAND and it has made me
quite sick, and undone all the good that the sea winds were doing.

'And tomorrow I join the Church of Rome – so now.' He didn't,
of course, for Georgie's Wesleyan Methodist background must be
taken into account. On occasion, however, he viewed more equ-
ably his own evangelical background. After reading *Robert Elsmere*
(1888) he wrote to its author, Mrs Humphry Ward: '. . . perhaps
my way is not so much reading as the exercise of morality – at any
rate it interests me deeply, and I think it a lovely book – not one
least bitter word in it – threading your way through intricacies of
parsons so finely and justly – of course it interests me – isn't it all
about the old life I remember and felt so rebellious about ?. . . I am
back five and thirty years and feeling softened and subdued with
memories you have wakened up so piercingly – . . .' (n. d. 1888?
HRC.)

Spring 1874

E B-J (*on my bringing design* Cecilia Playing Viol in Prison):
How's anyone to know it's St Cecilia?[1] It's best not to depart
from tradition – brings confusion into things that are at no
time too easy to make clear. I'll lend you Didron.[2] Once, in the
ardour of youth, I tried an innovation. It was a mistake. I drew
an Annunciation with Mary taking the Dove to her bosom;
and when the architect who had commissioned me (he was a
very good architect – Butterfield it was) objected I wouldn't
alter it. So he would never give me anything more to do, and
he was quite right – and I lost the chance of a lot of work.[3]

[1] Whereabouts unknown.

[2] A. N. Didron, *Christian Iconography: or the History of Christian Art in the Middle Ages*.

[3] William Butterfield (1814–1900), noted for introducing colour by means of bricks, marble, and mosaic. The three-light window (c. 1860) was for St Columba's Church, Topcliffe, near Thirsk, York-shire. Butterfield thought Mary's pose sacrilegious and gave the centre and right-hand panels to another artist. See H/W, p. 31 and Sewter, I, 13; II, 1–3. B-J's cartoon, oils on canvas, is in the Birmingham City Museum and Art Gallery.

Spring 1894 and Earlier

<div align="right">20 years back c. 1874</div>

E B-J: A good artist ought to work only for public purposes; no private person ought to own pictures. I'm as much a slave kept in Leyland's back parlour as a Greek artist at the time of the Empire.[1] Desperate harm it was to keep such artists spending all their talent in the cutting of minute gems that should have been used in statues and great pictures . . .

(*Remark, on question from me about Indian art*) I can't go farther East than Persia, and when from there I travel West and come upon the Nile and the Mediterranean Coast and breathe the sea air, I don't know how to contain myself for pleasure and happiness.

[1] Frederick R. Leyland (1831–92), wealthy Liverpool shipowner; art collector, and patron of Rossetti and Whistler, whose famous Peacock Room, now in the Freer Gallery, Washington, D.C., was executed for Leyland's house at 49 Prince's Gate, Kensington. His collection, which included many Burne-Jones works, was sold on 28 May 1892 at Christie's.

<div align="right">Recorded 6 February 1896</div>

E B-J (*once about something in Ruskin and Carlyle*): The fact is they're always wanting to preach, and never content unless they are scolding someone. Everything has to go through its period of neglect; if it survives that and comes to the surface again it's pretty safe. There's not so much pure gain in progress as people think, beyond the pleasure of going on and the healthy vitality of it. When you clutch at a new thing you have to let go of the old – can't hold more than a handful at any time.

<div align="right">Very early days</div>

E B-J: Carlyle and Ruskin are not a historian and a critic – they are two old Hebrew Prophets alive now and thundering. Carlyle is a Scandinavian War God from the North. It is a very good thing we don't live for ever – what on earth should we turn into? Carlyle has got to be like iron for hardness and want of elasticity; he would turn into adamant if he lived long enough, and what he would become after that there is nothing to liken to.

Anything that Carlyle has said already existed in the world

somewhere or another; he was a first rate littérateur and book maker – but Ruskin has said things in ethics the like of which for insight, delicacy and surpassing beauty and justice had never been imagined before. A shame of the Glasgow University people to pitch them one against the other – just like the detestable common odious ways of this world, to set one great man to run against another.[1] Ruskin is, as he says himself, a naturalist with a sense of beauty.

[1] Ruskin stood unsuccessfully four times (but never against Carlyle) for the Glasgow University Rectorship: first, in 1858, then in 1872, when he told Sir Henry Acland (1815–1900), Regius Professor of Medicine at Oxford, 1857–94, that he feared that 'the Scotch young gentlemen were greatly mistaken in setting me up for a liberal! It is none of my doing. I sent them Fors [Clavigera] to read, first – but they went on, in spite of it. If they elect me I shall give them a lecture on the beauty of the Scottish dialect' (8 November 1872. Acland Papers: Bodleian Library). He tried again in 1880, then in 1883, when, as Independent Club candidate, he came in last.

9 October 1881. Sunday lunch

E B-J: I know where you were last Sunday. *I* know where you asked yourself to – *I* went to see a gentleman yesterday. (*Mrs Holiday acknowledges she went to see Mr Watts.*) He has built himself a new studio to shew his pictures in; it has cost him seven hundred and forty eight thousand nine hundred and sixty two pounds eighteen shillings and four pence.

MRS HOLIDAY: Oh, but it did not *really* cost that, did it?

MISS COLENSO: I thought at first it might be a real sum till it began to mount up so.

E B-J:Well, if I were to say £700 you would simply go away with a notion that it cost some hundreds of pounds – but only exaggeration can give an idea of the expense of it.

MISS COLENSO: Is it built in his garden?

E B-J:It *is* his garden and all the neighbours' gardens. His *enormous* dinner came up while I was there, it took *many hours* to eat. What do you think it was made of – a little dish of lentils and then a *little* rice pudding (*said diminutively*) and the strong liquors he had to wash them down were some barley-water and milk. He lives all alone, and he goes to bed at 8 o'clock: he

says he does not sleep through all the night, lies awake and thinks. He gets up at 5 in the morning. I could not lead such a life all alone – I must cut away off to town![1]

MRS HOLIDAY: And keeps what is left of his rice pudding by his bed, in case he may want it in the night.

MISTRESS: Like the farmer who had a bucket of beer there that he dipped into with his mug? (*And shutting her eyes and turning her face away she imitated the action of the drunken man, scooping with her hand below the margin of the dinner table.*)

E B-J: That horse of his is getting bigger than the world, O it *is*, and too heavy for Europe to hold; if he keeps on putting more clay and stuff on it, it will go smash through into S. Africa – and there's [Alma] Tadema who is a small giant who feeds on bulls, (Oh he does – they go roaring down his throat) and he paints *little* pictures (*the diminutive tone again between the points of his teeth*) as big as one's hand, full of beautiful marble and mosaic pavements.[2]

MRS HOLIDAY: Ah then, I suppose he had suffered from pangs of hunger the other day when at the sound of the dinner-bell he caught me up joyfully and danced me round the garden like a feather . . .

[1] Catherine Holiday, who executed superb embroideries from Morris's designs, was the wife of Henry Holiday (1839–1927), stained-glass designer since 1861 for James Powell and Sons, Whitefriars. G. F. Watts's 'new studio' was attached to his home at 6 Melbury Road, Kensington. Despite civic protests, both were demolished in 1965. On Watts's frugality, see Mrs Russell Barrington, *G. F. Watts*, p. 70. Frances Ellen Colenso (1849–87), youngest daughter of the liberal and controversial Bishop Colenso of Natal, was a lifelong friend of Ruskin.

[2] Watts kept *Physical Energy* (1883–1904), his famous equestrian statue, in a continual state of revision, and himself in perpetual uncertainty about it. In 1906 it was stationed in Kensington Gardens. A bronze cast *did* go (by a conventional route) to South Africa in 1904, a memorial to Cecil Rhodes, whom Watts admired as 'the last great Englishman of his type' (Wilfrid Blunt, '*England's Michelangelo*', p. 195). There is another cast in Salisbury, Rhodesia.

Summer 1883

E B-J (*replying to Mr Spencer Stanhope*): Tell him I neither paint on wet white, nor get drunk every night, nor do any other of the things that are reported of me.[1]

[1] John Roddam Spencer Stanhope (1829–1908), English painter living in Florence, had written to Rooke in 1883 (PC): 'There is a thing I want to know and I dare say you can tell me. To wit does Jones always cover his paper with Chinese white before painting in water colours? What is the advantage? and does he use body colour as well? Mrs Stillman [Marie Spartali, 1844–1927] told me she had seen him working in that way, and I should like to know all I can about the matter. I would write to Jones himself; but when should I get an answer? I presume of course he makes no secret of the matter ... Also I hear he uses white of egg and I should like to know particulars about that also . . .' B-J was in fact rather secretive about his methods. Stanhope, exiled by asthma, sent him 'grumbling letters from Florence full of regrets for the sweet London air and the clean streets and the courteous people here, and complaining his heart out at the bitter exchange he has made – he waxes old and mustn't be trusted away again, but I sigh to be there many a time, if I only could, but the work thickens and I undertake new things and time overtakes me even before I begin them . . .' (B-J to George Howard, n. d. CH).

Spring 1894

E B-J ———— was in very low spirits about his work last night; but I tackled him. I said, 'Wouldn't you rather have a little carved Chinese god than one of those sloppy pictures?' And he said 'Of course I would.' 'Wouldn't you rather have *anything* you could buy, or *anything* that exists?' And he said 'Yes, indeed!' So I said 'Well then!'

1 February 1895 – June 1895

1 February 1895. Cold dull day with snow
E B-J: . . . Morris tumbled down this morning because of
the snowballs under his heels, and he would insist on repeating
to us the language that he used, and Georgie felt wounded.
Then he told us how he had broken his shoelace before start-
ing, and for a gentleman of his proportions it isn't pleasant to
have to stoop, and he would tell us what he said then, and
Georgie's feelings were hurt again. He is so funny, I *do* love
him[1] . . .

[1] Georgie, however, wrote to Cockerell (21 February 1907. V&A): 'I
really thank Morris for the rages and tearings of the hair by which
he expressed himself in early days, for though I can't imitate him I
can say "that's how I FEEL".'

7 March 1895
(My first visit after my mother's death.)
*E B-J (asked if he knew a way of mixing a brilliant white, and if it
would be of any use in his work)*: No, mine is so different to
landscape painting, I don't want to *copy objects*. I want to tell
people something. *(Twenty years before he said:)* People prefer
the *re-pre*sentation of an old idea to the presentation of a new
one . . . I never trust any but an artist's opinion about a work
of art. People don't know, they have to be told. They can't
bear to be out of anything, must be supposed to know. If they
get the hint, then they're set up and all right, but I have to give
them the hint . . .

Afternoon
E B-J: Byron's 'English Bards and Scotch Reviewers' was
only a criticism on critics and that's nothing about nothing.[1]
The only way is to take absolutely no notice of them. All that
we (the Rossetti school) have done is to go on wishing that

33

d——d fools should go on being d——d fools to the end of the chapter. At a time when it might have been an encouragement they made it hard for me to live, it became difficult to sell my pictures and impossible to get a proper price for them; now nothing they can say will be ever of any pleasure to me.

[1] Byron's retort (1809) to a devastating unsigned review by Henry Brougham, in *The Edinburgh Review*, of his first published poems, *Hours of Idleness* (1807).

April 1895

E B-J: People don't know anything about our work and don't really care; they only want to be up to the last thing out. I declare I'm more ashamed than pleased with the most part of the praise that ever I get. There was that design of Christ (*the man and women with the fruits of the earth*) no one even looked at it when it was shewn in the New Gallery. They only saw that it wasn't oil-painted; and yet it said as much as anything I have *ever* done.[1]

[1] *The Tree of Life*, an allegorical crucifixion, with Christ on a tree in full leaf, and, on either side, Adam and Eve with the fruits of the earth and their two children. Designed 1886, for the mosaics at St Paul's Within-the-Walls, Rome; cartoons executed 1891–93; installed, 1894. Exhibited at the first Arts and Crafts Society Exhibition, The New Gallery, October 1888. See Dorment, 'Burne-Jones's Roman Mosaics', *The Burlington Magazine*, 120 (1978), 58, 72–82.

Spring 1895

E B-J: . . . There used to be carpet beating in the field behind the garden before it was built on, and sometimes I used to tell models it was wife-beating, and that I sent my wife there regularly to be operated on. One day a model said she didn't think that people ought to beat children, so I told her I always beat mine, and I got Phil to come with me afterwards outside the door and he screamed loudly while I beat a cushion with a stick. He was proud of me that day, I can tell you, and thought me something *like* a father.

17 May 1895. Lunch. (Miss Norton)[1]

E B-J (*Middleton*)[2]: The writers in the papers nearly worried him out of existence because he had those splendid tapestries so well hung in the South Kensington Museum – because they know nothing about tapestry and the whole lot of them are not worth three threads of it. I should like to tell them so and have it put in print, only I can't.

MISTRESS: Morris was very funny this morning, said he had found a new way of putting an end to the newspapers – giving them a penny not to print themselves, instead of paying them to be printed. He said he was sure more people would be glad to pay them to stop than there are to pay them to go on. He said he'd be only too glad to induce a young lady friend of his not to 'Art', by the same method.

E B-J: Oh! I do think it's too bad not to say who it was, Georgie, I'm sure you know. People tell delightful scandalous stories and keep back the names of the people – and that's the whole point, and you know they're selfishly enjoying it by themselves the whole time.

[1] Sara Norton (d. 1922), daughter of Charles Eliot Norton (1827–1908), the editor and art historian, and friend of the Brownings, Carlyle, Ruskin, and the Morris/Burne-Jones circle.

[2] John Henry Middleton (1846–96), orientalist, archaeologist, medievalist; Art Director, South Kensington (Victoria and Albert) Museum, 1892–96. Morris wanted casts moved into a gallery without top-lighting and tapestries hung in the Great Hall; see *The Athenaeum*, 10 August 1895, p. 200; 24 August, pp. 264–65. In 1905 Georgie told *Athenaeum* art critic Frederic George Stephens (1828–1907), one of the two original non-painter members of the Pre-Raphaelite Brotherhood, that he (Stephens) plainly was still 'not prepared to learn that Edward and Morris both applauded it and thought it a great gain. Edward's argument was that the casts were but casts, and that some of the finest originals of them could be seen in the British Museum, . . . for the first time it was possible for the public to see the extraordinary beauty of the [tapestry] specimens. The value of the collection proved, he said, to be even greater than he had suspected until it was brought out under the high skylight. I remember those little Courts of Tapestry were almost like chapels to him – he often looked in just to see them and rejoice in their beauty' (11 January 1905, V&A).

The Conversations

24 May 1895. Lunch. Mistress, Seb Evans, W. Benson.[1]

E B-J: Morris has had a terrible life this last three weeks, haven't you heard what's happened to him? Well, about a fortnight ago he had a book sent to him (haven't you heard of the Huntingfield Psalter?). Well, for once to borrow a simile from Little Rooke, it's like Ely Cathedral, and he's given £800 for it and it's all his own and he's got it in his house, and now he can turn into an old gentleman and look at it every morning before he begins his work and open the pages of it, and *all the sunsets* in the Mediterranean Sea are not equal to one of them – he possesses the entire Levant.[2] And the other day someone wrote to offer him another book, and at first he was rather by way of running it down. He said he didn't much care for it, two hands had been engaged upon it, and one was rather a poor one and had done the most part of it, and he brought it over to me, and when I saw it I thought it was such a beautiful book (since in fact it wasn't I that was going to buy it but he) I advised him to buy it, and he went home that Sunday night and wrote off a cheque for £750 for it, and then he had a six and thirty hours of *torture*, for *all* Monday he didn't hear a *word* about it, and was expecting to get an answer that somebody else had bought it and all sorts of things, till, finally on Tuesday morning he gets a letter to say it's his. So he's got both Ely Cathedral and Winchester in his *own very house*.[3] And then a most beautiful fact was to be observed of him, that having got these books he gets suddenly anxious about his wife's health, thinks she ought to have some bottles of very rare Champagne to set her up. Oh! he's most beautiful, he's a *darling*, he's the queerest thing that ever existed on this Earth, there's nobody like him, there isn't anyone that *exists* that in the least *bit* resembles him . . .

[1] Dr Sebastian Evans (1830–1909), journalist, window designer, barrister, became B-J's friend in 1885. See *Memorials*, II, 156, 158–59; Fitzgerald, pp. 238–39. William Arthur Smith Benson (1854–1924), known as Brass Benson, designer and architect, assisted with a variety of projects; see *Memorials*, II, 81, 112.

[2] The Huntingfield Psalter, possibly made at Lesnes Abbey, Kent, for Lucie and Roger Huntingfield, early in the thirteenth century; see *Art of the Book*, p. 101. Morris had seen it in 1892 and finally

bought it on May 2, 1895.

3 The Tiptoft Missal, codex commissioned by John Clavering and his wife, Hawyse Tiptoft, in the 1330s. On May 12, 1895, Morris paid Sotheby's £750 (diary, WM:BL). *Art of the Book* (pp. 101–102) cites £900, from the notation by Frederick Startridge Ellis (1830–1901), London publisher and antiquarian bookseller, in the Morris Sale catalogue (1898).

June 1895. Lunch

E B-J (*on the Duke of Argyll's re-marriage*): *Was* it I that said he interfered about the Baroness Burdett Coutts? Then I'm afraid (*covering his face*) that throws some doubt on it. I *contribute* to History sometimes.

21 June 1895. Lunch

COBDEN-SANDERSON (*just back from France*):[1] I do love those dear French people in their own homes – they fit their place so well and their place fits them. I mean to try and introduce the blouse into England – of all the ugly, untidy ways of a workman's get-up his dirty shirt sleeves beat everything.

E B-J: You won't do it. My hope of an Englishman is limited. You might perhaps get him to give up his Toryism and his Radicalism, he may even abandon his Protestantism, his Dissent or his Church of England, but his frock coat never: he'll hold to his respectability to his dying day – the way he must put on a coat over all the rest of his clothes to go out for a walk in on a Sunday is inborn in him.

[*Rooke's interpolation*]: Twenty years before, when he had to assume a top-hat to take his son to Marlborough [College], the first time I ever saw him in one, he said, 'Wear a top-hat and you may do *anything*; go about in a slouch hat and if you are a saint you'll be suspected of the most awful crimes – but put a top-hat on and you may commit the worst of them with impunity.'

1 Thomas James Cobden-Sanderson (1840–1922), barrister, then master bookbinder and a partner in the Doves Bindery and Doves Press, Hammersmith; see his *Journals*, I, 94.

22 June 1895. Studio, afternoon

LUKE IONIDES: Ned, I think I'll take to painting again; I'll get a box and some brushes and make a start.

E B-J: Capital thing to do, nothing so happy and pleasant as being an amateur painter, nothing more miserable and anxious than being a professional one.

June 1895. Garden Studio

E B-J (*putting in Sleeping Arthur in* Avalon;[1] *enter William Morris and Mistress*): Any criticism to make, old boy?

WILLIAM MORRIS: No, I hate criticisms of any sort or kind, won't have anything to do with them – ahem – But what I don't understand is people asking for money for their opinions about other people's work, you know – that puzzles me I must confess.

MISTRESS: Or people *paying* money *for* them.

E B-J: Yes, Georgie, that's it.

[*Rooke's interpolation*]: Can't remember about whom or when he said 'He should know the proportion of things, and when Mr Morris speaks, he should be dumb.'

[1] *The Sleep of King Arthur in Avalon* (1881–98), the large oil commissioned by George Howard for his library at Naworth Castle but relinquished when he perceived the importance of both painting and subject to B-J, who regarded it as his magnum opus. It is now in the Museo d'Arte, Ponce, Puerto Rico. See *Memorials*, II, 116, 125, 340, 345–46; *Arts Council* 184, 185; H/W, pp. 154–55, figures 250–55, Plates 48, 49.

✿ Interlude: Summer 1895

Following the pattern set in the days of his work for Ruskin, Rooke with his family left England on July 3 for that summer's work, principally at Rouen. Cockerell, the most methodical of men, kept them abreast of the news from London and, true to the principles of Anti-Scrape, advised Rooke about some precious bits of Rouen: 'Close by you will find a carver's shop with an ancient lock or two, renaissance woodwork, and other curious odds and ends in the window. That was where my wooden angel came from – the bearded man inside, if you chance to make his acquaintance, is very nice and typical of French versus English workman intelligence, knowing well enough that his Cathedral is worth attention.'[1]

Rooke was concentrating his attention, as he wrote to Burne-Jones, upon 'a piece of the Southside of the Cathedral apse, outside, shewing a very old stonework of a chapel with a quite plain flying buttress above, only with two little images in the corner; and tops of towers beyond.'[2] This painting was for the Birmingham City Museum and Art Gallery, one of the commissions that Cockerell, Burne-Jones, George Howard, and others helped to arrange, both to continue Ruskin's pictorial record of ancient buildings, and to augment Rooke's income.

In all of his letters from abroad Rooke showed a fine instinct for writing about places and subjects for which Burne-Jones cared deeply. 'This is still the best place I have been,' he wrote from Rouen in July 1895, 'the church towers hanging over the houses so beautifully in the narrow winding old streets that remain. We always thought we ought to stay here, but in passing through were either being sent somewhere else, or I was intent on some remote, little known discovery that should prove better than the best, only it never did . . .'[3] Rouen and its cathedral, which Burne-Jones had first seen in Morris's company in the summer of 1855, was a symbol of their decision,

made as they paced the quay at Le Havre, to become artists. In 1878 Morris recalled 'what a wonder of glory that was to me when I first came upon the front of the cathedral rising above the flower-market,' but, he added ruefully, 'it scarcely happens to me like that now, at least not with man's work.'[4] But for Burne-Jones that experience remained fresh and clear, and in his chosen portion of the Cathedral apse Rooke found, very literally, one of Burne-Jones's sermons in stones. 'This contains,' Rooke wrote, 'much of what you epitomised for me as to be desired. "Impressive building" and "beautiful masonry" richly heaped together – so that I feel sure of your being pleased with the choice and of Mr Morris his contentment.'[5]

All four Rookes had a fine instinct, in their behaviour abroad, for what would assure their cordial reception. They had the gift of bearing themselves so as to be all but indistinguishable from local inhabitants. Settling in came to appear quite effortless; the secret of its apparent ease was their unaffected pleasure in the expedition and in the reason for their unannounced presence in unfamiliar towns. Immediately upon arrival, Rooke would take his painting gear and set out to choose his subject, while Leonora set out in other directions in search of rooms. Their means, which determined their demands, were so modest that in one town after another they lived a village life, shopping in the local market, picking up local mannerisms and colloquialisms, enjoying the simplest local amusements.

The variations in national character never failed to interest both Rooke and Burne-Jones. 'You always find the interest taken by the French in the supposed ways of our nation to be very touching,' Rooke wrote from Rouen, 'so it may be fluous and not super-fluous to mention that there is here a desert of gravel called "Place du Bulingrin" [Bowling Green]. Further that in a trial to obtain the expulsion (from a flat of a large Rouen house) of a lady called "La Belle Otero" on account of her goings on, it was pleaded, on behalf of the gentleman in whose rooms she lived, that there was nothing in the agreement to say that he might not "comme on dit en Anglais, live with as many ladies as he pleases." To my reading such a case I am sure you would not object.'[6]

Interlude: Summer 1895

In the summer of 1895, however, not even cheerful anecdotes rallied Burne-Jones for long. It was very hot, and English gardens bloomed luxuriantly, but the plight of many of his friends reminded him daily that he too was facing old age. Leighton was ill. Millais was ailing and depressed. Ruskin showed only intermittent flashes of his old enthusiasms and energies. Watts, sequestered in Surrey and hovered over by his watchful wife, had become a veritable Jonah, pouring forth gloomy warnings of the dissolution of English art (contaminated by French influence) and even of England herself ('eaten up by vice') – these being the inspiration for his 1895 painting, *Jonah*, which Wilfrid Blunt describes as 'remarkable but repulsive': an unsubtle sermon finally presented to the nation in 1897.[7]

It seemed to many that summer that England was having the narrowest imaginable deliverance from vice, for Oscar Wilde's slander suit against the Marquis of Queensberry had commenced on April 3, and the terrible turn-around and dénouement of his action continued through May and ended with his imprisonment on May 25 and the sordid bankruptcy proceedings in August. The Wilde affair cast Burne-Jones into vehement gloom, and in letters to Helen Mary Gaskell he dwelt long and resentfully upon it. 'I don't know what has been the matter with me these 2 days – such an ominous feeling I have had at my heart's root of some impending trouble and disaster . . .', he had written on April 1, 'perhaps the Luke [Ionides] story sickened and depressed me with its vulgar ugliness – perhaps I shuddered at tomorrow when a man I once knew may be hopelessly and deservedly ruined – in the Queensberry matter – it has troubled me and made my heart quake for it is dreadful to see a man destroyed . . .'[8] On April 4, which saw the discharge of Queensberry and the opening of the second act of Wilde's courtroom tragedy, Burne-Jones told his son that he had 'a sense of dilapidation and failure, somewhere – Tadema last night brought sad news of the state of Leighton, who seems breaking down – and [Comyns] Carr told me seriously in a corner he felt his head going and had done for weeks past, and he was frightened, and there is that horrible creature who has brought mockery on

every thing I love to think of, at the bar of justice to-day.'⁹

On May 25, the day of Wilde's imprisonment, Burne-Jones wrote: 'And so that poor wretch, who has done so much harm, and made the enemy everywhere to blaspheme hadn't the common courage to shoot himself – I looked eagerly for it for it didn't happen. But we shall be in clearer air now he is ended and others must go too – all the same lot who hang on to every good thing and try to drag it into their own feverish depths – I hope we have seen the last of the yellow book; I hope no decent being will go to any of these plays – and when the air is clearer and the stench of this harm has drifted away all of us who can will get about making life lovelier and finer than ever.'¹⁰

His pictures were Burne-Jones's one medium for 'making life lovelier and finer', but about them he was discouraged. He missed William Graham; it did not help to reflect that the age of Victorian patronage was approaching its end. Watts was not mistaken about the strength of French influences, and the young William Rothenstein, although himself trained in Paris, found himself in disagreement with his friends about Burne-Jones. 'My friends, with the exception of Ricketts and Shannon,' he wrote many years later, 'cared nothing for Burne-Jones. I, too, was aware of certain weaknesses; but no man who can draw and design so nobly and thereby impress his vision on the world is to be swept aside.'¹¹ Ned Burne-Jones had persistent nightmares about being swept aside: in the summer of 1895 he worried not only about his pictures but about his heart. In July, without telling Georgie, he went to see a specialist. Afterward, writing from the Athenaeum Club, he had told Helen Mary Gaskell that 'it is all right about the heart throbbings – they may bang themselves about as much as they like – the heart is all right, only some mechanical difficulty that will go when more strength comes . . .'¹²

He was concerned also about Morris, who had had a serious illness in 1891, gout complicated by a kidney disorder. It was a blow to his plans, for he had just opened the Kelmscott Press. The illness depressed him so, that he was heard to talk about dying. One biographer suggests that the collapse was connected with disappointment at the failure of the Socialist League, and the deterioration of his daughter Jenny's health.¹³

Interlude: Summer 1895

One may speculate, however, that it was an instance of the body's mechanisms bearing up under extraordinary strains, as Morris's had done during the strenuous years with the League, then breaking down when the heaviest tensions are removed. He had seemed to recover and had resumed his activities with the Press and with the Firm. He and Burne-Jones met as usual for their Sunday breakfasts, and their work went forward again. But there were unspoken worries between them.

Georgie found when writing the *Memorials* that she remembered less of the years since 1891 than of earlier years, for in the 1890's there were 'no more beginnings of things, which mark time so gloriously . . . Edward's desire to finish work that he had in hand grew strong as he realized the mass that was waiting to be gone on with.' This made him more patient, more methodical, 'but he was much oftener depressed than he used to be'.[14] Hence the list of the pictures that form the gallery of contexts for the talks recorded here by Rooke, a list that includes so many older pictures or reworkings of old themes: *Love and the Pilgrim* (or, *Love Leading the Pilgrim*), *The Car of Love* (or, *Love's Wayfaring*), *The Prioress' Tale*, *Aurora*, *Hope*, *The Dream of Launcelot*, *The Magician*, and the last great picture, *The Sleep of Arthur in Avalon*.

Rooke returned from France in September, and by September 23 life in the studios had resumed its accustomed pattern.

❧ 23 September 1895–15 July 1896

23 September 1895. Garden studio

I (*Catterson-Smith. Kelmscott Press edition of Chaucer*): Is the spelling his [Chaucer's] or Caxton's?

E B-J: He has never been properly edited till now; Skeat has done it.

I: Oh, he's a splendid man (*thinking of his dictionary*).[1]

E B-J: He's a ————. He says in his notes that no doubt if Chaucer's wife had been alive the Canterbury Tales would never have been given out, and he makes a sum of the number of lines of Chaucer's own and the translated ones in the *Romaunt of the Rose*, and talks about *per contra*, and because of many other stupidities, as in his remarks about the *House of Fame*, I say, with all delicacy and consideration and accuracy of expression, that he is a ————.[2] He can't get Mrs Chaucer out of his mind. Now I wonder, if Chaucer were alive now or is aware of what's going on, whether he'd be satisfied with my pictures to his book, or whether he'd prefer impressionist ones. I don't trust him, and if he and Mr Morris were to meet in Heaven, I wonder if they'd quarrel. I hope Botticelli and I would get on together; Michael Angelo would sniff contemptuously at me I know, and as for Raphael he's much too much of a fine gentleman to have anything to say to me.

CATTERSON-SMITH: He [Morris] said last night, at Socialists' Meeting, he didn't mind people differing from him in Politics or Religion, but if anyone differed with him about Art he'd like to *kill* him.

E B-J: Oh, he's lovely – and isn't it funny how if you've got one of his books in your hands for a minute, he'll take it away from you as if you were hurting it and shew it you himself.

[1] The Rev. Walter William Skeat (1835–1912), etymologist and medievalist; editor, Chaucer's *Complete Works*, 6 vols., 1894–1900; compiler, *An Etymological Dictionary of the English Language*, 4

vols., 1879–82. He regarded the modernising of Chaucer's English as 'a feeble suggestion' (Chaucer, *Works*, V, xxv). F. S. Ellis, who prepared the Kelmscott text, apparently used the six-text Chaucer Society edition (8 vols., 1869–77).

² Skeat writes (Chaucer, *Works*, I, liii) that regrettable elements crept in after Mrs Chaucer died in 1387. B-J left eighteen of the tales unillustrated, although, as he told Swinburne (*c.* 15 June 1896), 'Mr Morris has been urgent with me that I should by no means exclude these stories from our scheme of adornment – especially he had hopes of my treatment of The Miller's Tale, but he ever had more robust and daring parts than I could assume, and I trust it has been performed, that the volume could be placed in the hands of a new born babe without additional harm to its already sinful soul'; quoted by Duncan Robinson, in *A Companion Volume to the Kelmscott Chaucer*, p. 27.

24 September 1895. Bottom studio

E B-J: . . . Mr Morris and I were talking about what we would do if we were very rich, and he said he'd like to build a very beautiful city and have a keen lawyer like ———— to draw up a very stringent deed to forevent any railways coming near it, or gas or electricity or any modern improvement, and have a handsome King's house in it, not too vast, and I said 'King's Palace be blowed, but let's have a fine church.' And then I said I'd like to open up more of Herculaneum and see if more things couldn't be got out – and he said 'Oh d—n Herculaneum, d—n all Greek things, I say, old chap – Eh?'

Early October 1895. Studio

E B-J *([working on?]* a Cartoon of Abraham, Catterson-Smith drawing on Chaucer)*: The only time when I don't want a Republic is when I hear the names of those five kings (*repeats them sonorously*): Anaveaphel King of Shinar, Arioch King of Ellasar, Chedorlaomer King of Elam, and Tidal King of Nations. (*To Catterson-Smith.*) Which one would you sooner have?

CATTERSON-SMITH: Oh I think I'd sooner have Tidal King of Nations . . .

E B-J (*going on to the Irish subject*): I don't wonder some English should hesitate about making important changes in

the Irish Government that no one can really know the possible result of – and I'm quite sure there is an enormous number of right-minded Englishmen up and down the country anxious to do the just and desirable thing for Ireland. But what is beyond my endurance is the horrid lies and insidious stirrings up of those foul newspapers that know and really care for nothing and represent the basest side of the English view and the worst among the individual English that keep the fire alive for their own behoof. Don't know what led Gladstone to take up the Irish view, but his extraordinary obstinacy prevented his ever dropping it when once he had it in hand. And he was helped by an enthusiast he had among his followers, [John] Morley.

CATTERSON-SMITH: They say there is the least domestic crime among the Irish of all the peoples of Europe.

E B-J: Yes, and what gives me most pleasure is that the Scotch of all the populations of the British Islands are the bawdiest.

12 October 1895. Garden studio

E B-J (*Catterson-Smith drawing Chaucer asks something about Rossetti's methods*): He hated the mechanism of a picture.

CATTERSON-SMITH: Did he use to alter or try to improve a design when he had once made it?

E B-J: *Never*! He never would bother. He'd take immensely more trouble about his poetry, was never tired of trying to make a sonnet for instance fit in more closely, but if anything was wrong in a picture, he *wouldn't* get it right, wouldn't bother. He never got a model and tried to study at a thing till he had learnt it thoroughly, never did more than get as much nature that way as he couldn't do without or as helped him easily. There was one of the most beautiful things he ever did, the watercolour design of Dante led to the dead Beatrice. He painted two large pictures of it afterwards and never went to the trouble of making a single study for either of them, and they weren't nearly so good as the small first one.[1] What he did, he did in a *moment* of time, designing was as easy as drinking wine to him. But he hated trouble or anything that ran counter to his mood, and was quite without any stern

46

morality about his work. He *would* have the very easiest method of painting and didn't care in the least whether it was lasting or not – had the deepest scorn for the whole of that aspect of it. I used to say to him, 'Why do you paint with colours that you know are not permanent?' but he wouldn't listen to me or entertain the point for a moment. Red lead for flesh colour was the delight of his eye, he couldn't resist it for the least instant. It was an *overwhelming* temptation.

CATTERSON-SMITH: W. Morris speaks with the greatest belief in him.

E B-J: I should think that was quite true. I never knew anything that could encourage the superstition that some people had, that the gods were jealous of the possible achievements of great men, as much as in Rossetti's case. Everything was ready for the making of a glorious creature. The perfect hunger for romance that was spread abroad in the world at the time when he came into it. The mingling of blood in him, his own admiration and discrimination for all that was splendid; his surroundings and things he was brought up among, the people of all sorts of cultivation that he must have known from his earliest days, never was anyone so started, so ready for a great career. The achievement too, *was* immense – but – it might have been bigger. No man ever did two arts at once so perfectly before – ever. Painters for instance have written poetry before, and it was always interesting because of the greatness of the writer, but no one had ever done the two well, as he did.

CATTERSON-SMITH: I suppose a poet has never taken to painting.

E B-J: Oh no, why should he? No object in trying to learn a new, difficult art if he has the means of expression ready to hand. He is born into the language, he has nothing to acquire, he has simply to pour out, if it's in him. (*Returning to Rossetti.*) He never put up with any inconvenience whatever, and when the age came at which sleeplessness came upon him, as it comes to all of us more or less that have any activity of mind, he couldn't bear it and took hold of the first quack medicine he could find that promised any chance of sleep, and so he got on to chloral, and as always happens, had to increase the dose to

make it effectual so that in the end he would take at one gulp what would have been enough to kill him at the beginning. This, long continued, lowered his vitality and weakened every part of him, developed every kind of disease in him that he might have been at any time liable to, and besides, told upon his mind. For the last ten years of his life he was entirely without power of will, and there is no doubt he approached what was, it was clear, to some degree congenital. I don't say he was ever entirely out of his mind, but he grew very violent at times and was always difficult to manage. It was lamentable to see the downfall, like the fall of a great Colossus, a great mountain. Down he went. We *all* suffer for it. Towards other men's ideas he was decidedly the most generous man I ever knew. No one ever so threw himself into what other men did. It was part of his enormous imagination. He was even tiresomely generous, you didn't know how to receive it. The praises he at first lavished on me, if I had not had a few grains of inborn modesty, would have been enough to turn my head altogether.

[*Rooke's interpolation: Long before*]: Rossetti was rather hurtful to him. When he saw his designs he said, 'My dear fellow, you don't need to learn to draw any longer – take a studio and begin work at once' – yet he wrote that poem.[2] In spite of all that, not to gild the statue overmuch, it must be said that when I began to prosper he didn't like it altogether. He was always, too, a little ungenerous about Morris.[3]

CATTERSON-SMITH: I heard that he always spoke so highly of Mr Morris.

E B-J: He did, and really thought it, yet it couldn't keep him from little insults and unkind names. They were very different too in their work. Like many people, he couldn't bear the length and quietness of an Epic. He wanted to keep a poem at boiling point all the way through, and he did to that degree that it went into ether with fervent glowing heat before he'd done with it. The short form of his poems helped him to this. As soon as the pot went off the boil he'd take it off the fire. (*As to epic –*) Those who love architecture know how delightful the long, splendidly built straight wall is, and how precious it makes a piece of rich ornament to be when you come to it. If a

building is all crockets you go mad.

CATTERSON-SMITH: He didn't think much of many who were in very high estimation then? Big-wigs that is?

E B-J: Oh, he hated all big-wiggery. He was most scornful of the men of his time when he wanted to be, and everyone caught it in turn. His scorn for —————— went beyond the power of even his vocabulary.

I: And that wasn't limited.

E B-J: The strongest that ever I knew. Unthoughtful, absolutely unmeaning skill filled him with fury. He was *so* fascinating that he could bring over whatever man he chose, and (*very slowly, and in a low, distinct, almost reverent voice*) I'm *quite sure there's not a woman in the* WHOLE *world* he couldn't have won for himself. Nothing pleased him more though, than to take his friend's mistress away from him. You couldn't depend upon his mood, you know, at all – but (*playful chaff*) he never sneered at my work as Rookie does over there.

[*Rooke's interpolation*]: Above talk began with interchange of remarks about the many times some of the Chaucer drawings had been designed and re-designed, and the trouble they had been, ending with C.-S. saying 'You don't do everything right off at once?'

E B-J: No, we'll leave that to geniuses, we're only plodding coves, we're hard working chaps, we are, ain't we, little Rookie? Sometimes it's the other way about, and things don't have to be greatly altered – there's that design of Love's Wayfaring, came to me all in one evening pretty much as it is. I don't think it had to have anything done to it afterwards.

1 Rossetti, *Dante's Dream at the Time of the Death of Beatrice* (1856), watercolour; see Surtees 81. Mrs Surtees finds two sketches preliminary to the watercolour version, twelve for the oil replica (1871), and eight for the second oil (panel) version (1880); and she quotes letters that show Rossetti selecting models with great care. B-J, the bedazzled younger artist, may have been unaware of this – or Rossetti may have played down the prosaic details.

2 Person unnamed and poem unidentified.

3 Morris had written that 'Rossetti says I ought to paint, he says I shall be able; . . . I *must* try' (quoted, Henderson, p. 37). However, Morris 'had no more talent for humble discipleship than for paint-

ing' (Fitzgerald, p. 54), and Rossetti's subsequent closeness to Mrs Morris would not have eased tension between him and William; see *Dante Gabriel Rossetti and Jane Morris: Their Correspondence*, ed. John Bryson with Janet Camp Troxell.

Still 25 October 1895

COBDEN-SANDERSON: I thought it a pity over in Ireland to see a place put apart in a Catholic Chapel for poor people and beggars.

E B-J: Yes, it *is* a pity. Strange that for centuries the church was the only earthly thing that stood between the rich and the poor, but I suppose they couldn't keep it up for ever. A great pity their ideal couldn't have been kept up for ever. I remember when I was little I was taken to a Catholic Chapel and saw how they did their service and snuffed up the odour of the incense. I used to think what a pity it was all wicked.

(*Cobden-Sanderson comments on ceremony in religion.*)

E B-J: Yes. It's all very well to object to formalising worship, but you're obliged to. Wesley no doubt was himself a great creature, but there's not a spark of originality in his wretched followers. When I was courting I used to go to chapel with the Missis because I wanted to be with her (her father was a Wesleyan preacher you know). Oh, how I hated it! They'd all say the same thing, though they thought they were being original – not one had a second idea in his head; it was always 'O Lord we approach thy footstool with feelings of deepest humility' – ah – don't I know it! (*With disgust.*)[1]

[1] B-J's dislike of Nonconformist unoriginality extended even to Georgie's clothes. He had bought her a hat, he told Helen Mary Gaskell, 'for she gets horrid hats and bonnets – Baptist bonnets and frocks she gets always – and so I circumvented her and bought a pretty one . . .' (Spring 1894? B-J:BL). He declined even to try to circumvent Methodist architecture: 'One afternoon came a deputation of Wesleyan Methodists, to invite me to decorate their chapel – their most historic and beautiful chapel – somewhere in the City Road [London], with subjects from the life of Wesley and showing the birth, rise and culmination of Methodism. One of the deputation said it was a beautiful building of brick, with round topped windows and a doric portico. I was very polite, but excused myself – I said that as an Englishman I was proud of the distinction

with which they had honoured me – but that as a Romanist I had psychical difficulties which I knew they would appreciate as gentlemen though they might deplore them as divines. This is quite true in substance and in essentials.' (B-J to Mary [Gladstone] Drew, 15 December 1890. Transcript. Fitzwilliam.)

29 October 1895. Garden studio

. . . E B-J (*speaking of*] Love's Wayfaring): I have a hope there'll be no part shirked in it. Don't like parts of pictures looking as if no trouble had been taken over them. But when these are in a great man's work, you don't mention it. Even M. Angelo shirks sometimes, but Botticelli never; he thinks well about it before he begins, and does what's beautiful always.

([*At work on*] Love Leading the Pilgrim.) Shan't put much colour into this – make the landscape melting grey, L'Amant rich black and Love a silvery thing – the figures would jump too much with full colour.[1] What's nice in a picture is to have a very fair (supposing the lines are very beautiful) or very beautiful colour, or else fine splendid chiaroscuro, but you can't have both colour and chiaroscuro together; one kills the other . . .

[1] *Love Leading the Pilgrim* (1895–97), oil. Tate Gallery. See Arts Council 186.

October 1895. J. D. Batten to lunch

E B-J: Ford, does he do any painting now?

BATTEN: I think not. I think he only does the drawings for the fairy books.[1]

E B-J: I like them very much, such nice ones they are, but it is a pity to give up painting altogether; when anyone does nothing but designing he unravels himself too quickly.

[1] John Dickson Batten (1860–1932), painter, fresco artist, and illustrator of chivalric and fairy tales, particularly those edited by Joseph Jacobs (1854–1918), folklorist and friend of Morris and B-J. Henry Justice Ford (1860–1941), landscape and portrait painter, illustrator of the fairy tale collections by folklorist Andrew Lang (1844–1912). For lists of books illustrated by Batten and Ford, see R. E. D. Sketchley, *English Book-Illustration of To-Day*, pp. 158–59, 165–66.

The Conversations

2 November 1895. Garden studio

E B-J (*He, lifting the line of hills in* Love and L'Amant [Love and the Pilgrim]): This is a movement in the landed interest; the farmers will have so much more ground to plough.

I (*referring to a battle in Rottingdean Parish Council by the Mistress*): But you can't let it out in allotments, it wouldn't be handsome enough. Perhaps that's the reason why the Landowners make difficulties.

E B-J: No, I've no belief in the keenness of their sense of beauty. My belief in the landed gentry doesn't extend to that.

(*On Presidents.*) If ———— Society only had such a man as Wyke Bayliss; he's pulled the Suffolk Street Society through an awful time. Whistler not only ruined them in pocket and left them with a heavy debt to pay, but cast every opprobrium and ridicule on them he could.[1]

I: He might have made a fine position for them.

E B-J: Yes, if he had been a man of any sense of responsibility or wish to be serviceable to his fellows instead of being a sort of half charlatan. They did him what honour they could and put him at their head, and he just took it as a lark. The only serious thing he saw in it was a chance of advancing his immediate followers to their detriment. Then the moment he wearied of it he did his best to send them adrift. But this other man's loud vulgarity isn't relieved, as even Whistler's faults are, by a sense of comicality . . .

[1] Sir Wyke Bayliss (1835–1906), architect and miniature painter, was President, Royal Society of British Artists, from 1888. Whistler, President from 1886, reduced its already dwindling income from sale commissions by cutting the number of works exhibited from 800 to 500. However, as benefactions, he loaned the Society £500 obtained by pawning the famous painting of his mother and three other works, and he printed fifty impressions of his lithograph, *Maurder's Fish Shop* (1890) for a benefit lottery. Bayliss, less autocratic, was also less lively than Whistler, who departed denouncing the obliteration of his famous butterfly signature on the Society's signboard. See Whistler, *The Gentle Art of Making Enemies*, pp. 205–28; Whistler's rough drafts of this correspondence are extremely interesting (Whistler Papers: Glasgow University Library Special Collections).

5 November 1895 . . . Lunch

E B-J: There's one writer who hasn't had justice done to him – that's Gaboriau. Rookie, you must read a Gaboriau and tell it to me. He's the most wonderful inventor of detective business that has ever been. Do you remember that wonderful chase through Paris that lasts a *whole* day – by the police, a detective and a woman?[1]

I: Didn't Dickens do good detectives?

E B-J: Yes, but it's quite a different kind of invention that I am thinking of: the clever tracking out of intricate mysteries. Edgar Poe began it, I believe, in the three stories of the Gold Bug, the Mystery of Marie Roget and the Purloined Letter – but I should very much like to know whether he was first or Dumas with his half burnt paper of the Abbé in the Chateau d'If. I wish I could find out.[2]

[1] Emile Gaboriau (1832–73), whose first great success was *L'Affaire Rouge* (1866). Such chases, always instigated by Gaboriau's master detective, M. Lecoq, occur in a number of his tales.

[2] B-J may have followed Ruskin's lead; Ruskin told F. S. Ellis in 1874 (*Stray Letters from Professor Ruskin to a London Bibliophile*, p. 13) that he had been 'taking a course of Emile Gaboriau to acquaint myself with modern Paris. He seems to me to have a wonderful knowledge of the town and its evils', which Ruskin considered good preparation for a revolutionary future, which he saw coming on 'faster and faster'. 'Half burnt paper': in Alexandre Dumas, *The Count of Monte Cristo* (1845), the will giving the Abbé Faria the fortune that he passed on to Edmund Dantes (the 'Count'), his fellow prisoner at the Chateau d'If.

8 November 1895. Lunch. W. A. S. Benson

MISTRESS: Mr Benson, will you have some bread and butter pudding and some prunes.

E B-J: Capital end line for a comic song – would bring in thousands of pounds to Chevalier. He's the son of Phil's French Master at Kensington Grammar School. He's got a splendid string of Christian names – Nebuchadnezzar I daresay isn't in it, but Alphonse and Napoleon are.[1]

[1] Albert Chevalier (1861–1923), comic actor and singer, dubbed 'The Coster's Laureate'.

9 November 1895. Garden studio

E B-J (*Doing head of Love in* Love Leading the Pilgrim, *me at perspective of wheel in* Love's Wayfaring): Did you see Daudet and Zola had been interviewed about the murder trial of the Marquis at Bourges by the newspapers?[1]

I: Like their impudence. What answer did they get?

E B-J: Zola said it shewed how true his books are; he doesn't see that it is his choice of material, not his truth to life that people object to. I've never read him, he makes me miserable, and so does Daudet. The object of art must be either to please or to exalt; I can't see any other reason for it at all – one is a pretty reason, the other a noble one for it.[2]

I: Doesn't Zola derive too much from Balzac with too little of his own, besides his unfortunate proclivities?

E B-J: Balzac's a man of a very different order.

I: Is he exalting?

E B-J: I *think* he is –

I: – and certainly amusing in *Contes Drôlatiques*.

E B-J: Oh, little Rookie!

[1] The Marquis de Nayve advertised for and obtained a rich wife, lured away her illegitimate son, then pitched him down an Italian ravine, where the remains were found a year later. The Marquis was acquitted on 5 November. B-J told Helen Mary Gaskell (postmark 6 November 1895. B-J:BL) that 'such newspapers as I have seen say it is the shockingest trial in their memory – but shortlived is their memory for I remember one here six months ago by the side of which this French matter wears a celestial hue': that is, the Wilde trial in May 1895.

[2] Reading Voltaire, B-J told George Howard that 'I am learning much about the world – Georgie doesn't like the passages I have shown to her – she thinks them ribald and scurrilous – I thought them just and witty . . .' (n. d. CH). He rejected French naturalism, however: 'No, nor will I ever again read a French story . . . there is one subject I will not willingly read ever and that is treachery in love – I cannot bear it and how fond they are of it . . . so defenceless a poor lover is . . .' (B-J to Helen Mary Gaskell, postmark 7 September 1894. B-J:BL). At Henry James's Reform Club dinner for Daudet on 6 May 1895, B-J was further depressed by the guest of honour, who, ravaged by syphilis, 'is a sad spectacle.' B-J regretted that Daudet 'will write no more good work, which is a

great pity' (to Helen Mary Gaskell, postmark 11 May 1895.
B-J:BL).

<div style="text-align: right">12 November 1895</div>

E B-J: . . . There's one thing I owe to my little father, that is
his sense of pathos. O what a sad little home ours was and how
I used to be glad to get away from it.

The half holidays when he used to lead me to sit with him in
the churchyard over his wife's grave – and how he used to grip
my hand on the way there till he pinched it so I used to have to
cry out with the pain . . .

<div style="text-align: right">25 November 1895. Garden studio</div>

E B-J (*first painting his first figure of crowd in* Love's Way-
faring. *Catterson-Smith comments on artistic vanity*): They say
———— goes about saying he is the best man for next President
of the Royal Academy. He says three things are necessary – for
a man to be well off, to have no family and to ———————— and
that he has all three qualifications. He told a model this: fancy
taking a model as your confidante.[1]

I: It's such a handy person to unbosom yourself to.

E B-J: Yes, very sympathetic, *while she's sitting to you*, but
then she goes away and gives you up to your enemies. This
one wasn't in the ways of the world, and when she was sitting
to me said ———— is going to be the next President, Sir. And I
said, Oh, how have you heard that – and she said Oh, he told
me himself Sir. Rossetti was very funny about artistic vanity.
He distributed his friends into classes for it one day, put
himself and me in the first class, such and such in the second,
others in the third and so on. I said, Which one will you put
Morris into? – and he answered, Oh, he goes into one all by
himself. And I asked him why he put me in the first, because I
was always in tribulation about my work, and he said Oh, Ned
thinks such a lot of himself that he never thinks any picture he
paints is good enough for him to have painted. Wasn't that
clever of him? And there was another complimentary joke he
made about me – he said I was the laziest man he knew, and
when I wondered how he could make this out in the face of
facts – for in those days I would sit for long, long hours

pegging away without stirring – he answered, Well, when once you sit down to work you are too lazy even to get up again.

(*On living in the world.*) I shall try and live less and less in it, live altogether out of it if possible.

(*Discussing with Catterson-Smith about Mr Morris's choice of a publisher.*) I wish he would take one of first rate position; any other is an experiment and he has made many that haven't been too successful. I wish he would have Swinburne's publisher – who is Swinburne's publisher now? I should like to see them standing side by side – Swinburne has an enormous reputation beyond the immediate circle of his readers. If it is a question of mentioning a poet, people say 'Ah, Swinburne' – they never say, 'Ah, Morris'. People don't want Epics, they find them too long and wearisome. They'd rather read a story straight off in prose, if they want a story. Then too, you can't find short quotations to take from Morris. He must be taken in great gulps, and people somehow think it is not easy to read. You don't see his books on bookstalls and I think it's for want of a businesslike publisher. (Atalanta in Calydon *doubtless here mentioned, but I didn't catch it.*) It's a brief poem and a masterpiece. The thought in it is momentous and the rhythm goes on with such a rush that it's enough to carry the world away. Tennyson too, how you can quote from him splendid things without number, pieces of perfect art and thought. Browning is splendid too in early time. Later on I get bored. I was very much bored with the Ring and the Book, didn't want it at all. (*On Lewis Morris.*) I've never read a word of him, couldn't for my life. The sort of people that read him are one's Aunts – intelligent Aunts and Uncles.[2]

(*Long ago, on publication of a decadent Swinburne.*) He tries to get too much into a line, overweights it and it tumbles to pieces; you can hardly make it out. While Morris's line is so simple, unencumbered and straightforward it endures forever – conveys its meaning and makes its mark at once. In parts too he is less an artist than a man of imagination.

(*I telling him the Royal Watercolour Society was re-editing its rules, Alfred Fripp's death leaving them much at sea about them.*)[3] The best thing they can do is to burn their books and begin

afresh. I don't mean change their way of painting, but start new traditions of management. I won't go to their social meeting; there's a lecture and I don't want to be lectured. People have made up their minds pretty well by this time that the days of preaching are fairly over, and as to lecturing, Pah!

[1] Leighton was plainly very ill, and speculation had begun about his successor. See Leonée and Richard Ormond, *Lord Leighton*, pp. 139–47.

[2] Sir Lewis Morris (1833–1907), Welsh barrister and conveyancing counsel; an officer of the University of Wales; prolific and popular author of weakly Tennysonian idylls, epics, lyrics, and poetic dramas.

[3] The death of Alfred Downing Fripp (1822–95) started difficulties over rules limiting membership to forty, although the number of Associates was unlimited.

27 November 1895. Garden studio

. . . I: Did you see that most of the French writers had refused to sign the petition about Oscar Wilde?[1]

E B-J: Poor wretch, I'm very glad though that they haven't signed – it might have helped the popular belief amongst us that they are vicious. Though I must say it's not altogether without reason. They tell tales about the sexes which I think they'd better not tell, and in a way which you and I can't approve of. But there's honour amongst thieves, don't let us talk about them – we are not so much better than they are – hypocrites, little Rooke, hypocrites we English are. Sly dogs, with their orders of the Bath and the Garter. 'Des Sly Dogues', (*pronounced* á la Française) Rookie.

Well I can't say that I've been hardly used, can I?

I: Except in early days.

E B-J: No, nor even then. People abused me when I was young, but I daresay it was very good for me. If they'd praised me no doubt I should have been very mortal about it and believed every word they said, and never tried to do any better. Damn the thorns, they're much worse than the robins. (*Taking some out round Love's feet in* Love Leading the Pilgrim.)

(*Cry of Sweep in the street while he was talking about work.*) Oh, do stop that horrid row! (*Boy whistling.*) There's again that boy

57

who can't whistle and will try, do you hear him, how incompetent he is? (*Taking out some of the work around Love's feet, finding a bird painted on the rocks there much in the way.*) Bother that bird – damn the robins – did you never hear the story of Damn the Robins?

I: No, never.

E B-J: Well, you know how Dickens' stories used to be made into plays when they came out. One was made out of *Nicholas Nickleby*, and Dickens went to a rehearsal. He wasn't at all accountable for it you know, and had very little chance of influencing it. Smike was made the hero, and a lot of rubbishy soliloquy was made up for him to say in a country scene. Poor Dickens sat through this for a long time without saying anything, until they came to a part where Smike had to go maudling on about Robin Redbreasts, upon which Dickens lost his temper and started up shouting 'Damn the Robins, we must have the robins out'. It was horrid for him, poor dear – poor darling, it was horrible. But his slightest word is *holy*. That shall be a symbol for us when there is anything that disturbs a picture and has to come out. 'Damn the Robins – we'll have 'em out.' (*And this became a tag.*)[2]

(*To a stuffed eagle which was on the floor in the way a while after-*) Damn that robin.

[1] In November 1895 Stuart Merrill (1863–1915), American poet living in Paris, tried but failed to persuade the writers to petition Queen Victoria for Wilde's release. They, and Henry James as well, felt that it served no good purpose; see *The Letters of Oscar Wilde*, ed. Rupert Hart-Davis, p. 390, note 2.

[2] Edward Stirling (1807–94), London theatre manager, playwright, and inveterate adapter of Dickens' novels, frequently before the end of serial publication. *Nicholas Nickleby* was in its eighth instalment when Stirling's version opened at the Adelphi Theatre in November 1838, with Mrs Keeley (Mary Ann Goward, 1805?–99) as Smike. Dickens approved, 'bating sundry choice sentiments and rubbish regarding the little robins in the fields which have been put in the boy's mouth by Mr Stirling the adapter'. See *The Letters of Charles Dickens*, ed. Madeline House and Graham Storey, I, 460, note 1. Dickens took revenge in Chapter 48, through the unnamed 'literary gentleman present who had dramatised in his time two

hundred and forty-seven novels as fast as they had come out – some of them faster than they had come out – and *was* a literary gentleman in consequence.'

28 November 1895. Garden studio

. . . E B-J (*after telling a funny story of the simplicity of a famous friend, like Goldsmith's missing the joke of the way to turn 'em green*):[1] But better not to repeat it – the only way is to gild your hero. You can't trust people with the facts about anything or anyone. Nine hundred and ninety nine million nine hundred and ninety nine thousand nine hundred and ninety nine people out of every thousand million are of such a *beastly* nature that they're sure to turn round upon you if you do.

The average man keenly desires to think that any unusual person is after all very like himself. And when for the sake of shewing all sides of your hero and making him more real and solid you relate his foibles and put in some of the shades of his character – and he has them, for you might just as well expect to see a great tree without its darkness or a great mountain without its shadows – they up and say, is this the chap that you're so set up with?

CATTERSON-SMITH: It used to upset me very much when I first used to read about the shortcomings of my heroes.

E B-J: It did me too – I remember it as one of the most miserable days of my life when I read the first little account of Edgar Poe that appeared a long time ago and made him out a regular common cove. It happened to be a wet day and I felt unfit for any mortal thing after reading it. I went into the kitchen to try and get some comfort out of baking and the ruddy glow of the fire, but it wouldn't do – what did anything matter if one who wrote such beautiful things could behave so. Then years afterwards when I got a little more accustomed to some of the contradictions of existence, blest if a new life of him didn't come out saying the first was all lies and that he didn't die dead drunk or didn't do anything like it, but had been drugged to death by electioneers, and so on all the way through.[2] . . .

Except for that abominable race of people who always like a sketch better than a picture. It's biography of course, not art.

You get very close to the personality of a man when you've got a study of his, it's as good as a letter, asking you to breakfast or about any other such trivial matter.

CATTERSON-SMITH: Old masters' studies?

E B-J: Yes. It's a sad pity so few of theirs remain: plenty of M. Angelo and Raphael, but of the older ones how few. What a thing it would be to have a good lot of Mantegna's, and how many are there to be found – of Giotto's only two or three.

I feel rather sad to be so much at the end of the things I like. It's a bitter disappointment after all Ruskin's splendid sayings about the art of the glorious time of European history, to see the way the new generation is taking to all that dismal, soulless poor Renaissance work, and the passion there is for it among the young of the present time. Perhaps it's the best thing though for people to busy themselves about who haven't a spark of imagination or originality.

[1] See John Forster, *The Life and Times of Oliver Goldsmith*, II, 208–10. At one of Sir Joshua Reynolds' dinners, the peas had an unnatural colour, and a guest quipped that they should be sent to Hammersmith because 'that was the way to Turnham Green'; Goldsmith, repeating this at another party, hopelessly muddled the pun and was so embarrassed that he fled.

[2] Notorious 'Memoir', in the 1850–56 edition of Poe's *Works*, by his literary executor, the Rev. Rufus Griswold, journalist and roving Baptist preacher. On Griswold and his distortions, forgeries, and slanders, see Arthur Hobson Quinn, *Edgar Allan Poe: A Critical Biography*, pp. 350–53, 677 ff. The 'new life': John Henry Ingram, *Edgar Allan Poe: His Life, Letters and Opinions* (1880).

29 November 1895

. . . E B-J (*On* Chronicle *art criticism*): It doesn't so much matter that Pennell should be employed to write about what he knows so little of; think what goes on every day about all public matters.[1] Last night I was reading in the *St James's Gazette*, which is a Tory paper, that there was no reason for keeping up the superstition that the Turkish Empire must be held together at any price – this being just what Mr Gladstone said 20 years ago, and for saying it in a dignified manner he was called all the villainous names that could be strung together –

while this nameless whipper-snapper says it with pert impudence and absolute immunity.[2] And then he goes on to say that with our responsibilities in India of course we must have Egypt and Arabia and a bit of Persia and how much else who shall say – all this for the benefit to the populations of our extended rule. And if the French were to think of mentioning their share, what robbers they would be; as a rule the English are, I must say, born pirates. If they'd hoist the Black Flag and skull and cross-bones instead of the Union Jack I'd say be hanged to you and do as you like – but they are such damned hypocrites with it all . . .

[1] Joseph Pennell (1860–1926), etcher and engraver, art critic for *The Star*, signed himself A. U. (Artist Unknown). He and his wife, Elizabeth Robins Pennell (1855–1936) were Whistler's most diligent admirers.

[2] See 'Sir Charles Dilke on the Turkish Question: Against "Partition" ', *St James's Gazette*, 31 (1895), 10. In 1876 Morris and B-J joined the 'Eastern Question Association', dedicated to keeping England out of war with Russia over Turkey. They were bitterly disappointed when Gladstone, who campaigned for office on the issue, advocated support of Russia; see *Gladstone's Speeches*, ed. A. T. Bassett, pp. 470–504. To Rosalind Howard, B-J wrote: 'This is the first time in my life that I have admitted to myself that Gladstone can do one harm – he has really helped to throw us over' (fragment, n. d. CH). See E. P. Thompson, *William Morris*, pp. 192–93; *Memorials*, II, 73–74, 83–84.

November 1895

E B-J: Little Rooke, I'll bet you that when the Chaucer comes out the papers will say something like this: 'The illustrated books of the Season are Mr Morris' reprint of Chaucer with designs by Sir E. Burne-Jones, and —————'s *From Basle to Lucerne*, with admirable Kodak views.'

2 December 1895. Garden studio
. . . SYDNEY COCKERELL: Mr Morris was saying the other night that prudence was a great mistake.

E B-J (*painting in middle woman in front row of the* Car of Love *crowd*): Ah, I know what that means – it means he's going to

buy another old book, don't you think it does?

SYDNEY COCKERELL: It may.

E B-J (*to parlourmaid*): Put it down there Annie, please. I think that means another book. You'll see. He's a very subtle reasoner. Did you see his lecture last night, wasn't it beautiful?[1] I wish I'd been there; I couldn't go. Friends come in on a Sunday night. Phil comes . . .

[1] On December 1, a lantern lecture for the Hammersmith Socialist Society.

3 December 1895. Garden studio

. . . E B-J (*painting Love's wing in* Love Leading the Pilgrim): William Rossetti's got out a Life and letters of his brother.[1] He does one sensible thing. People ask him, is this all he has to tell about his brother and he says no it isn't, but he's not going to tell any more than he has. But in proportion as he sticks to that people are going to find it not interesting. I shall have to write a little monograph of him to leave behind when I die, if I can.[2] He has been sadly misinterpreted and misunderstood, he wants being made human to people. I can't bear that he shouldn't be.

I: I've never seen anything about him or even of him, that makes him dear to me as the things you tell me.

E B-J: But I wish they wouldn't publish letters. It's a cruel thing to publish letters – they're publishing everyone's letters. What do they want with biographies of eminent people – their works are their only proper biographies.

I: Carlyle liked biographies.

E B-J: He made his own biography – he had the happiness of expressing himself most completely. I don't see what on earth people can have wanted another biography of him for.[3] Quite a needless thing the publication of all his wife's complaint of his harshness. There's many a woman leads a much more oppressed life than hers on the part of entirely commonplace husbands of the shadiest kind and never says anything about it. Why couldn't she have considered that this was an extraordinary and splendid creature for whom a little self suppression was a thousand times worth while?

Are you going to do any figure picture this year? I think you had best. Something certainly like the Ruth picture that was quite successful, all of it nicely finished.[4] I'm quite sure it's best to keep to a similar kind of work – people get to look for the same kind of work and accept it. I'm a great believer in pegging away. It's what I have kept it in mind to do and by keeping on I've forced people to take Romance for granted as far as I'm concerned. If I were to begin a new sort of work, any Greekish things for instance or any other I should have the same sort of uphill work again. There's the *Fall of Lucifer* for instance, people didn't know how to take it because they thought it was different to my usual things.[5] They didn't know whether to praise it or deplore it because it was new. No single picture of mine has ever been a startling success; you can't say that any I've ever shewn has been what they call 'the picture of the year' . . .

I (*returning to biography*): You were content only to know Carlyle and Dickens in their works, and only Rossetti for his aid.

E B-J: I never wanted to know *anyone*. I never wanted to know Ruskin or Rossetti even. It was quite an accident – my knowing them. I wanted to look at Rossetti in the face, no one I wanted to see so much, but I had no anxiety to become known to him. Ruskin would take me to Carlyle, but it was no good – I knew he couldn't be interested in anything I was at. I never sought to know famous men of any kind; I never thought I ought to take up the time of busy men.[6]

I: The account of Rossetti you want to give, there is no time for as yet – no, you couldn't dictate it.

E B-J: No, I should need to have my mind quite clear of everything else to do it properly, so it would be no use trying to do it in that way. . .

[1] William Michael Rossetti (1829–1919) proceeded despite his belief that one ought not to write a brother's biography: 'But circumstances have proved too strong for me, and I submit to their dictation'; see *Dante Gabriel Rossetti: His Family-Letters*, pp. ix–x.

[2] B-J left some notes, which Georgie used for *Memorials*; see, for example, II, 117, 258, 264.

³ 'Another biography': by the historian James Anthony Froude (1818–94).

⁴ Rooke, *The Story of Ruth* (1876–77), a three-part oil, exhibited at the Royal Academy and purchased for the Tate Gallery, 1877.

⁵ *The Fall of Lucifer* (1894), gouache and gold paint design (Sold Sotheby's, 1981, £110,000), originally intended but not used for one of B-J's Roman mosaics. It was then called 'The Fall of the Rebel Angels'; see Arts Council, 190; Dorment, 'Burne-Jones's Roman Mosaics', *The Burlington Magazine*, 120 (1978), 72–82. The design depicts the disgraced angels leaving Heaven in orderly procession, banners flying. It is signed and dated 1894, but B-J wrote to Helen Mary Gaskell (postmark 22 April 1895. B-J: BL), that he had just 'finished Lucifer': perhaps a reference to a later version.

⁶ In 1856 B-J went to the Working Men's College, Great Ormond Street, hoping only to glimpse Rossetti. They were introduced, however, and Rossetti soon introduced B-J and Morris to Ruskin. On the meeting with Carlyle, see below, p. 117.

5 December 1895. House studio

E B-J (*Master at Bangor Medal.*¹ *Mr Morris in next room*): Mr Morris has bought another book – what did I tell you the other day about prudence?² He's in high spirits this morning in consequence. I shewed him this design; he said it was beautiful – I knew that meant something. It's a bible, a fine old bible, but much injured – capital letters and pictures cut out – he's wild about it, quite furious. Says Jabez Balfour ought to be taken out of prison and given a thousand pounds and be crowned with a laurel wreath as a reward for not having cut up MSS.³ I asked him whether he wouldn't begin the Chaucer over again so that we might do it better (*a current joke just now*) and he says emphatically he will not. I said 'I like a thing perfect', and he says he likes a thing done. Yes, he's always saying he wishes men would finish their work. If you like I'll go and ask him. Nobody like him, is there?

(*Enter Mr Morris afterwards.*)

E B-J: Catterson-Smith here says he'd like to begin the Chaucer afresh too.

WILLIAM MORRIS (*looking from one to the other*): I daresay he would, but I can't afford it 'with the style that I live in', old chap. (*Departure with flourish of walking stick*)

¹ For the University of Wales; see *Memorials*, facing p. 246; Arts Council 222.
² Morris bought a three-volume Latin Bible, c. 1260, for £650; see *Art of the Book*, 22.
³ Jabez Spencer Balfour (1843–1916), notorious embezzler convicted in 1895.

10 December 1895. House studio

. . . E B-J: Mr Morris was very funny again the other day. I made a note of some of the things he said – if I can find it – (*looking among papers on table*). Oh, here it is – we were talking about the destruction and perishing of fine old things, and he said 'Well, old chap, that's one thing to be said in favour of my library – you can't drive a railway through it, eh? It's safe on that score.'

MRS MACKAIL: When I was at Kelmscott last and he was shewing me his books, I watched to see which one he liked best of all and then I asked him for it. He stared at me with his face suddenly fixed and his mouth open, as though he didn't know what had happened.

E B-J: And then afterwards did he burst out into a great guffaw of laughter?

MRS MACKAIL: Yes, when he saw me laughing at him and what a trick I'd been playing, he began to laugh too. He's so nice – he's a darling . . .

12 December 1895. House studio

E B-J (*Painting dress and background of portrait of Parisian lady*):¹ Do you know Menpes' work? He has an exhibition I'm to go to on Saturday – he's a very nice fellow, too – I remember a tiny little picture of his not much bigger than the palm of my hand, that had a Venice bridge in it and groups of people and little boys, each one with a characteristic face and an expression, and the whole in splendid breadth.²

I: Enough to fill me with despair.

E B-J: Well, we're always in that state of anxiety about our own work and fear of being obliterated and put out of existence, that we can't enjoy the successful work of our fellows as we might. The breadth of vision that a simple member of the

public has about pictures is denied us. He can go to an Exhibition and enjoy the most opposite kinds of art, while one of us, if he has his own work as strongly at heart as he ought, can't properly consider most others. Mr Morris gets out of the difficulty by absolutely thinking of nothing but what he's got in his own mind. As to Rossetti – oh, how generous he was to other people's work – he shewed singular generosity to me always, until he got ill.

(*In reply to my telling of impressionist breadth.*) What I would like is to get breadth by beautiful finish and bright, clear colour well matched, rather than by muzz.

I: As in Rafael, say.

E B-J: I never think of Rafael.

I: Not even in the few perfect frescoes, such as *Dispute of the Sacrament* and the smaller ones that go before it [at the Vatican]?

E B-J: Fresco doesn't give full, brilliant colour. It is work like Bellini's I'm thinking of. But what between my extraordinary love of bright colour and my extraordinary love of dark colour and my extraordinary love of chiaroscuro and my extraordinary love of a hard clear line – among my many loves I get into difficulties.

[1] Baronne Madeleine Deslandes (1863?–1929), author of romances and short stories (pseud. Ossit); friend of artists and writers, Wilde among them. For B-J's portrait (1894), see Jacques Lethève, 'La Connaissance des peintres préraphaélites anglais en France (1855–1900),' *Gazette des Beaux Arts*, s. 6, 53 (1959), 315–28.

[2] Mortimer Menpes (1860–1938), Australian etcher and painter, exhibited thirty-eight paintings made in Mexico, at the Dowdeswell Galleries, November-December 1895. As one of Whistler's most devoted confrères, Menpes had told him: 'I am proud at having had the chance of knowing you as I do, and grateful too. I see better the folly of dreaming away a life with sickly notions of breadth . . . I suppose in life the same as in pictures breadth without detail means emptiness (Corot) and detail alone means hell (Frith). I am getting rather mixed and on the whole would be wise to finish up' ([1884] Whistler Archives. Glasgow University Library). By 1897 Menpes himself had been packed up and expelled from Whistler's circle. For Menpes' Venetian pictures, see his *Venice* (1904), with text by Dorothy Menpes.

19 December 1895. Garden studio

E B-J (*painting man in front row of* Love's Wayfaring *pulling Love's Car between two women*): I went to see the Spanish pictures at the New Gallery that are going to be exhibited – what hateful things they are. Beastly things Spanish pictures are. They made me feel quite sick.

CATTERSON-SMITH: Velasquez? I suppose.

E B-J: Yes, they're the best of the lot, but I don't like them either.

CATTERSON-SMITH: Very black, aren't they?

E B-J: Oh, horribly black, and such wicked scoundrels that they are the portraits of.

(*Comments on the Venezuelan business.*)[1]

CATTERSON-SMITH: Are we going to have war with America?

E B-J: Well I must own that the way the English have behaved in the past isn't by way of giving the Americans a friendly feeling towards us. When they were in straits the English papers were prophesying their downfall as hard as they could. We were in a perpetual chuckle all the time that the United States were breaking down all the way round. There was great triumph in the English breast – which must have raised up corresponding feelings in the American breast, and I'm not one of those who think the breast hasn't much to do with it – I believe it has a great deal. Yesterday by way of helping matters the Stockbrokers sent over that beastly telegram about excursion boats to see the battles. Quiet people like us, who hate rows and in the main want justice done, are foiled and impeded by these heavy dull dogs who spend the whole of their lives cheating on the Stock Exchange. These blasted stockbrokers and newsvendors if they had to go out to the war I'd cheer them on like anything, but for them to be sending our nice sailors, that's very different. Then what a state we're in about Turkey. But we're not in the wrong on this point and for once in my life I should be delighted to be heartily on the side of the English.

CATTERSON-SMITH: What would they say to the bombardment of New York?

I: Or London?

CATTERSON-SMITH: It couldn't be.

E B-J: Couldn't it?

I: A rising in Ireland.

E B-J: Well, anything that comes on the English from Ireland they most richly deserve for their insulting pride and bullying of poor folk. But what's commonly called the Vengeance of Reason usually overtakes people for long-past crimes when they're behaving decently and I believe that's how it is in this case.

CATTERSON-SMITH: Who can tell what mightn't result from some great catastrophe of war – a new era might come in.

E B-J: Who could possibly tell. Everyone's blind in this world, no one can foresee. I don't believe in justice on a small scale and not on a big one. I'd much rather have it on the big scale.

[1] Dispute, inflamed by jingoist papers and politicians on both sides of the Atlantic, over the Venezuela-British Guiana boundary. If President Cleveland invoked the Monroe Doctrine, he could precipitate war with Britain.

23 December 1895

. . . I: Mr Morris was gaily declaring last night that to be bankrupt wouldn't matter if all people were bankrupt together and had no money. If all were equally so it would come to the same thing, except that we shouldn't have coins, which are handsome objects. (*He was shewing me ancient coins.*) There'd be just the same quantity of food, clothes and houses.[1]

E B-J: Yes, but that wouldn't work. Before getting to my painting of a morning I should have to carry my *Fall of Lucifer* up to Skoyles and ask him to give me legs of mutton for it and he'd say 'I'm very sorry, Sir, but I've got no place to put it, Sir' – and he has places to put legs of mutton in – then I shall have to bring it back again. Oh, I think he's much better out of all that, except for the fun – the fun's nice.

I: It's so good that you've quite ignored the *base* stories in Chaucer and done no pictures to them.[2]

E B-J: Chiefly done for your sake, Little Rooke. I'd like to pretend Chaucer didn't do them. Besides, pictures to them

would have spoiled the book. You don't want funny pictures either. Pictures are too good to be funny. Literature's good enough for that.

(*I telling him what William Morris said about the letter S in English.*)

E B-J: Yes, it makes singing in English not an easy matter. You can sometimes hear almost nothing of the words but the hissing of the S. In singing, when the language ought to be at its best, it's at its worst. In poetry too, it's very hard to dodge it, perhaps Tennyson managed it better than anyone ever did . . .

CATTERSON-SMITH: Morris said the other night, 'What I think about music (*contemptuously*) I shall never tell *any*one.' But I think I know pretty well what he thinks about it. He likes a tune, anything simple, but as soon as it gets elaborate he hates it.

I: As soon in fact as it gets to have the same character as his splendid design in ornament.

CATTERSON-SMITH: I can't stand much of it; it sets my nerves all on the go after a while – I have to come away before the *Messiah*'s half through.

[1] Morris was rationalising a purchase again; cf. above, p. 64. He bought these coins on December 16 (diary, WMG), but just before Christmas he bought another manuscript, a Psalter, probably Beauvais, for £375; see *Art of the Book*, 23.

[2] Cf. above, p. 44. If the Miller's tale is unillustrated, so are other quite unexceptionable ones.

Anytime[1]

E B-J: Whistler – that combination of almost man of genius and charlatan. As disastrous to be his friend as his enemy. Hard to say which is worse, perhaps the former. One thing about his work, his technique is so perfect, and through the whole of it there's not one bit of bad colour – that's saying much. But his conception of a woman! It's too disgraceful even to be mentioned.

I: That snow picture, the Chelsea street, I like most.[2]

E B-J: The one with the figure in it that's out of tone – much

too black. He's always tried to pay me out for appearing against him on the slander trial, but I was obliged to back up my Friend. I had no animosity against him, nor shewed any[3] . . .

[1] Indicates a well-remembered or often-repeated remark. In R-MS, after entry for 23 December 1895.

[2] Whistler, *Nocturne in Grey and Gold: Chelsea Snow* (1878), oil on canvas, Fogg Art Museum, Harvard University.

[3] On 25 and 26 November 1878 was heard Whistler's libel suit against Ruskin, for remarks in *Fors Clavigera* (Letter 79, *Works*, XXIX, 146–63) about Whistler's *Nocturne in Black and Gold: The Falling Rocket* (1875), shown in 1877 at the Grosvenor Gallery: 'I have seen, and heard, much of Cockney impudence before now; but never expected to hear a coxcomb ask two hundred guineas for flinging a pot of paint in the public's face.' See Whistler, 'Whistler v. Ruskin: Art and Art Critics', in his *The Gentle Art*, pp. 25–34; *Memorials*, II, 86–89.

At the trial, B-J displayed both grace and charity. Afterward, he told George Howard (late November 1878? CH): 'I hated going to that abominable trial as you may imagine – never disliked anything so much in my life and moved earth and hell to get out of it – but when the lawyers would have it [that] I could help Ruskin of course I went – and for the time threw policy aside and answered every question as truthfully as I could – my average pay for a day's work is from £5 to £7 and I was justified in saying £200 [*sic*] was too much – prices like that will go near to discrediting the value of the work of every one of us; the very first serious depreciation that happens in a sale room – and the painstaking and young and struggling artists will be the first to suffer – if Whistler is to have £200 you shall have a £1000 – this is no argumentum ad hominem to wheedle you on my side – I ought to know good work by now – Whistler's work looked more abominable than I had thought – and I said all the good of it I could think of – but I believe Frith who put the powerful mind of our friend Morris into words was nearest the truth. But I did hate it my dear.' William Powell Frith (1819–1909), painter of the immensely popular *Derby Day* (1858, in the Tate Gallery, London) testified for Ruskin, saying that Whistler had 'very great power as an artist' but that *The Falling Rocket* was not serious; see McMullen, *Victorian Outsider*, pp. 190–91.

Whistler received one farthing in damages but had to pay costs, which bankrupted him, and lost his new home in Tite Street,

Chelsea. B-J told George Howard (late September 1879? CH) that 'Whistler is in Venice happy at last, having no money but no debts – nine bailiffs attended him toward the last, so that his movements are embarrassed . . . Now I hope he will be content for a bit . . .' At the Goupil Gallery's Whistler retrospective in 1892, David Croal Thomson (1855–1930), its Director, wrote to Whistler (23 March 1892): 'Mr Burne-Jones came paid his 1/– and was here quite an hour. He is a bigger minded man than one would have thought. He examined every picture and had a long talk with Walter Sickert who will doubtless tell you what he said.' Whistler must have replied incredulously, for Thomson wrote (26 March 1892): 'A mean-minded man would not come at all. A mean-minded man would have come and pretended he was of the same opinion [as formerly]. He did come, pay his money (for no one happened to see him enter), stopping a long time and also evidently well pleased with what he saw. *On dit* for he did not say so openly, that he is much vexed to see his old opinions come to daylight again!' (Both letters: Whistler Archives: Glasgow University Library.) B-J was further conspicuous since few other Academicians came to the Goupil.

1 January 1896. House studio
(*E B-J painting on surcoat of sleeping Lancelot in* The Dream of Lancelot at the Chapel of the San Graal.)[1]

I: I'm so glad to hear the Chaucer designs are finished; it's only now occurred to me to think he has had to wait all these centuries to be so glorified, and that he may never be more so.

E B-J: Well, he can hardly be. When you've once gilded your statue you can hardly do it again.[2]

Do you see they've made a Poet Laureate? A chap called Austin, a Conservative and writer of verses who's not of the slightest consequence. I wish with Swinburne and Morris alive they'd let it drop – it doesn't matter however. I see that he's old too, and it's much better than if it had been Lewis Morris – not the least harm really.[3] And they've made Leighton a Peer too, which I'm very glad of because he'll probably like it, and no one's pegged away at public duties more steadily than he has. I've sent him round congratulations.

I'm so glad Christmas week's over, it's a horrid time – everyone's so sodden and overfed, children so spoiled and cross. Things can go on all right again now.

I: Is it that little remains of all the glory except the eating and drinking?

E B-J: Old times were very different, the world was made up of small compact communities then, pretty much apart from each other and they had this one Great Feast to celebrate – now it is of *Millions* all going on together like hasses [asses]. . .

There's an exhibition of Spanish pictures at the New Gallery. Have you seen it? It's perfectly hateful. It's full of nothing but dismal dog's dullness. I never hated the profession of painting so much as I did the day I went there. I was in such a rage that I said I was glad it was popular – glad that every piece of folly had a fool to like it. It clears the world (*as a magnet gathers iron filings*). Of course all this enormously pleases the newspapers – they've got all that they want, all that their hearts can desire.

I: Will they lead many people to go and see it?

E B-J: Oh, yes, I should think so – yet in spite of it people will *not* like the thing they don't like; the poor public always saves itself in some nice blundering way. But it's an extraordinary surprise to me to go there. I feel not so much as if I belonged to another time or country but to another planet altogether. There's one thing, all this Spanish painting was done at a very late time, when art in other countries had pretty well ceased and everything was beginning to tumble down to the frightful inanity of the late dismal age. There was something in the race too to account for it and very likely the Inquisition was a terrible injury. As fatal to Spain perhaps as Puritanism was to England. Velasquez is very much over rated just now. He's skilful in the laying on of thick paint and there's an end. He's not only unpoetic but profoundly prosy. But there's one worse, and that's Murillo. He has absolutely no merit at all. He's a very awful man. I'm quite certain it's completely bad – haven't the least doubt of it at all. I mayn't know about the value of my own work – it may all go, and if it does it will simply deserve to go – but I do know about these things – they're thoroughly worthless, and I do know that Gothic work is perfectly glorious . . .

[1] *The Dream of Launcelot at the Chapel of the San Graal* (1896, South-

ampton Art Gallery); see Arts Council 192, 368. This returns to the
theme of Rossetti's Oxford Union mural (1857) for which B-J was
model; see Fitzgerald, p. 64.

² Catterson-Smith was copying eighty-seven B-J drawings on the
woodblocks; for his note on their method, see *Art of the Book*, pp.
137–38.

³ Alfred Austin (1835–1913), barrister and versifier. Mackail says
that 'Gladstone kept his own counsel about the Laureateship' (II,
287–88), but see Alan Bell, 'Gladstone Looks for a Poet Laureate',
TLS, 21 July 1972, p. 847. On Lewis Morris, see above, p. 57.

2 January 1896. House studio

E B-J (*comments on Jameson raid in Transvaal*):¹ So we're
likely to be in for it all round. And the year begins pretty badly.
I remember my dear old [William] Graham saying that he
foresaw such evil days for his country that anyone who hadn't
a son or a child might think himself lucky. Ours is only a
material empire, and no material empire can last for ever –
ours'll have to go someday. And things move so quickly in
these times that it won't take anything like so long as it used to.
Formerly it was a matter of long years to destroy a great
empire, but now one might go in fifty, or even half of that.
England ruined if it lost India. Remember, England wasn't
ruined when it lost America; England wasn't ruined when it
lost France.

But a material empire makes no appeal to my mind. The
English achievements that I'm proud of are of a very different
sort. I love the immaterial. It's all very well for us today that
the Munro [*sic*] doctrine isn't acknowledged outside of
America, but what about 'Rule, Britannia' – we'll have to drop
that. What's always said against us and what's quite true, is
that we've a different way of behaving to little states and big
ones. With big ones it's arbitration, but with little ones it's
ultimatum. Ultimatum to Burmah, Ultimatum to the
Afghans, Ultimatum to Chitral, Ultimatum to Ashantee,
Ultimatum to Transvaal, Ultimatum to Venezuela – but with
America, arbitration and with the European powers, arbi-
tration. When I see people passing the newspaper placards in
the street with a big *Ultimatum* printed on them and proudly
straighten their backs as they go on after sight of it, it makes

me sneer, and so I will, won't I sneer? Very much I'll sneer. I'll sneer all round. It's so dreadful that the National Conscience should only be aroused when it begins to be frightened.

By this time people ought to be ashamed of these quarrels between civilised nations; they're in essence nothing more than mean little parish squabbles about boundary stones. I'd take their guns and gunpowder away from them, stupid infants . . .

[1] On 29 December 1895 Sir Leander Starr Jameson (1853–1917), sometime physician, South African adventurer and cohort of Cecil Rhodes, prematurely launched the raid that they had plotted with foreign residents of the Transvaal as a device to oust President Paul Krüger. The defending Boers forced the raiders to surrender. On January 6 Rhodes resigned as Premier of the Cape Ministry; on January 11 Jameson was sacked as Administrator of Matabeleland. After trial and fifteen months' imprisonment he returned to South Africa. However, he had changed the course of history: Krüger used the reparations to buy munitions for the Boer War.

6 January 1896. House studio

. . . E B-J (*Too dark for him to paint. Numbering Chaucer designs*): What a rum affair out in the Transvaal. It's that rascal Rhodes that's at the bottom of it. What a fuss they did make of him last year. Chamberlain behaved very well, has been just in time to save the honour of the country.[1] Grabbing every bit of spare land everywhere. Let these thieves catch each other. They all call each other interlopers, and the first interloper is the aboriginal. I don't want to see the Anglo Saxon race predominant anywhere, I don't want to see the French race predominant anywhere, I don't want to see the German race predominant anywhere. It's very bad for every one of them, makes them into insolent tyrants. And very bad for the world too. Quite easy to understand that the other nations won't allow of our pre-eminence. I've no sympathy you see with these material empires. We're known for overweening greed only too well. If the English were wise they wouldn't be led away by the bombast of the newspapers and would see that the opposition to them by the other peoples isn't all jealousy, that there's really some reason for it. Things never will be right at

all until the same rule that governs individuals in a society in their behaviour towards each other is applied to nations.

Such fun about the German Emperor. He's only behaving like a thorough Tory as he is, and the English Tories are surprised at him. I've got a Tory in-law who's always saying in a deep voice what a splendid Emperor he is, a model one, a noble Emperor. I'm not rich, but I'd give five bob if I could go round and call upon her just now and make a few remarks to her about him – but unfortunately she's not in London, she lives in the country.[2] He's a very young man, and takes himself very seriously. But I can quite understand a disposition to telegraph – I'd half a mind myself to rush out to the post office and wire to Krüger, 'Congratulations on your splendid victory, E. B-J.'[3] No doubt he did it just to rile us though, and did rile. I'm so glad Gladstone's out of it though – just fancy if he'd been in and had all this bother.[4] But we've always known how isolated we are, that the Americans owe us no goodwill, that the French would always like to see us in a mess, as we do them, that the Germans owe us a grudge for not taking part with them, and that Russia in the last 50 years past has become a big overpowering foe – but it's an unpleasant surprise to us to find the sentiment of the whole of Europe and America against us. It's a pity there's such a heap of rubbish talked in London about our chances in a war with the Americans.[5] When I hear those foolish talkers in London, and I hear much more of it than you do, talk of all the damage we could do them, I marvel. No doubt they might catch it at first, but they'd end by pulling through! They're a spirited race. It's ridiculous to say they've got no army; they'd have an enormous army in very little time. They'd a million and a half of men at the end of their war. They gained all they wanted then, never shewed any spirit of retaliation, behaved very well, used great forbearance in their triumph. They let the President of the South escape scot free.[6] Of course they'd have all the Irish on their side; I'm very sorry for it, not a bit glad, but don't wonder at it in the least. Of course the Irish are glad. If I was an Irishman I should be very glad. That was a silly message that Redmond sent through, and like all such things are, out of taste.[7] Much better to keep quiet and see what will happen. Of course in a war against us,

the Americans would have four times the enthusiasm they had in fighting with each other. Therefore if the English are a fine race and are determined to go down with glory, let them fight to their hearts' content, but it's silly of them to underrate what they'd have to encounter.

[1] On December 31, Joseph Chamberlain (1836–1914), Secretary of State for the Colonies, 1893–1903, ordered Jameson back to the territories of the South Africa Company.

[2] Unidentified .

[3] The German press openly sympathised with the Boers. On January 3 Wilhelm II telegraphed congratulations to Krüger.

[4] Gladstone, bitter and disappointed, left office for the fourth and last time in March 1894.

[5] It *was* rubbish: the Americans realised that President Cleveland's interpretation of the Monroe Doctrine in the Venezuelan affair robbed Congress of prerogatives with respect to declarations of war.

[6] Jefferson Davis (1808–89), President of the Confederacy, 1861–65, was accused of treason and of complicity in Lincoln's assassination. He was imprisoned and twice indicted but never tried. Released in 1867, he never requested a pardon, but, with great dignity, advocated burying the past and looking to a united future.

[7] John Edward Redmond (1856–1918), Parnellite M. P., from 1891. In 1896 he introduced a new Land Bill, and, in 1912, the third Home Rule Bill, an effort wrecked by the 1916 Easter Uprising. Since 1892 he had been an important link with Irish-Americans, visiting the United States to report on Home Rule and to raise funds.

7 January 1896. Studio

E B-J (*beginning design of Sigurd killing the dragon.*[1] *Comments on Stanhope*): Faults of his pictures were what anyone could see, what any cook could see. His colour was beyond any the finest in Europe.

CATTERSON-SMITH: That's pretty well – wasn't that enough for him?

E B-J: Well, he wasn't keenly criticised, but he wasn't noticed, and that isn't cheering. He was really an artist, and he wanted to be praised and encouraged, and wasn't so; it was all uphill to him.

I: And his liking your things so much that he wanted to do like them wasn't good perhaps?

E B-J: It was a great pity that he ever saw my work or that he ever saw Botticelli's. Though there may be a time for him yet.[2] An extraordinary turn for landscape he had too – quite individual. The first thing I saw of his was a city of (*evidently only half caught and not recognised*). Rossetti was in a perfect state of enthusiasm about it – that was how he got to know him.[3]

I: The first time I saw him was one afternoon when he came into the room in the winter of '69 to '70, after you were out – and he was in such a passion of admiration over your head of Phyllis that in my then unenlightened condition I supposed he couldn't be an artist.[4]

E B-J: Oh, little Rookie!

I: Well, I thought I ought to make a clean breast of it.

E B-J: Call that a clean breast? I call it a most dirty breast – after that I don't know really what can be said! He was a nice chap. But asthma led him a terrible life. He had a lovely house built for him by Philip Webb a little way in the country, at Cobham.[5] Just a bit over severe – as the work of that great architect sometimes is, a bit gloomy perhaps. Then asthma came on him there – it's such a curious, capricious disease as to locality – and he had to leave it, and he bought another house, and then if you say why did he do that, I just can't tell you. And he had to leave that, and finally go to Florence where he's much better, though his living there has injured his work very much.[6]

CATTERSON-SMITH: Is he old?

E B-J: Oh, no, quite young! About 8 years older than I am – that carries him to 70, now that's just the prime of life you know. We used to have such jokes together, all that's over now a long time. His studio was on Campden Hill, just near the reservoir. I had one of my pictures in it that was too big for my room. I never finished it, but that doesn't matter.[7] I remember one snowy day Mr Howard that's now Lord Carlisle, and I went to see him, and we made a lot of snowballs to throw at him, a good heap of 50 or more, and Mr Howard hid on one side of the door with his heap and I put mine on the other side and pulled the bell and then darted into my place. Then he

came to the door with his palette in his hand covered with colours, and we let fly at him, and it was knocked and trampled in the snow and the snowballs went down his neck, and everything happened that was wretched to him. And he was so goodnatured about it and roared and chuckled. And we'd left some of our snow balls on the ground, and some little wretch of a street boy came and collared them and pelted us with them, and that was all accepted in good part, and we pelted that horrid little boy back again and rather loved him for it. But his (*Stanhope's*) absence from London has removed him from his proper atmosphere, and from his contemporaries and their criticism, and he's got to think more and more exclusively of old pictures to that extent that he'll almost found his own pictures on them and give up his own individuality. But I did love him.

(N. B. *At any time*.) I always thought Holman Hunt greatly injured his chance of work by living away there out in Jerusalem – away from everyone and out of the circle of painters. It's fatal to an artist to do that . . .[8]

(*Brings illustrated Tennyson* Poems *for Catterson-Smith*.) As a book it's nothing. There was no command over the type and printing such as Mr Morris has, and there were so many hands engaged on the pictures as to make it impossible as a book. (*Turning to a picture of* 'Two lovers whispering by a garden wall', *where he had put an old woman raising a threatening umbrella behind them*.) I'm afraid I added to that design. (*On another*.) What a beast, what a blasted b——y thing. (*Another*.) That's Millais, that's weak. (*Another*.) That's very good of Millais's, a very ingenious design. (*Another*.) *I* put those toes sticking out of the bedclothes. (*Another*.) That's a very happy one of Millais. Look at her little breath – the snow and everything – that's Millais at his best. But what a book (*tumbles apart*) – won't even hold together at the back. It's a hideous book – has beautiful things in it. The Lady of Shalott is the very best of Holman Hunt.[9] Rossetti used to make a very careful pen and ink drawing – then turn it round in a glass and draw it on the block. Once or twice he was pleased with the cutting, but usually it meant 3 or 4 days of grumpiness. I would go round to him of a morning as I did every day for the first 2 or 3 years

that I knew him and used to find him in the worst of tempers. He couldn't get them to cut his line thick enough. The engravers would always cut it away and fine it off to nothing, thinking, the silly fools, that he couldn't draw and they'd improve it for him and make it delicate – so lost all strength and depth of tone. And then he used to *groan*. He wanted a nice thick line and there was no room for him to draw it for them thicker than it had to be, as he would have done if there had been. Besides the boxwood was hard to get a rich line upon in the method of those days. Once they sent him a block a sixteenth of an inch too short. It was at the top, for this beautiful one (*St Cecilia*) on the town wall – and while he was cursing about it someone who was by said could so little as that matter, on which he called out, 'Good God! what do you mean by that? I could get a whole city in there.' [10] . . .

CATTERSON-SMITH: A lot of F. Walkers were shewn us by Pennell on Friday.

E B-J: I think for an absolute representation of what a scene in a story would be like F. Walker's drawings are perfection. Taking the event that he has got to illustrate as his object, he renders it exactly. This way he does the prosy ugly church interiors of the time in *Philip in Church*, and the look of the people couldn't be bettered or made more like.[11] If in Purgatory for my sins I had to write a modern novel that's the kind of illustration I'd choose for it. Neither did he ever weaken himself by any width of mind. His absolute want of cultivation was a piece of good luck for him. It was a bit of a misfortune in a way that Millais ever knew Rossetti. The ancient life that he used to try to make was so unreal. (*A while back.*) The best illustrated books are Du Maurier's that he's done himself and the worst I think those of Thackeray that he made drawings of his own to . . .

[1] The Kelmscott Press edition of Morris's *The Story of Sigurd the Volsung and the Fall of the Nibelungs* (1876), planned as early as April 1892, announced in November 1895, published in February 1898. B-J was to make twenty-five illustrations, later increased to forty, but only three were completed: *Gudrun Setting Fire to the Palace of Atli* and *Fafnir Guarding the Hoard* (1895), and *Sigurd*

Slaying the Dragon (1896). See *Art of the Book* 88; Arts Council 307, 308.

[2] B-J repeats, in different context, the criticism of Robert de la Sizeranne (*La Peinture anglais contemporaine*, p. 225): 'Dès que Burne-Jones assemble plusieurs figures, il disperse l'intérêt. Les imitateurs de Burne-Jones, tels que MM. Strudwick et Stanhope, Mme Stillman, font de même.'

[3] Picture unidentified.

[4] On B-J's *Phyllis and Demophoön*, see above, p. 10, note

[5] Benfleet Hall, Cobham (1860); see Paul Thompson, *The Work of William Morris*, p. 19. Philip Speakman Webb (1831–1915) set up his London office in 1856 and was Morris's supporter in Anti-Scrape and in his Socialist venture.

[6] Hill House, near Barnsley, Yorkshire, a renovated farmhouse.

[7] B-J, *Tristan and Iseult* (begun 1872); see *Memorials*, II, 30. Present whereabouts unknown. Stanhope combined Campden House and Lancaster Lodge, Campden Hill, London W.8.

[8] William Holman Hunt (1827–1910), co-founder of the Pre-Raphaelite Brotherhood in 1848, was in Palestine from 1854 to 1856, and 1869 to 1871. See Diana Holman Hunt, *My Grandfather: His Wives and Loves*, pp. 116–67, 266–75.

[9] Having 'many hands' was Tennyson's idea, and the Moxon 1857 edition of his *Poems* is a hodgepodge of engravings. For Rossetti on the choice of artists, see *Letters of Dante Gabriel Rossetti to William Allingham, 1854–1870*, ed. George Birkbeck Hill, p. 97. Eight artists and five engravers (the brothers Dalziel counting as one) made fifty-seven illustrations. Nor did the same artist and engraver always illustrate all of one poem. 'Two lovers whispering': by John Calcutt Horsley (1817–1903), for 'Circumstance' (p. 62). 'Her little breath . . . the snow': Millais' illustration for 'St Agnes' Eve' (p. 309); 'toes sticking out'; that for 'The Lord of Burleigh' (p. 353). Holman Hunt's famous *Lady of Shalott*: on p. 67. On two Rossetti sketches for 'The Lady of Shalott,' for which B-J was a model, see Surtees 85, 85A. On Moxon as publisher, see Harold B. Merriam, *Edward Moxon: Publisher of Poets*, pp. 169–87.

[10] *St Cecilia*: for 'The Palace of Art', in the Moxon edition, p. 113. See Surtees 83; D. G. Rossetti, *Letters . . . to Allingham*, p. 104; W. M. Rossetti, *D. G. Rossetti as Designer and Writer*, pp. 27–30. An early example of Rossetti's troubles with engravers was the frontispiece of Allingham's poem, 'The Maids of Elfen-Mere', in his *Day and Night Songs* (1860). However, the Dalziels complained also: 'How is one to engrave a drawing that is partly in ink, partly

in pencil, and partly in red chalk?' (quoted in Rossetti, *Letters . . . to Allingham*, p. 112). See also George and Edward Dalziel, *The Brothers Dalziel*, pp. 81–89. George (1815–1902) came to London from Northumberland in 1835, his brother Edward (1817–1905) in 1839, the year their firm was founded.

[11] Frederick Walker (1840–75) studied at the Royal Academy but learned more from incessant independent sketching. Thackeray's *The Adventures of Philip*, serialised in *The Cornhill Magazine*, January 1861–August 1862, was his first major assignment. For 'Thanksgiving', the drawing of Philip in church, see Thackeray, *Works*, Biographical Edition, II, facing p. 619. One of Thackeray's own drawings, 'Laura's Fireside', faces p. 180.

8 January 1896. House studio

. . . I: Will there be many horses to do in *Sigurd*?

E B-J (*painting landscape of* Launcelot at the Well): Not many. But they'll come into some of the subjects. (*Shews me* Killing of Fafnir.) A horse is such a fine ornament in a picture – when a knight and his horse look like one animal. I won't seek horses to do, but I won't mind them when they come in. I can't do them anything like as well as some chaps, but I'll get through them somehow.

I ([*commenting on prehistoric drawing of*] reindeer on the bone.)

E B-J: The Assyrians do beasts too, much better than men. The mules and lions are quite perfect, couldn't be better done. The Greeks on the other hand didn't make very much of beasts.

I: (*the Egyptian horses good.*)

E B-J: The Egyptians are very equal all round in their art, more than any other people have been.

(*Voice of Mr Morris reading some of his writing to Mistress in next room.*)

I: It's prose, isn't it?

E B-J: Yes. One can tell the difference in the sound of his voice from when he reads poetry. What a pity he doesn't write any more.

I: I suppose he has written enough for his reputation, but should like to have the pleasure of there being always some coming out.

E B-J: A poet is soon in danger of repeating himself. Swinburne hurt himself that way. All of Tennyson that's really Tennyson can go into a very small book. It would almost be well for a poet to die young, unless he left off being a poet. But a painter needs to have a long life.

I: It seems hardly fair to the poet.

E B-J: Oh, my dear little Rooke, you don't suppose that anyone of high motive in life is anxious to go on living for the sake of living – so full life is of anxiety and all sorts of trouble . . .

13 January 1896. Garden studio

E B-J (*painting first man in* Car of Love. *To Catterson-Smith come back from Mr Morris*): Well, how was he this morning? Did he make any jokes?

CATTERSON-SMITH: No, he asked me to smoke a cigarette. I said I couldn't stay then.

E B-J: Did you tell him whatever leisure he had, *we* were too busy at this time of the morning – that however easily he was taking the Chaucer, *we* were anxious about it?

(*Catterson-Smith giving him proof of* Philomela, *he throws it down sideways on table and looks at it upside down and all ways from a distance.*)[1]

E B-J: I always do that first before looking into it properly – things catch my eye that way that would be seen by anyone looking at it for the first time and that I shouldn't observe otherwise. (*Then, looking into it* –) Isnt't it nice? But do you think we can afford ourselves those little blacks in the tapestry?

(*After our talking about morning's political news:*)

CATTERSON-SMITH: If we had war with America, it would touch us all up in many unexpected ways. Bread would go up to any price for instance.

E B-J: We'd have to look out then, and I'd have to toady Mr Morris, and I'd promise to give up the idea of doing Morte d'Arthur and take to designing for his books, and we'd all go down to Kelmscott and live on the cocks and hens.

CATTERSON-SMITH: There's no end of 'em there.

E B-J: Yes, and we'd live on pigeon pie from one week's end to the other. And then, when the war was over, I'd say to

him, 'Look here, old chap, I know you'd like me to make the most of my life and carry out the plans of work I've had in my head' – and he'd say, 'Certainly, my dear old fellow,' and then I'd say, 'Well, old chap, you know that your writing so completely pictures all that belongs to the story that it leaves no room for any illustration to it and doesn't need any, and I'd much better go on with my Morte d'Arthur.' I say, Little Rooke, what a bore it would be if we were all called out.

I: Aren't we too old?

E B-J: Very likely – but Phil would have to go.

I: Perhaps he wouldn't so much mind.

E B-J: I daresay not. – Chamberlain's done splendidly no doubt, and the trouble's over for the present, but sooner or later it'll all begin again, and in the end they'll get hold of the Transvaal, no doubt of it. What those wretches will do some day is they'll revolt against the Mother Country like the U.S.A. Then they'll be free to indulge themselves in whatever scampishness they please . . .

[1] Illustration (p. 441) for 'Legenda Philomene', Part 7 of *The Legend of Good Women*, in the Kelmscott *Chaucer*, pp. 441–42.

18 January 1896. House studio

E B-J (*painting angel in* Launcelot at Well). Do you know Menpes? He's such a nice fellow. He does very *little* pictures – *so* beautifully that you lose all sense of their small size and they look quite big. But as soon as he increases the size of his pictures and does them bigger, he begins to lose all that and they don't look as large as the small ones. He couldn't do a picture of the size of that one of Dieppe that you're at (*about* $^1/_8$ *Imperial*).[1] He can't make his colour look solid either – it's all diaphanous.

I: He'd be an acquisition to the Water Colour Society.

E B-J: Well, he doesn't do a great deal in water colour, and has got a position of his own – that's all he wants. He wouldn't be inclined to endure the long snubbings they still think they owe it to themselves to give to men sometimes.

I: Unless they snatch at a man they think advantageous.

E B-J: As they snatched at that invaluable chap ————

and they rather snatched at Hemy.[2]

Menpes is off to Japan. Such a happy life for him and people who live as he does, always cutting about. At least it seems so to me who never sees anything of the world and always stays at home in the same place. In fact I ought to forget there is a world. I ought to behave as if there weren't such a thing as the world existing at all. I got out that maid in the Maiden and Necromancer picture yesterday – one of my failures, it always stuck.

I: I never knew you considered it so. I thought you only needed time to go on with it.

E B-J: Well, I didn't like the heads; it always discourages me if the heads don't promise well.[3]

I: That too I hadn't imagined, but now that you have this nice model that won't be a difficulty.

E B-J: Yes, I must do the maiden from her. Menpes looked at all the heads I'd done from her when he was here yesterday very closely for a long time. He surprised me by saying he can't draw in pencil.

I: Many don't use it, and in the drawing schools they don't after the first.

E B-J: Use chalk I suppose.

I: Yes, and charcoal, which is fine to work with but not easy.

E B-J: You can't *draw* with it, you *paint* with it. Menpes was astonishing over the pencil drawing – he kept looking at it so closely and prying into all the strokes. I've never had my pencil drawing so pried into before.

I: Men use pencil for sketching.

E B-J: That's not the same thing. I never used it to sketch with, I use it as a finishing instrument. But it's always touch and go whether I can manage it even now. Sometimes knots will come in it, and I never can get them out, I mean little black specks. There's no drawing I consider perfect. I often let one pass only because of expression, or facts I want in it, but unless – if I've once india-rubbered it, it doesn't make a good drawing. I look on a perfectly successful drawing as one built up on a groundwork of clear lines till it's finished. It's the same kind of thing in red chalk. It mustn't be taken out. Rubbing with the finger's all right. In fact you don't succeed with any process

until you find out how you may knock it about and in what you must be careful. Slowly built up texture in oil painting gives you the best chance of changing without damage when it's necessary.

I: But those who paint at once in oil have to be as careful with it as with work in any other medium, and take anything right out that doesn't do – preferably when it's wet.

E B-J: That kind of work has its charm too – all kinds have. Certainly a picture that looks as if it had been painfully struggled with looks rather dreadful. But a picture with no workmanship in it is a very tiresome thing too. Indeed it's very hard to do anything at all, isn't it? Oh, desperately hard it is. Launcelot's very hard to get right. (*Scraping it.*) But when I've tingled it up with bright points of light, and buzzed about it and given it atmosphere I'll get it right at last. Hard to get colour into it because of the night – or the knight. (*Laughing.*) What should we do, 'tisn't likely to happen, but what should we do if we couldn't sell any more pictures? One thing that would puzzle us, we couldn't be sure beforehand whether it was going to be so or no – or whether it was only a temporary clog in the market. So we couldn't take any resolution about it.

I: Artists exhibiting singly or in groups seems likely to be the future of exhibitions. I saw one with six painters last week – one of them was named Peppercorn.

E B-J: I've seen the name.

I: It's rather a good name to get known by, striking and easily remembered.

E B-J: I'm not so sure of that. You might only remember it was the name of a familiar object and might recall it as Mustard-seed, or Mustard-pot, or Cruet-stand, or Four-poster. I don't think it *is* a good name.

(*I talking of Du Maurier and* Trilby.)

E B-J: Don't think he cared about that. He minded about Whistler. One has no weapons to fight him with[4] . . .

[1] Probably the picture of Dieppe Castle with caption 'Dieppe 1895 (Lord Carlisle and Wm Morris)' probably commissioned by them (Album); whereabouts unknown.

[2] Charles Napier Hemy (1841–1917), English genre and narrative

painter; in 1896 became both an Associate of the Royal Academy and a member of the Royal Society of Painters in Water Colours.

[3] Unfinished oil, *The Wizard*, also called *The Magician* (c. 1896–98), Birmingham City Museum and Art Gallery. The Magician's face is the artist's own; the maiden's is that of Frances Horner.

[4] Whistler was too plainly the model for Joe Sibley, 'the King of Bohemia', in the novel *Trilby* by the *Punch* illustrator George Du Maurier (1834–96), serialised in *Harper's Monthly Magazine* (London), January–August 1894. Whistler came to London, bent, he said, on 'lithographs and law' (*MM*, p. 103). See Leonée Ormond, *George Du Maurier*, pp. 463–79.

23 January 1896

E B-J (*altering outermost of 3 Graces in* Venus Concordia):[1] In my anxiety to make it a good figure in itself I've made it too independent of the others, and it's become an isolated figure instead of part of the group, and that won't do. We mustn't indulge in favourite passages in a work . . .

(*Preparing for painting.*) Don't you find it takes ⁴/₅ths of your time to get ready? So different for a poet, who has only to light his pipe and be happy. But we're always forgetting that it's really a trade that ours is.

I: A carpenter, they say, has to spend a fourth of his time sharpening his tools. I remember someone who employed one grumbling at it and saying he oughtn't to have to pay for the time spent in it.

E B-J: Ha, ha! Oh, how I like an employer! Isn't it so like an employer!

(*On British claims.*) Haven't we had a splendid position – even I thought the European Powers didn't mind us. They were too much occupied with their mutual difficulties I suppose. But heaven itself said that Britons never should be slaves, and that, by a strange want of logic, they should make all other people so. Now then the Americans come upon us with an astounding doctrine of their own, which is also said to be a Heavenly Charter. Quantities of Heavenly Charters going about the world it seems, no end of them. As to being loved, I can't see how we can expect it. The English deserve all they get for their haughty pride and foul scorn with which they treat little peoples. We despise all other peoples – there's no one we

admire or care for just now. We pour perpetual contempt on
the Americans. I do, we all do. Mr Morris does. Have you
heard of the wrong they've just done him – he has some
reason. Some wicked wretch over there has been photograph-
ing and copying all his letters and ornaments, and those he
reproduces exactly he calls the Jenson letters, and those he
mommocks and alters and spoils he calls Morris letters. *That's*
the last touch of ignominious insult tacked on to the injury. It
is irritating, isn't it? He's in a great rage, and it's no wonder.
Irritating to the last degree it is. Takes away one's heart for
working to have the results of it parodied and misrepresented
besides being stolen. What wretches, eh?

I: Can't he register his books over there and publish in both
countries at the same time?[2]

E B-J: He was very funny about that. This is what he said:
'Well you see, old chap, the copyright law is in such a queer
condition. It's about as logical as a law of inheritance that
wouldn't allow a man to leave his property to a son that hadn't
red hair, or for him to have it on any days but Wednesdays and
Saturdays. (*I laugh*.) Do you like that, isn't it funny of him?

(*To Mrs P. who has come about 12.30.*[3] *About* Venus Concor-
dia.) This is my panic picture. I suddenly woke up one night
and thought what a bore it would be to Phil and Georgie to be
left with such a lot of pictures that weren't finished. Is it
inexcusable in me to have such a lot? Say I did it instead of
going out visiting. They wouldn't like to destroy them. I
know Phil wouldn't out of affection for me, yet what could he
do with them? So I thought I'd like at least to get it into an
agreeable state of Grisaille, but now you see I'm going on and
on and on, and I'm not a bit further on than I was . . .

[1] *Venus Concordia*, begun early 1870s and left unfinished, was one of
three predellas for *The Story of Troy*; see H/W, pp. 108, 154; Plate
40. Present owner: Plymouth Art Gallery.
[2] Morris modelled his Kelmscott 'Golden Type' upon 'the perfected
Roman type, to wit, the works of the great Venetian printers of the
fifteenth century of whom Nicholas Jenson produced the com-
pletest and most Roman characters from 1470 to 1476'; hence,
what Morris called the 'regenerate type of Jenson-Morris' (*Letters*,
pp. lxiii, 326). Copyright law was indeed in a queer condition;

American publishers helped themselves to foreign materials. The Jenson Press, Philadelphia, was 'one of the semiprivate presses run by printing idealists, available for commercial hire' by job printers; see Susan Otis Thompson, *American Book Design and William Morris*, pp. 198, 205–206.

³ Unidentified.

<div align="right">January 1896</div>

E B-J: I'm getting very anxious about Mr Morris and about the Chaucer. He hasn't been in good health for a long time and I don't know what it means. He hasn't done the title page yet, which will be such a rich piece of ornament with all the large lettering. I wish he wouldn't leave it any longer, I keep urging him to do it.¹

I: But you've done all the designs now.

E B-J: Oh, they're anything but off my mind, they've to be cut yet, a good many of them – and till that's done I don't feel a bit safe about them. The heads, above all, are such touch and go – so easy to spoil them. But they're going on better and better, we've got into the way of it by this time, that's the best of a big piece of work. And then looking after Catterson-Smith's drawings for the engraver runs into no end of time and is a constant anxiety. It'll be a great relief when it's all done.

I: Then the world will go dull through a great work coming to an end.

E B-J: No, then there'll be something else to go on with.

¹ Suppressed unease about Morris's health now gave way to explicit anxieties. His own diary entries, always laconic, veered from weariness and discouragement, on the one hand, to a stubborn determination, on the other, to persevere. Cockerell noted (diary, February 20. CP:BL) that Morris had begun the *Chaucer* title page; Morris's diary (WM:BL) records his dogged struggle to get on with it: 'I began on Chaucer title again. Felt better today' (March 8). On March 9 he 'felt tired today but went on with Chaucer title.' On March 10: 'Did Chaucer title.' But Cockerell recorded its completion on March 27.

<div align="right">January 1896</div>

E B-J (*comments on wood engraving*): What ought to be done

would've been for me first to make a shaded drawing, and then for a *very* clever wood engraver to interpret it into his black and white line. That's the ideal way of doing it.

I: But I suppose it's very rarely been done. Albert Dürer they say has left evidence of his dissatisfaction with the cutting of his drawings.[1]

E B-J: Oh, hardly ever [done]. The way we're doing now answers fairly well, but the coming in of two hands between my drawing and the print helps to move the thing further from me. Of course by looking closely after it as I do it doesn't go very far wrong, but the other way rightly done would keep more of the character.

[1] Dürer did what B-J would have liked to do: trained his assistants to cut blocks to his specifications; see Erwin Panofsky, *The Life and Art of Albrecht Dürer*, p. 46. B-J's method was to have Catterson-Smith use black ink and chinese white to firm up the lines of B-J's drawing. W. H. Hooper (1834–1912) then cut the design into the woodblock, each step receiving B-J's approval. Eleven drawings, the transitions to woodcut designs, and proofs of the woodcuts, with notes by B-J, Cockerell, Hooper, and others, are in the Pierpont Morgan Library, New York. B-J attended to the most minute details. One drawing has this note: 'The grass about feet wants light/Lines of rocks running up to figure about shoulder and hand cut off at outline of figure.' Cockerell had added, 'Corrected Jan 28 '95.' On another, B-J wrote simply 'white speck *out*', the careful Cockerell adding 'Corrections made Jan 30 '95.'

6 February 1896. House studio

E B-J (*painting Angel in Chapel door in* Launcelot at the Well): I played the Mistress such a nice trick yesterday morning. There's a speaking tube from my room to hers, and I got up and got quite dressed and as carefully as I could, and it was a few minutes to 8. Then I blew up the tube and she answered – and I said in a very sleepy voice, 'I feel very tired this morning, and I think I won't get up just yet,' and she answered down it, 'Don't, dear, I wouldn't' – and I yawned back and made sleepy noises and said 'I think I'll turn round again and have another doze.' Then I made haste upstairs and in a quarter of a minute was knocking at her door, and she answered 'Come in,' think-

ing it was the maid – and you may guess how surprised she was and how it amused her. She was pleased and I was pleased and now you're pleased. More couldn't be achieved by a great work of art. At least it hurt nobody and was at no one's expense . . .

I (*laying in a replica of* Aurora *on a new canvas*):[1] I can well understand some painters electing to finish at once in the first painting – the colour goes so beautifully on to the new canvas.

E B-J: Yes, but in the result the colour is generally garish [R-TS: wants uniting and subduing by a tone over it all. And then] your single painting isn't firm enough to glaze on, you destroy the beauty of it by retouching it and it's only as though you'd smeared an ineffectual watery dirty wash over it. And those who don't make it garish have to make their pictures very grey, with but little strength of colour. So there you are caught on that side. There are a hundred ways of painting, all difficult and all open to some objection or other. The cruel thing is to try and fetter your artist and tell him there's only one way.

I: Or to fetter people's minds and say there's only one right religion.

E B-J: *Ah*, there it's different: religion's a very opposite thing! No one has a *right* to think for himself on that matter. Everyone should feel, but very few people should be trusted with thinking. How many are there who can do it with any accuracy or breadth? . . .

[1] *Aurora* (1896), exhibited at the New Gallery that year, now in the Queensland Art Gallery, Brisbane. The unfinished replica (1896) is in an English private collection; see H/W, p. 160; *Memorials*, I, 304–305. Graham Robertson thought that the *Aurora* 'when all but finished' suffered from Philip Burne-Jones's influence on his father's taste in colours; it was at first 'a radiant figure clad in the rose and gold of dawn, with flushed cheeks and golden hair. When Phil had finished with her, her robes were colourless, her face pale, and her hair almost grey' (*Letters from Graham Robertson*, p. 442). Perhaps hoping to encourage his son in a serious career, B-J professed solid faith in Phil's judgment; he told G. F. Watts that 'luckily for me Phil is an inexorable and admirable critic – as jealous for my work as I am, and especially useful in this, that he

takes the picture always from its own point of view, and never suggests impossible changes, but only corrections – and he has a most true eye for colour – isn't this lucky for me. I find continual hope from him – more than ever I can give him back' (April 1888? WG).

<div align="right">12 February 1896</div>

E B-J (*painting head of Launcelot's Angel. Eyeshade on*): . . . The newspapers are in a great rage with Michael Davitt, who has written to the *Times* to tell the English why they're so much hated.[1] I'm afraid I should come in for all the vituperation that's heaped upon him if I were to publish my opinion, which is pretty much the same as his. It's for our damnable cheek and unimaginative insolence. The nicest Englishman has a real contempt for a foreigner.

I: Perhaps people will take it to heart after denying it.

E B-J: No, they won't a bit, they're too stupid even to think of it – and as for Davitt he's only 'a scoundrelly convict'. The Germans hate us, the French hate us, the Americans hate us – even the Turks, and we're astonished. We are always profiting by other people's ill luck. What did the Turks and Russians get by the terrible war they each suffered so much in – nothing. We got Cyprus. What did the French and Germans get out of their war but frightful calamity and eternal hatred – we made ourselves sure in Egypt. 'For a time,' we said, 'for a short time' – and there we are still, and who knows if ever we'll go! The French made the Suez Canal while we were sneering at them for trying to do it, and when they'd made it we went and bought it. And we think nobody's got his eye on us or takes any notice. We've never done anything to the Americans but pour contempt on them in our newspapers, and we're surprised that should affect them. Genuinely surprised, I believe. But that's part of our stupidity. Nothing more likely than that to make them hate us . . .

When I was going to Leighton's funeral I saw the wreaths still on Charles' Statue.[2] It was reported that on the anniversary night one old man came and knelt down and prayed there, and afterwards three old men – guess who they were. I'm going out to speak to the Missis for a minute and I'll give you

till I come back to guess. (*Coming back*.) Well, have you thought who they were?

I: I can't imagine in the least.

E B-J: D'Artagnan and Athos, Porthos and Aramis of course!

I: I was there the night the wreaths were put there, and there were men selling the *Legitimist*, 1d; it was quite a burlesque of Mr Morris's socialism or of any other cult.[3]

E B-J: Such a pity he ever took that up. What wouldn't I give that he should never have been in with it all.

I: Isn't it any relief to you to think that at least it's public spirited and in the interest of the less fortunate?

E B-J: Not in the least. When he went into it I thought he would have subdued the ignorant, conceited, mistaken rancour of it all – that he'd teach them some humility and give them some sense of obedience, with his splendid bird's eye view of all that has happened in the world and his genius for History in the abstract. I had hopes he'd affect them. But never a bit – he did them absolutely no good – they got complete possession of him.[4] All the nice men who went into it, like Philip Webb and Charley Faulkner and Catterson-Smith, were never listened to, only the noisy, rancourous creatures got the ear of the movement. There's that wretch –––––, do you know him? How I hated his being in such company, who ought to have the best. There are numbers of that *Commonweal* [Socialist paper] that are most deplorable. Poor Charley Faulkner should never have been in for that vulgar row and turmoil – he was much too delicate minded and sensitive for it all.

I: Hadn't it something to do with his death?

E B-J: Oh yes, it killed him, by the most painful of deaths, a terrible one lasting for years. I couldn't love it, could I? Poor fellow, he never forgave me because I couldn't.[5]

[*Rooke's interpolation*:] In very early days I remember asking him why Mr Morris fussed about agitators, and he said, 'Well, there are all these poor workmen wanting they hardly know what, and they haven't any decent leading – they need men of intelligence and wide vision to lead them' . . .

1 Michael Davitt (1846–1906) was imprisoned as a Fenian, became a Parnellite, and was twice elected to Parliament. He resigned in 1899 to protest the Boer War. For his letter, see 'Irish Nationalists and the "Crisis" [in Venezuela]' (*The Times*, 17 January 1896, p. 7).
2 Leighton died on 25 January 1896.
3 Charles I was executed on 30 January 1649, near Charing Cross. His equestrian statue (1675) at that spot is still decorated on the anniversary by Jacobite sympathisers.
4 B-J had felt the same when Morris broke with H. M. Hyndman (1842–1921), journalist and leader of the Socialist Democratic Federation, to form the Socialist League. B-J had told George Howard that 'I sing paeans of delight to myself that Morris is quit of Hyndman but I am also heartily sorry for Morris – who does win my heart's admiration at every turn. I am sure you and Rosalind would feel nothing but sympathy for him – I hear little else but that as you may suppose – and I wish for ancient times – sigh heavily for them . . .' (April 1885? CH).
5 The mathematician Charles M. Faulkner, a friend since Oxford days, was an original member of the Morris firm. He suffered a stroke on 3 October 1888, three days after giving a Socialist League lecture at Hammersmith, and died 30 February 1892. Philip Webb wrote to Mackail: 'C. F. had the capacity of seeing the value of that toward which he had no natural attraction; and this, to me, seems to be one of the rarest of fine qualities' (4 June 1898. Mackail Papers: WMG).

18 February 1896

E B-J: . . . The English are the modern Carthaginians, living off commerce, planting large colonies, acquiring large territories, dominant at sea, holding the key of the Mediterranean, employing armies of mercenaries and leaving their traces everywhere (in stout and soda water bottles).

26 February 1896

E B-J (*Town and river background to* Aurora): Yes, it's a great load off my mind about Mr Morris, though he's in a serious condition and will always have to take great care of himself – if we can get him to – and will have to consider himself from this time as an old man.[1]

The printing's going on very fast, perhaps they'll have to come to a standstill before long. They've begun Troilus; it's a very long poem, the longest of them all – not so long as the

Canterbury Tales of course, but longer than any one of them. I always think it was his most careful work, as the Legend of Good Women is the *least* careful. That looks as though he'd felt there was a great lot to tell and very little space to tell it in, and as if he were in a hurry to get it all in and couldn't. He's very much the same sort of person as Mr Morris; unless he can begin his tale at the beginning and go on steadily to the end, he's bothered. There's no ingenuity in either of them, the value of their work comes from the extreme simplicity and beautiful directness of their natures. They're neither of them typical artists. [R–TS: they're typical poets but not typical artists.] Swinburne is a splendid artist, he can go to the heart of the matter at once and allude to things by a word or two in a masterly way . . .

House Studio

(*Telling him* Middlemarch *and repeating Carlyle's verdict that it was just dull, and I saying her books were a record of the Evangelical time.*)[2]

E B–J: Yes, I suppose there will always be times when her books will be studied. But ladies never give us any fighting – they only give us magnificent sentiments instead. I like a Dumas duel. I can't fight myself; I suppose that's why I like to read about it. (I used long ago to like fencing very much. I used the foils at Oxford a great deal; I used to get on rather well with them. I was quick, and though not strong, had a fairly strong wrist and could often overbear my antagonist by momentary vehemence: didn't like broadsword and single-stick; it seemed to me brutal and not very keenwitted, and I didn't like getting hard raps.)[3]

I: There are such enormous paragraphs (in *Middlemarch*) lasting for pages, and there's rarely more than a break or two in the type on any page.

E B–J: Very different to Dumas, who goes on Yes, No, But I say yes. And I assert No. I insist Yes, I persist No. Then have at you! That's human and natural and has quite enough in it to make a quarrel out of.

I: Was that a new design I saw in a corner of the other room; there seemed to be tremendous things going on in it.[4]

E B-J: Yes, it's the Last Judgment; do you approve of it? Awful, isn't it, to think of? But though it did fill our childhood with terrors, it was an incitement to our imaginations, and there's no telling what good there is in that.

[1] B-J told Helen Mary Gaskell that he had taken matters into his own hands (postmark 22 February 1896. B-J:BL): 'Morris worse, indeed a good deal worse – so I telegraphed to [Dr. W. H.] Broadbent for an earlier appointment and it is to-day – personally I must take him . . . Yesterday was dreadful unhappy for I was not on my guard about Morris, and had lulled myself – one should never lull oneself, or even be off guard in this world. I wrote to Millais – dear Millais – if they waste his time and force him to make speeches I'll kill them – all 39 of them [the Royal Academicians] I'll kill. . . .

'4 o'clock – just back – Broadbent was examining him for about $\frac{3}{4}$ of an hour – he is ill and the tendency is bad – but things have not yet gone so far as to feel alarm – only his nursing and way of life must be rigid, – better than I feared – not quite so good as I hoped.'

[2] Carlyle told John Churton Collins that he 'found it neither amusing nor instructive, but just dull.' See L. C. Collins, *Life and Memoirs of John Churton Collins*, p. 44.

[3] Early in 1853 B-J met Archibald MacLaren (1819–84), who had a gymnasium in Oriel Lane, Oxford. He later wrote books on physical education and military training, but he engaged B-J to illustrate a collection of European fairy tales, *The Fairy Family* (1857); see John Christian, 'Burne-Jones Studies', *The Burlington Magazine*, 115 (1973), 92–109; R[obin] Ironside and J. A. Gere, *Pre-Raphaelite Painters*, p. 47.

[4] Design for the splendid west window (1896), St Philip's Cathedral, Birmingham; see H/W, Plate 47; Sewter, II, 19–20.

28 February 1896. Dinner

MISTRESS: There's boiled mutton, but don't give your Master any carrots. (*To him.*) Relations are strained between you and carrots, aren't they, Ned dear?

E B-J: Carrots and I are not on speaking terms. When I see a carrot in the street I walk on the other side. Potatoes and I are on speaking terms merely, there's no friendship between us . . .

Tuesday: March 1896

E B-J (*touching up armour study – Perseus with Mirror for Exhibition*):[1] . . . It seems as if nothing prospered in this country in the way of art unless in connexion with beer and brandy. Lots of pictures I remember in the Academy that will smell of mutton chops to the very end . . .

[1] Study for *The Baleful Head*, Number 11 in the set of eleven paintings on the Perseus and Andromache story (1875–88), commissioned by Arthur Balfour for his music room but never completed. A set of full-sized studies (tempera on canvas) are in the Southampton Art Gallery; a set of cartoons (chalk and gouache on paper), in the Staatsgalerie, Stuttgart. See Kurt Löcher, *Der Perseus-Zyklus von Edward Burne-Jones*. Balfour's patience was extraordinary, but B-J was never satisfied with these designs. Studies were shown, 1892, at the Salon de Champs de Mars.

5 March 1896. House studio

E B-J (*painting* Aurora *river reflection*): . . . as for decoration, it's a mistake to suppose it's any easier even under modern conditions; it's rather more difficult – everything depends on its first design, and if that's faulty there's no mending it afterwards. But if a picture wouldn't make a good engraving you could still make it a good picture by the painting of it and alter and improve it in a thousand ways. It's a great warning: one ought never to give drawings away . . .

28 March 1896

. . . I: I went to see Tissot's Life of Christ designs.

E B-J (*touching up drawings*): Ah, I must go and see them – I've only seen a few. But in them the local colouring quite obscured any sense of the subject. He approaches it from quite the opposite side from any view I could take of it. There was the Annunciation. I want to see the Virgin's face and her little expression – I'm not to be put off with turban and burnous instead. That won't do, it isn't enough. It was only the view of an Arab woman's dress as she sits on the ground. I've no dislike to Arab dress in itself, and it's probably not unlike what was worn at the time – things change so little in the East – but it's no use trying to put me off with it instead of the subject.[1]

23 September 1895 — 15 July 1896

I (*anciently*.) Don't you like Eastern dress?

E B-J: I can't put up with turbans – could never do a picture of turbans. He's turned devout in his old age, and that's charming in him. He used to paint very fat ladies lolling in hammocks, but if you've ever seen a lady in a hammock – even the slimmest – you'll know what he gained by that. And he used to put plenty of calf shewing and shoes dropping off, and everything that a gentleman would like – and once he painted a Hansom Cab with a gentleman in it smoking a cigarette and thinking of what? can we suppose?[2] Now he repents and has become pious, and we like him for it, don't we? So now, nothing but the life of Christ will do for him – and we've no objection to that, only we must not have the story so overlaid with what he's picked up in a journey to Palestine that some of it's hardly to be recognised.

I: Have you seen his modern version of the Prodigal Son?

E B-J: No, I haven't.

I: In the last picture the returned is seated at table sharpening a carving knife to carve the fatted calf himself.[3]

E B-J: Oh, the wretch! Je ne puis pas le tolérer; il est exécrable ce prodigue! What's become of the Doré pictures that they've turned out to make way for these? Poor Doré, he was really an imaginative man. Out of the 1500 designs that he did a hundred of them are wonderful. Which is saying a very great deal[4] . . .

[1] James Joseph Jacques Tissot (1833–1902), French painter, etcher, illustrator; friend of Ingres and Whistler. In 1870 he settled in London with his mistress. He returned to Paris after her death in 1882, abandoned his series, *La Femme à Paris*, turned to Biblical subjects, and in 1886 went to Palestine. His 365 Biblical pictures, supplemented by paintings, pen-and-ink drawings, landscapes, and figure studies (1886–87) were shown at the Lemercier, formerly the Doré Gallery, 36 New Bond Street; then published as *The Life of Our Saviour, Jesus Christ* (1897), three huge volumes dedicated to Gladstone.

B-J told Helen Mary Gaskell ([24 April 1896] B-J:BL) that Henry James spoiled his visit to the exhibition: 'I wanted to go and see the Tissots before leaving town but am not fit to look at anything today – and I want to study them. I went one afternoon

but dear Henry James was there, and began at once to serve them up critically – now that bores me always – I wanted to look at them and think about them and think that over, and after a time I could settle the place of them in my own mind – but don't care [want?] to influence anyone else – so that visit was a failure – the idea interests me and I want to study them and the very vocabulary of criticism sickens me – it has grown by now to be an unmeaning jargon – and at the first sound of it I fly.'

² B-J exaggerates: in the etching, *Le Hamac* (1880), the lady is quite demure. The man in the hansom in *Going to the City* (1879), oil owned by Edmund J. McCormick, is not smoking but is reading the paper and probably thinking of Exchange prices.

³ Four oils, *The Prodigal Son in Modern Life* (1881–82 and c. 1881–82): *The Departure, In Foreign Climes, The Return, The Fatted Calf*. Also, a series of etchings (1881); see Michael Justin Wentworth, *James Tissot*, pp. 244–55.

⁴ Paul Gustave Louis Doré (1832–83), French painter and illustrator of the romantic and grotesque, first exhibited in London in 1868. He opened the Doré Gallery in 1869.

20 April 1896

. . . E B-J (*finishing* Aurora): My share of the Chaucer work's nearly over now. Finishing is such nervous work. I don't get irritable, but nervous beyond all telling. Oh, what a time I've had! Nearly cried on Saturday. Do you ever cry, Little Rooke?

I: My heart beats sometimes so that I have to leave off just at the critical moment.

E B-J: Poor *little* thing – do you hear him, Philly?

PHILIP BURNE-JONES: Mine used to do, but nothing that I do is worth it, so I don't let it now.

E B-J: Millais cries sometimes – I met him one day in the street looking so wretched, and he said he had been crying. That was about four years ago.

(*Talking of alteration in* Dawn [Aurora].) I did it on the other one first – that's the good of having two pictures, one to wash the other, as Mr Morris says of having two shirts. This is a ladies' picture, that (Lancelot) is the gentleman's picture. No sentiment appeals to them. I don't know why ladies shouldn't care about it, but they don't. Perhaps they think it's ridiculous to make such a fuss about a mere peccadillo. They don't

approve of the morals of it. But, Lord, it doesn't matter. The great point is, not that they should understand us, but that they should worship us and obey us. . . .

(*At lunch*.) That dear Watts with all his virtues has got one failing, he has a perfect weakness for giving his works to the Nation; the Nation doesn't value them one bit for that.[1]

[1] Eighteen of forty-one Watts works in the Tate Gallery were presented by him in 1897. The National Portrait Gallery has fifty-two works, twenty of which he presented in 1895 or earlier. Many more were added by the terms of his will.

5 May 1896. Garden studio, first
time after the Winter

E B-J (*preparing arm, hands and feet of* Love Leading the Pilgrim): . . . The fact is I'm still very tired. And the death of poor Alfred Hunt too is quite upsetting.[1] It seems as though nothing had been happening but deaths of artists. Such a lot of them have been going. Such a lot! Such a lot! Poor Millais is ill again, I hear. But I feel touched and sorry about the death of that poor fellow: of course it's not the same to you, who haven't known much about him. He was a Fellow of his College who decided to take to painting about the time that I was at Oxford. I remember seeing him once there. There was a printseller in the town, who I daresay may have been a great humbug, but he was very much looked up to by us because he had seen Millais and Holman Hunt, and we used to go there to hear him speak about them. And one day when I was there a gentleman passed through the shop; and the printseller said afterwards 'Do you know who that was?' with great respect and awe. It was Alfred Hunt, and I didn't see him again for hundreds of years after that.

I: And you didn't even speak to him then while you were at Oxford?

E B-J: No, that would have been too great a glory for me. At that time I didn't know that I was going to be a painter – only thought painting was very wonderful. There was a great landscape of his in water-colour in the shop; it was a woodland scene, and I remember saying to myself that if I were to paint,

it wouldn't be only woodland scenes. He always looked to me an anxious kind of man – a regular worry-mutton – took life very heavily I fancy.

[1] Alfred William Hunt (1830–96) died on May 3. Son of the Liverpool painter Andrew Hunt (1790–1861), and a Fellow of Corpus Christi, Oxford, he gave up theology for painting in 1853. Turner and the Pre-Raphaelites were major influences on his work. His daughter Violet (1886–1942), novelist, had a long liaison with the novelist Ford Madox Hueffer (afterwards Ford) (1873–1939), maternal grandson of Ford Madox Brown.

7 May 1896
. . . I (*in the afternoon, on my telling him about Madox Brown's evening at Guild*): Of course there was that old fallacy about his being the inspirer of Rossetti.[1]

E B-J: Anything more impossible couldn't be. All that Rossetti learnt from him was about methods of painting, such as they were, but no two people could be more diverse in taste, temper of mind or direction of thought in design.

I: I took it that he, like Brown, revolted from false [question mark and blank space].

E B-J: But that irascible, quarrelsome old Brown was a very interesting fellow.

[1] In 1848, after less than two years in the Royal Academy Schools, Rossetti rebelled and asked Ford Madox Brown to be his teacher, but he disliked Brown's methodical ways and his still-life exercises assigned. He veered away to Holman Hunt, but Brown certainly gave him much encouragement and practical help in the form of commissions; see Surtees 31, 34, 40, 105. B-J had seen little of Brown since 1875, when Morris, Marshall, Faulkner and Company, founded in 1862, was reorganised, putting Morris, who was not only the producing partner but principal investor, in sole charge. Brown felt that he and the other original investors were forced out just as the firm began to turn a profit; see Mackail, I, 305–308.

9 May 1896. Garden studio
(*Deep tone over the previously grey landscape of* Love Leading the Pilgrim – *copying from pastel colour trial.*)

1 Self-portrait miniature
by T.M. Rooke, 1870

2 Burne-Jones photographed by F. Hollyer in the 1880s or 90s

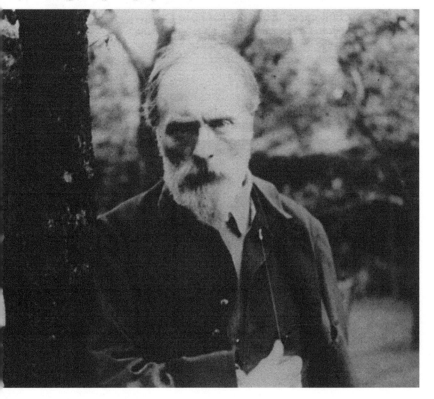

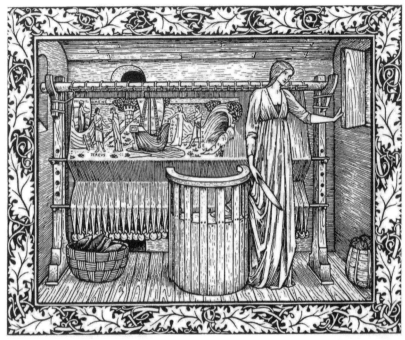

3 'Legenda Philomene' from the *Kelmscott Chaucer*.
See Burne-Jones's comments on 13 January 1896

4 *Love Leading The Pilgrim*, begun 1877 and finished 1897

5 'Thanksgiving'
(Philip in Church)
by Frederick Walker.
See Burne-Jones's
comments on
7 January 1896

6 *The Sleep of King
Arthur in Avalon*,
unfinished at Burne-
Jones's death

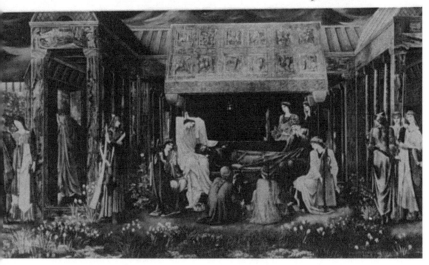

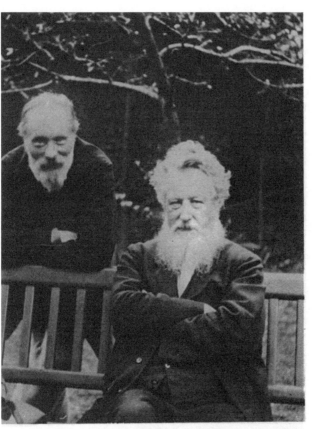

7 Burne-Jones and
William Morris
in the garden
of the Grange,
about 1890

8 The Grange,
North End Road
about 1900

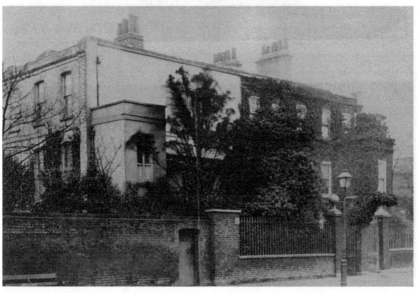

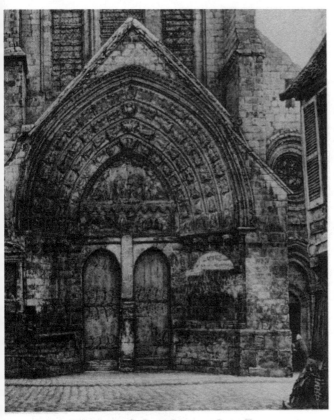

9 One of T.M. Rooke's architectural studies:
St Stephen, Beauvais, 1893

10 The Tadema-Poynter Piano. See Burne-Jones's comments on 23 December 1896

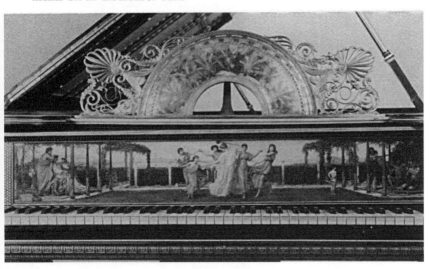

11 Burne-Jones by
George Howard, 1897

12 Burne-Jones by
Aubrey Beardsley, 1891

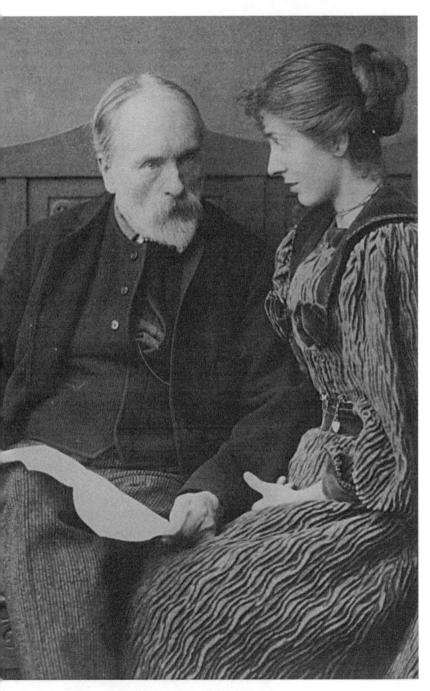
13 Burne-Jones and his daughter Margaret, 1896

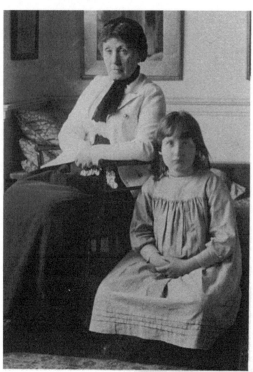

14 Lady Burne-Jones and
her granddaughter
Angela (Thirkell)

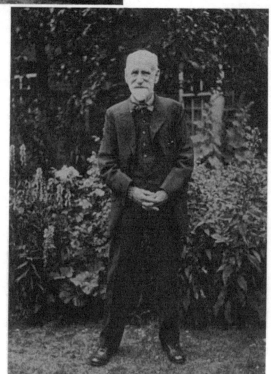

T.M. Rooke in 1931,
aged 89

I: I like it in that stronger colour.

E B-J: I think it'll do now. Yesterday afternoon I left off early, having come to an end of the piece I was doing, and not wishing to begin another so late in the afternoon, I went up to town and saw the National Portrait Gallery. Have you seen it yet?[1]

I: No.

E B-J: A pokey hole it is, and with the exception of Watts' a dreadful lot of things they have there. His are the only things that have any pretension to be art at all. The rest aren't much above the level of Madame Tussaud's. A great deal too much Royal Family there is. I tell you what it is, Little Rooke, I can't stand the humbug of Gainsborough any more. Reynolds is all right, he's got *no* ideas but he can paint – Gainsborough's simply an impostor. He just scratches on the canvas over loose flimsy stains and puts markings in black round them. The only thing he paints solidly are the scarlet coats, and they're just simply crude vermilion. There's a most inferior Duke of Sussex there, one can't even believe that such shocking faces ever existed.[2] The bottom rooms are gloomy, dark cellars where you can see nothing, and the top ones are raked with blinding light from sky lights that are close to the pictures. So that Watts' portraits that are put in them are seen to the greatest disadvantage; they seem all gobs and ribs of canvas – there's not the least chance of a ray of sentiment penetrating them. He was sometimes over rough in his work. I never took any pleasure in that kind of painting and can't imagine why he did it. Titian's and Tintoret's heads are painted very simply and rapidly with quite agreeable texture, but there's nothing of that in them.

I: Perhaps moderns might call them heavy.

E B-J: If they are they've been made so with perpetual varnishing and rubbing.

I: It's rather dreadful to use a public spirited gift like that for the portrait Gallery so ill.

E B-J: An architect ought never to be asked to build a picture Gallery. They should get a painter to advise and a builder to build. An architect wants to make an impression with his flight of stairs and rubbish of that kind. Who wants his

architectural features – damn his staircase – we want to see the pictures . . .

You've heard they're trying to get Leighton's house bought, to keep it as it is. I've let my name be put on the Committee List because I liked the dear fellow. He was such a very good fellow – but the house itself makes me feel leaden-hearted about the project. I shall have to subscribe, but it shall be the smallest possible subscription that will save me from dishonour. What possible enthusiasm or interest could one get up about a house by Aitchison. He is a dull creature. There couldn't be any gain in making public property of it, and to have all those splendid things from the East built up in such a silly way couldn't please me, could it? And they could not be moved without endangering them. It's a great shame.[3]

I saw Sargent's portrait at the New Gallery too, and took a good deal of trouble to see what it actually was. I must say I hated it.[4] The expression was so silly. It's just what a lady puts on when she's trying to look amiable and thinking of nothing and which if you took any notice of would fill you with despair. The only thing to do is to look away when she does it and forget it if you've caught sight of it, if you can. But to make it permanent in a portrait! And the dreadful careless way in which he'd drawn her arm and painted her fingers with dabs of red paint as though she'd been dipping them in fresh blood.

I: Perhaps it was cold weather.

E B-J: No, they get red when the arm hangs down, but not as she lets it drop, which is what is supposed to be represented, only with her keeping it hanging down a long time while it is being painted. An age that makes Sargent its ideal painter, what can we say of it? . . .

[1] The National Portrait Gallery, founded in 1856, opened in its present building on 4 April 1896.

[2] The Gallery has no Gainsborough of the Duke of Sussex; B-J means the portrait (c. 1764) of the Duke of Bedford.

[3] The 'Arab Hall' at Leighton House, 2 Holland Park Road, begun in 1877, to commemorate his Middle East travels. George Aitchison (1825–1910), President of the Royal Institute of British Architects, 1896–99, had been Leighton's friend since student days in Rome.

[4] Sargent, *Princess Thérèse Clary-Aldringen* (1896), wife of Prince

Siegfried, Hereditary Ruler of Clary-Aldringen; she died c. 1930, and c. 1945 the portrait disappeared somewhere in East Germany. Reproduced in *Men, Women and Things: Memories of the Düke of Portland*, facing p. 221.

11 May 1896. Lunch

E B-J (*vigorously*): Mr Morris looked much better yesterday, but very thin and shrunken. How ill he must have been. He's bought another book. How much do you think he's given for this one?

MR MACKAIL: £1,000.

E B-J: Well, £700. He had to send Cockerell over to Stuttgart first to see it, and gave him a blank cheque – and Cockerell was very judicious about it. He knows all about books of course, and decided that it was worth buying. He wrote over to say exactly what it was like – how many pictures there were in it, and how that the gold was a very nice colour though not so highly raised nor so brightly burnished as in some of the others, and what the condition of it was. Then when Cockerell got it over he had to take it to Kelmscott where Mr Morris was – who wouldn't open it when he first saw it but handed it to [F. S.] Ellis who was there, and when Ellis had looked at it he said 'It's not a dear book, it's cheap.' Then Mr Morris took it, and in ten minutes his heart was aglow. He brought it for us to see yesterday. It's a bestiary. So happy it must have been for the monks to see. There was a pea-green donkey in it quite big, standing all by itself. It was an Oriental donkey, so might well have been pea-green. Another was a most exceptional crocodile with a splendid spine and tall legs.

MR MACKAIL: Like a giraffe.

E B-J: And an indigo bear, licking its brown cubs into shape, and mind you they needed it, for they were just round balls. And a fox lying on his back with his mouth open and a bird putting his beak down his throat. Do you think that fox was dead – not a bit of it, there were the heads of all the little foxes looking out of holes waiting for the bird to be snapped up. On another page there's a cat going at a mouse and so that you needn't tremble about that, on the next page there's a mouse actually eating the holy wafer – mind you. Isn't it

dreadful? And at the end there's an inscription to say that the Abbot of [Radford] has given to his monastery of Christ Church of Lincoln certain books, to wit the Gospels and a life of St Anselm and this one and a Mappa Mundi, and that whosoever [blank space], that is to say makes away with any of them or separates them will have to answer for it at the judgement seat in the last day.[1]

MR MACKAIL: Has Morris inherited this curse?

E B-J: Oh no, on the contrary he deserves well; he has restored the book to its country; for it's undoubtedly an English book. They must have been dispersed in Henry VIII's time, at the dissolution of the monasteries. But he left in the lowest spirits, so full he was of denunciation of the times and the disregard and destruction of everything beautiful. He said it would be a million years before people would make things beautiful again . . .

[1] This was the English Bestiary and Other Texts given to Radford (now Worksop) Priory in 1187 by Philip, Canon of Lincoln, and now in the Morgan Library. See *Art of the Book* 24; *Letters*, pp. 382–83. The Morgan Library dates the work c. 1170; the anathema is on the verso of the first page.

 26 May 1896. Coming into Garden studio (*Drapery studies still unsatisfactory.*) . . .

I: I suppose modern excitement about technique is like the Renaissance once about drawing and chiaroscuro, which were also technical qualities.

E B-J: Such as they were. But it's such a foul kind of technique the world's gone mad about. I can't imagine a more detestable kind of painting than Sargent's. Unless it were Gainsborough's.

I: What a silly Agnew to give £10,000 for the Duchess of Devonshire when he might have had Avalon for that.[1]

E B-J: Yes, or for half of it or a quarter.

I: And it couldn't have been stolen either.

E B-J: It would have been rather hard to steal certainly. But I shall never have such a commission again as the Briar Rose. The only money I ever was able to put by came out of that and

the interest of it is only enough to pay my Life Insurance, so I have to work for my living just as hard as ever[2] . . .

[1] Gainsborough's portrait of Georgiana, Duchess of Devonshire, sold at Christie's in 1876. Agnew paid £10,000, the highest price to that date for a single picture. Three weeks later it was stolen by an American professional thief and reappeared only in 1901, when it was acquired by J. P. Morgan. See *Pictures in the Collection of J. Pierpont Morgan at Prince's Gate and Dover House, London*, pp. [17–36].

[2] Georgiana Burne-Jones added this note in R-MS: 'In this talk about laying by money his memory failed him, for he invested £14,000 out of the £15,000 received for the Briar Rose at once, which produced about £420 a year, while his Life Assurance amounted . . . £173 . . .'

11 June 1896

E B-J: Georgie and I have had a wedding day [9 June 1860] – the 134th anniversary. (*Draping two front figures in* Avalon.) When I begin to colour this it shall be like tapestry colour at first, the shadows done with colour and all the lights white – then after that I shall be able to see what had best be done with it, and done that way it can be made into anything. Because it's all very well to say it's to be deep colour. Deep colour it shall be – but I'm not at all prepared to say what.

I: Have you seen that beautifully rich piece of tapestry in the South Kensington Museum with all the lights gold and silver – I like it best.

E B-J: Yes, but I like the big tapestry better where you see the figures clearly made out by the white lights on them. The other's too nearly like painting or jewel work for me to like it so well as the big tapestry. Big tapestry's beautifully half way between painting and ornament – I know nothing that's so deliciously half way. One of the most splendid designs in the world is that tapestry in the Vatican Museum with the Pope and Charlemagne in it.

Mr Morris was better yesterday a little. He was railing at the doctors, poor dear, as he always likes to do.

I: That's perhaps a good sign.

E B-J: Yes, I like it much better than when he's so meek

spirited. He's going to Folkestone where he can make a voyage across to the French Coast whenever he likes. The doctors say a long voyage would do him most good – but that he can't manage for many reasons. I've been going on with my astronomy, but my feelings are still hurt by their calling that swift star Groombridge No. one thousand three hundred and thirty. It's so unworthy of him, he goes shining and rolling on at that incredible rate. He's such a splendid fellow. Do you know how quickly light travels and that it takes seven hundred thousand years for it to come to us from the furthest stars which – (*opening arms despairingly*) – as if you and I didn't matter – That's what it does. At first I was indignant. It makes out the world to be not nearly as big as it seems. But one makes up one's mind to everything. And the microscope shews things to be just as infinite in the direction of minuteness. Though they're stuck fast with the telescope just now they go on improving the microscope still.

20 June 1896

E B-J: Phil and I went to the Goupil Exhibition of our old pictures.[1] My little early ones didn't give me the shock I expected – but they looked so sincere. I was quite touched with them. There was such a passion to express in them and so little ability to do it. They were like earnest passionate stammering. I wanted so much to put expression and nice shape into the faces and couldn't do it at all. As for drawing it didn't seem to be more than a boundary to stop colour at.

I: And to their action and expression.

E B-J: If it would. There was one thing in them however that did look like inborn gift; that was the colour. It was so strange you couldn't tell how it had been ever imagined – the colours in the colour box wouldn't give you the least cue to it, they weren't the least bit like it. Some did make me laugh. There was a little lady who for reasons known only to herself was eating and drinking in a garden – a charming little lady, and she was being served by such a delightful fat maid. Such a fat maid with such nice little boots and everything.[2] The Holman Hunts looked very well too. I never saw such colours in my life. There was a red in one of his pictures that was the

most splendid red I'd ever seen. And every part of the picture glittered so with force and strength that nothing like it exists. Yet at a distance all this brilliancy killed itself, the colours counteracted each other and fought till the whole result was lost and there was no effect at all. The red mighw just as well have been a dull brick colour. It couldn't stand against Rossetti's colour.[3] As I've said before, I always think of him as being less a born artist than one who has made himself one by intense determination and force of will. Rossetti's pictures are going sadly. Heads that had been once so beautiful are now seamed and haggard, with dark marks where the red lead he used for flesh-colour is turning black. That's very sad. There's a most lovely design of Tristram and Iseult drinking the love potion in the ship. It's splendid, one of his very best.[4]

Mr Morris has been one voyage across to France, but he doesn't say much about it. Evidently didn't enjoy it as he used to enjoy voyages. It tired him very much and he doesn't talk of going again. He was sent to Folkestone in the hopes that he'd go often . . .

(*Afternoon. Still about Goupil's Pre-Raphaelite Exhibition.*)

The Merciful Knight looked quite genuine in feeling. It was that the Water Colour Society hung high up out of sight behind the door.[5]

I: What they call the naughty boy's corner.

E B-J: They have their regular four rows of pictures, and it was stuck right up on top of them so that no one could see it. Some of them were furious with me for sending it, and let me see that they were. They would be talking together when I turned up and let drop remarks about it of a hostile nature for me to overhear, in what I may call, since there are no ladies here, a feminine manner. That indirect way they have when they want to pay you out, of dropping a sort of audible stage aside for you to catch, the sound of which shall be anything but gratifying to your feelings. I suppose some of them always hated me. When you were elected they all shook hands with you. With me all but two did, and they would never have a word to say to me. One was old Duncan and the other I've forgotten, but no doubt could pitch on the name in a catalogue of the time . . .[6]

I've had an amusing letter from Swinburne. I had written to him saying how often when I heard or thought of a funny thing I imagined a letter to him about it which never got written, and in his answer to that he said 'such a letter as Gregory might have written to Augustine if they had been contemporaries, which no doubt they were capable of being'. So full of jest is he.[7]

[1] The public exhibition of the James Leathart Collection, June–July 1896. William Michael Rossetti wrote the introductory note to the catalogue, *A Pre-Raphaelite Collection* . . . See also his article, 'A Pre-Raphaelite Collection', *Art Journal*, 58 (1896), 129–34. The collection was sold at Christie's, 19 June 1897.

[2] Rossetti, *The Bower Garden* (1859), water-colour; see Surtees 112.

[3] Perhaps Hunt's *The Hireling Shepherd* (1851), in this exhibition and now in the Manchester City Art Gallery.

[4] Rossetti, *Sir Tristram and La Belle Iseult Drinking the Love Potion* (1863?); see Surtees 200–200B: a sepia or Indian ink design with water-colour, for stained glass.

[5] B-J, *The Merciful Knight* (1863), gouache, in the Birmingham City Museum and Art Gallery. The subject is drawn from the story of an eleventh-century knight miraculously comforted by the Christ of a roadside shrine; see H/W, illustrations 92, 94. Exhibited 1864 with the Old Water Colour Society.

[6] Edward Duncan (1803–82), marine and landscape painter.

[7] See *The Swinburne Letters*, ed. Cecil Y. Lang, VI, 100–101.

24 June 1896

LADY ELCHO (*who had seen Mr Morris at Folkestone*): He puzzled me very much just as I was coming away, on the stairs, he said he didn't approve of education – and I wondered what he meant. There was no time to ask him. And it's serious – I don't know what to do about the boys.

E B-J: Well, it's such a funny world. By the present way, people's faculties are more often stuffed up than drawn out. *In*ducate is rather the word that represents it. People ought to get into the habit of saying quite in an ordinary tone of voice, 'My boys are being inducated at Eton.' A man who can make a door has been *ed*ucated to some purpose. His faculties have been drawn out in the most efficient way.

MISTRESS: If it will open and shut properly.

E B-J: That dear Ruskin meant the same thing when he asked to be allowed to shake hands with the man who built a wall properly and couldn't read or write. Children ought to be born labelled whether they should learn reading and writing or not.

MISTRESS: Book-learning – there's no better term for it than that, after all these years.

LADY ELCHO: Printing he disapproves of too. (*Everyone laughs.*)

E B-J: It's quite true and he's not wrong. It isn't such a paradox as it seems . . .

<div style="text-align:right">c.7 July 1896</div>

E B-J (*partly to Dr Evans*): Splendid work the Chaucer is. It's the finest that ever was printed. As I was passing in a cab through a street up in London something glorious flashed out of a shop window right into the cab, and looking at it with astonishment I had just time to see it was the Chaucer. (*To Dr Evans*): There's very little of me in it – you know ⁵/₆th of it at least is Morris's.

<div style="text-align:right">10 July 1896. Garden studio</div>

E B-J: I'm quite haunted with the illness of people – can't get poor Millais out of mind – then there's always that dear Morris.

I: Does he like his book? (*Meaning the new MS.*)[1]

E B-J: The Chaucer? Doesn't think any more about it. He's quite removed it out of his mind as he always does with anything that he's finished. Before beginning to paint I think I must make a note in pastel of a twilight sky I saw last night. The Mistress and I went for a drive out Wimbledon way. It was so hot and we wanted air and were too tired to walk, so we took a Fly and then saw this wonderful sky, as you do see sometimes on rare occasions. (*Painting blue hanging on palace wall in* Avalon.) Someone came to ask my advice about a monument [to Leighton]. Naturally I couldn't say that I hated monuments and hated St Paul's, but I do. The kindest thing you can do to people when they're dead is to let them alone and

<div style="text-align:center">109</div>

be quiet. Monuments are hateful things, sticking out every-where in the way and lumbering a place up. I'd clear them all out of Westminster Abbey. Lovely the Arena Chapel is that has no monuments; it hasn't any, has it? As for St Paul's, the beastly place, they can stuff it up as much as they like – fill it with sofas and armchairs for anything I care. In fact furnishing is what it does want. But I do hate a Necropolis. Horrid doleful chill pompous display miserable to go into and to think of. Given up to the Royal Academy and the Artillery Company. I like a comfortable happy place, not a deadman's hole. So glad I never did those 4 quarter domes they wanted me to. Such wretched scroll work all round the spaces.[2]

I: I thought the capitals underneath looked as though they'd go well with Mantegnesque designs.

E B-J: Yes, but he's too late for mosaic. It ought to be fresco. Nothing fits mosaic but the severest Byzantine, anything else is too late for it. Even Gothic doesn't do for it. Fancy mosaics in Salisbury Cathedral.

[1] Morris and B-J went – their last expedition together – to look at English manuscripts and 'found the [Windmill] Psalter to which his [Morris's] 4 fine leaves belong' (Cockerell diary, 5 June 1896. CP:BL). It belonged to the banker Henry Hucks Gibbs (1819–1907), in that year created Lord Aldenham, from whom Morris purchased it for £1,000; see *Art of the Book* 25.

[2] On B-J's refusal in 1891 to design mosaics for St Paul's Cathedral, see *Memorials*, II, 217–20.

15 July 1896

E B-J (*painting in Amazon with shield in* Avalon): I'm caving in a bit. Feeling always giddy and sick. Overdone rather. I've been keeping at work pretty closely and have had a tough time in many ways and the heat's put the last touch. Always anxiety about Morris, and about Margaret I was in a regular state of panic till she was safe. Quite needless of course, but the panic was here and there was no stopping it. However, Mr Morris looks much better. His interest in life is so strong again and he's taken this journey to heart and wants to be off. On the globe I see the distance of Spitzbergen from the North Cape is about the same as France. The globe would be more exact than

a map no doubt. . . Mr Morris said nothing about his Chaucer
– as I told you he's put it quite out of his mind. I haven't, I can't
forget it. I'm more constant than he is. I love it. I turn it over
page after page and gloat over it.[1] It doesn't matter whether it's
a picture or a page of print, they're equally beautiful. I'm
delighted it's come out so quietly, entered like a gentleman
without making any noise. Not a mention of it in a single
newspaper. They've not had a copy of it – not one of 'em.
Perhaps they don't know it's out. They don't know what to
say about it – can't make head or tail of it[2] . . .

[1] On July 6 Broadbent prescribed a voyage to Norway. Morris, who
disliked the sea, hated the idea and was not cheered even by the
delivery of the Aldenham Psalter on July 6 and the vellum–bound
Chaucer on July 8. He and John Carruthers (1836–1914), engineer
and old Socialist colleague, were to sail for Spitzbergen on July 22.

[2] Cockerell had said (diary, 3 July 1896. CP:BL) that a *Chronicle*
reporter 'wanted to know if any well-known people were sub-
scribers, or if we had a letter from Mr Gladstone. I said I would not
say. I didn't tell him we really didn't know the names of the
subscribers, as it was done through booksellers.'

BLESS YE MY CHILDREN· MAN·ÉOJ

♠ Interlude: Summer 1896

This was the summer of the death of William Morris. He lived until October 3, but anxieties about him had taken possession of the season. From the time of his departure for Norway, his friends, however hopefully they spoke, knew in their hearts that he was in grave danger. They realised anew how much their own energies and ideas were invigorated by his; the links that held his circle together seemed to weaken before their very eyes.

On July 17 the Rookes set out as usual for the Continent, but only a few of that summer's letters survive. Burne-Jones went to Rottingdean on August 13, and Millais died 'while I was travelling down here – and I'm glad the torture is over for him, and the watching for his children and wife'. He was not comforted by a newspaper article pronouncing Millais 'thoroughly English and we may safely admire him – he has [none?] of the morbidness of Rossetti and the Ethical Something or other of Holman Hunt – so now we know and it's well to be told – but I feel heavy enough and sad today – though I longed to see that it had come.'[1]

Cockerell, always methodical, kept up his diary and wrote regularly to Carruthers and to Philip Webb, now living in retirement in Sussex. Morris improved in appetite and spirits during the voyage but by July 19 was rebelling against having to face the fogs of Spitzbergen. Carruthers continued overland, leaving Morris at Vadsö, surrounded by 'lots of civilized people' awaiting an expected eclipse.[2] Morris and Carruthers came home on August 18, and Cockerell wrote to Webb: 'W. M. declared himself better "in spite of the voyage" and said uncomplimentary things about ships, fiords, globetrotters, astronomers, cooks, etc. etc. but he is undoubtedly stronger, and more like his old self. He ate his lunch with great relish, saying that the cutlets actually tasted of *meat!*'[3]

The following day, however, he was 'not so obviously

better as one might have hoped'. Burne-Jones, up from Rot-
tingdean for Millais' funeral services on August 20, found
Morris 'very ill – his cough troublesome and all energy and
interest gone'. He wrote to George Howard that 'such hopes I
had of the voyage but all is dashed, and I am anxious beyond
words . . .'[4]

Thereafter it was all downhill. More doctors were sum-
moned. On August 30 Morris asked Cockerell whether he
would be 'prepared to carry on the Press after his death, with
Emery Walker, and I said that I was in favour of it ceasing – as
otherwise it would fizzle out by degrees, and the books already
issued would suffer by inferior ones following them. He said
he thought I was perhaps right.'[5]

At better moments Morris tried to work at bits of ballads for
the Press; in worse moments he had nightmares and dreamed
that he was writing Farrar's *Life of Christ*.[6] He tried to put the
Windmill Psalter in order. On September 22 Arnold Dol-
metsch came and played old music on the virginals; Morris,
Cockerell wrote, was 'a good deal affected – so much so that he
could listen to only a few of the gentle old tunes'.[7]

He died quite peacefully at 11.15 on October 3, and Cock-
erell wrote: 'I had never seen a dead man before – and was
startled to see how little it resembled the living Morris. The
face was singularly beautiful, but the repose of it made it the
more unlike what I had known.'[8]

Margaret Mackail went to Paddington Station on October 6
to see the coffin – plain oak with iron screws and simple
wrought-iron handles, covered with flowers and with tapes-
try instead of a pall – placed on the special train that would take
it to Lechlade, whence a two-wheeled farm cart garlanded
with willow and country flowers would draw it to Kelmscott.
She saw her father, looking very tall, very dignified, very
knightly, among the quiet crowd of socialists, workingmen,
and other friends. John Mackail also, in rough notes written
later, remembered 'E B-J standing by grass with Mrs Morris,
seemingly 6 feet high and broad-proportioned – like St
George'.[9] Margaret, going homeward through the rain in
London, reflected that, for her parents, life would never again
be the same.

Interlude: Summer 1896

Burne-Jones a few days later wrote that 'the burial was as sweet and touching as those others were foolish – and the little waggon with its floor of moss and willow branches broke one's heart it was so beautiful – and of course there were no kings there – the king was being buried and there were no others left.'[10]

🐦 4 October 1896 — 26 July 1897

E B-J (*Morning after death of Mr Morris*): I haven't cried much. I look upon his death more as a symbol of what had already happened than as a lamentable thing in itself. I never had any hope from the first, and when he came back from that uncomfortable voyage that made him miserable, poor dear thing, and took him away from all his friends and did him no good, it was quite clear what would very soon be. You remember saying he looked like a ghost coming into the garden studio that day in the early summer; the same look came upon him more and more. He got to be such a shadow that he was no more than a glorious head on a crumple of clothes. His poor body had dwindled into absolutely nothing. The strain of watching it was terrible to me sometimes, and I felt that I could hardly bear it and I must get away and fly from the pain of it. I should have liked to have rushed off to Venice or somewhere, but of course if I *had* gone away I should have been still more miserable, and had had to come back again by the first train. One thing that I was always frightened of has been spared; I was so dreading that this disease might have got to his brain, and that would have been quite unbearable – but he was himself to the very end. There was for a short period a look of something like indignation in him, but that soon passed away and his face became quite placid again, and he died like a little child. I went and looked at him afterwards because I wouldn't give way to my dislike to doing it – but it was nothing – I was neither glad nor sorry that I had; but all that talk about the beauty of death I don't believe a rap in – it's nothing like the beauty of life. But I'm sorry for the world and the years of splendid work it has lost – he could well do without it, but the world's the loser. And now I must go on with my work; things must be done and the living have to live.

I've been working this morning. Phil is there talking about things. I'd always work, even if I tore up what I'd done afterwards. I shall be at work tomorrow; come and bring your things that you've done away, and do some work with me.

10 October 1896

E B-J (*Du Maurier dead two days before*): Come along, I'll be upstairs directly, but we won't talk sadly today – it can do no good and I've been doing nothing but that lately. I'm slowly gathering my life together again and picking up the threads of it – but I'm frightfully tired. After that miserable day which is certainly the worst I ever had in my life [October 6, the day of Morris's funeral], I went to work on Wednesday with great energy and did two entire cartoons that day – come and look at them. This is David grieving for the illness of his kid; I did all that in the morning – and here he is making up his mind to it and pulling himself together; that I did in the afternoon. But on Thursday I felt very tired and more tired yesterday, and today still more tired.

I: How strange there should have been those to do then.

E B-J: I picked them out.[1] . . .

Studio

I: I heard the Mistress reading Blake's Life to you last Monday.

E B-J: Yes, there's so much that's alike in all those great creatures. Blake and Morris resembled each other in so many things – in their splendid simplicity above all. We came upon his remarks on the death of Sir Joshua Reynolds, in whose life time he had kept his own counsel – but afterwards puts it down pretty plainly. '*This man was born for the depression of Art. This is the opinion of William Blake.*'[2] How do you like that?

[1] *David Lamenting the Illness of His Son Absolom* and *David Consoled*, both for St Cuthbert's, Newcastle-on-Tyne, now demolished and the windows moved to the Laing Art Gallery, Newcastle; of the second, a duplicate at St Stephen's, Broughty Ferry. See Sewter, II, 37, 140–41; H/W, Plates 246, 247.

[2] See Alexander Gilchrist, *Life of William Blake, 'Pictor Ignotus'*, I, 97–98. The passage that begins 'This man was here to depress Art'

ends with 'Reynolds and Gainsborough plotted and blamed one against the other, and divided all the English world between them. Fuseli, indignant, almost hid himself. I AM HID.'

19 October 1896 . . . Afternoon, in studio

E B-J: Did you see the Goupil Exhibition? What did you think of Holman Hunt there? I learned, once amongst the Preraphaelites, to disintegrate the colours of things as the rainbow disintegrates sunlight, and it amused me for a little while – but I soon got tired of it. The simple effect of the look of a thing is what I like so much better. And Rossetti soon tired of it and Millais too, and everyone else did except Holman Hunt, and he holds to doing it even more and more the older he gets to be.

24 October 1896

I (*Painting dress in old oil replica of* Hope.[1] *. . . Mrs Carlyle in her letters tells of having to take sleeping draughts. Telling him about them.*)

E B-J: That all sounds very bright and clever. I daresay much of her complaining, that wasn't ill health, was only smart talk. People don't understand wit. I think I can pardon her now. It was that fool Froude – he oughtn't to have published the hopelessly sad things; the world wants cheering. It has quite as much misery in it as it can bear. Was she jealous of Lady Ashburton?[2]

I: Froude says Carlyle liked to meet with the important people that came there and see something of the real world and influence it; do more than write shadowy books for it.

E B-J: How silly! What better could he do? Shadowy they should be – what's the world but a shadow? And drawing-room life is not real life at all; nothing is so far from reality as a fine lady. I ought to know it as well as anybody, for I've seen it for myself. His books were what he ought to keep to, except for diversion. If it diverted him that's all very well. We only went once to see him; I did not like going where I knew that all I loved would be contemptuously treated, but we went because dear Ruskin wanted us to. Mrs Carlyle was very kind indeed to Georgie – took a great deal of trouble to wrap her up in shawls and wraps I remember.[3]

117

Lunch

E B-J (*to Georgie*): You look tired; you can easily overtire yourself with that work though it's only reading documents; it may get very fatiguing.[4]

MISTRESS: It is very interesting – such a lot of things I find I had completely forgotten. I never remembered he (Morris) had been so often to Rottingdean. Then there are a great many interesting letters about his social views.

E B-J: I hope it won't be a key note in the book.

MISTRESS: Well, but it was an important part of his life.

E B-J: It was a parenthesis in it; he was before all things a poet and an artist.

MISTRESS: But he talked much more to me about it than he did to you.

E B-J: As he well knew he must. I shall always deplore it.

MISTRESS: Well you know, Ned dear, we are not quite agreed upon that point.

E B-J: Yes, I know, but that doesn't prevent my deploring it. I never minded Ruskin doing it, as you remember. I liked him to do it. I liked it extremely in *Unto This Last* and in *Fors Clavigera*, but for Morris to take it up was different.

[1] B-J, *Hope* (1862), watercolour. An oil on the same subject (1896), sold to the Whitin family of Whitinsville, Massachusetts, was shipped to them in 1897. Present owner unknown.

[2] Jane Carlyle was desperately insomniac, which aggravated various nervous disorders; see, for example, *Letters and Memorials of Jane Welsh Carlyle*, ed. J. A. Froude, II, 188–89. Carlyle meekly submitted to lionising by Lady Harriet Baring (1805–57), first wife of the 2nd Baron Ashburton (1799–1864). She was grandly condescending to Jane Carlyle, while Carlyle resisted understanding his wife's feelings about the situation. Froude's controversial biography of Carlyle and Carlyle's relations with his wife are now examined with sympathy and balance, in the Introduction (pp. 1–60) to John Clubbe's abridgement, *Froude's Life of Carlyle* (1979). B-J remained emphatically anti-Froude; see *SHL*, pp. 91–92.

[3] The evening, in November 1862, 'passed off safely on its human merits'; see *Memorials*, I, 257–58. See also Raleigh Trevelyan, *A Pre-Raphaelite Circle*, p. 187.

[4] She was sorting papers for Mackail, already at work on his biography of Morris.

4 October 1896 — 26 July 1897

16 November 1896

. . . E B-J (*Repainting figure of* Venus Concordia. *I telling him of death of Mrs Carlyle*):[1] That dear Ruskin came to tell us about it next day. He was very distressed about it.

I: The only mention of him seems to be that about his giving their servants a sovereign each at Christmas.

E B-J: I've always but little doubt that Carlyle didn't know his value. He couldn't understand Ruskin's love of beauty. All that had to be a sealed book to him, and he must have had suspicions that it must all be humbug.[2]

[1] Jane Carlyle died in her carriage on 21 April 1866, after alighting to pick up her dog, struck while running alongside.

[2] Rooke is reading *Letters and Memorials of Jane Welsh Carlyle*, prepared for publication by her husband and edited by Froude (1883). Ruskin is mentioned three times in the two volumes. Froude, in his biography of Carlyle, quotes Ruskin on Carlyle: ' "What can you say of Carlyle," said Mr Ruskin to me, "but that he was born in the clouds and struck by the lightning? . . . not meant for happiness, but for other ends; a stern fate . . ." '; and, Carlyle on Ruskin: ' "There is, in singular environment, a ray of real Heaven in R." ' (Froude, *Thomas Carlyle . . . 1795–1835*, II, 475; *Thomas Carlyle . . . 1836–1881*, II, 383).

18 November 1896

E B-J (*looking very grey and ashy coloured*): There's such an oppression on my chest this morning that I've asked the doctor to come and tell me whether it isn't inflamed, and whether I'd better go to bed again or not. Waking I was nearly choked, and then coughed so much as almost to faint. Every cold takes such a hold of me now that each one makes me feel as though it might be the last of me, . . .

(*Painting hills at right hand end of* Love Leading the Pilgrim.)

. . . I: There's such a bad reproduction in a Christmas paper of a figure of Lord Leighton's, wrong and bad everywhere – only with a look of his soft handling.[1]

E B-J: He always did like a bed of down as much as I did a bed of thorns. But I never could care for his work, though perhaps it isn't quite kind of me to say so – But it can't hurt him now. It never seemed to me to be inspired by anything else

119

than the Opera. As though he'd been to that entertainment and been so pleased with it he couldn't get it out of his head, and that rather low. It was like bad rhetoric to me – not quite believable – very much in fact like his speeches on public occasions that his friends could never listen to without feeling ashamed. Nothing to be done but to hang down your heads and hide your feelings under applause. Remember a very funny thing that Millais said once after having seen Leighton's pictures. It was to Mr Prinsep I think, in his exceedingly simple, childlike way – for he was always more like a school-boy than anything else. He said 'You know, my dear fellow, when I came back to my own work I quite felt like a giant.' It's no wonder he felt like a giant. A giant he *was*.

I: The agitation about Mr Poynter hasn't held on.[2]

E B-J: No, that's all over I fancy – but it was mean. Yet I don't regard him as altogether fortunate. I should look on anything that took me away from my work as the greatest misfortune. In fact I'd much rather come to an end at once than allow it. Couldn't bear to live on without my work.

[1] Leighton, *Flaming June* (1896), in *The Graphic Christmas Number*, 54 (1896).

[2] Choice of a National Gallery Director in 1894 was between Sir Sidney Colvin (1845–1927), then Keeper of Prints and Drawings at the British Museum, and Edward Poynter. Poynter got the post. B-J exulted that 'the National Gallery is safe for a time . . . all those treasures – irreplaceable – . . . who minded whether they were imperilled or not – it was the last thing ever discussed when the question rose – it matters little what they buy, it matters more than any question of the day how they keep what they have' (B-J to Helen Mary Gaskell [28 April 1894]. B-J:BL). After B-J's death, Georgie presented his *King Cophetua and the Beggar-Maid* (1880–84) as a memorial – with 'an earnest hope that this gift to the nation be accompanied by one condition – namely that it should be hung in the National Gallery in Trafalgar Square to which his mind and soul constantly turned as a hallowed place while he was alive. That would, to my mind, make the memorial perfect, and I cannot rest without telling you how much importance I attach to the idea' (G. B-J. to George Howard, 7 August 1899. CH). *King Cophetua* hangs in the Tate Gallery, not in Trafalgar Square.

7 December [1896]

E B-J (*Painting dart and about that end of* Love Leading): House is full this morning of a rather spiteful rejoicing. That daddy-longlegs thing at Brighton has been smashed up and the rails all torn and twisted.[1] But no doubt they'll try and mend it and go on again when the summer comes – but it's hardly likely they'll take it on to Newhaven as they meant. But it's a company, and we know very well what that means. Scoundrels in the City get it up in collusion with a self-interested engineer, and tempt poor investors to put their money in it, and soon that's all spent and they call meetings and issue new shares that are not taken up, and then there's a smash and general ruin, and the property is bought up cheap by a new company – which is what has already been done at Brighton – and then that fails, and there's more ruin and another company again buys it up – till what has cost hundreds of thousands is sold for a few hundreds. That's what happened with Olympia, only there's the building always. Rottingdean's a silly little village, always bursting to join itself on to Brighton, never thinking that when people can go there easily they'll do all their shopping there where things are to be had much better and cheaper . . .

[1] On December 4, 1896, a gale brought down the new Brighton-Rottingdean Electric Railway, a kind of over-the-water funicular, which Morris, who called it the 'Rottingdean Humbuzzer', hated with a passion. Angela Thirkell described it as 'more like a vision of the Martians than anything you ought to see at a peaceful seaside village' (*Three Houses*, p. 133).

9 December 1896 . . . Lunch

E B-J: Everyone ought to be taught to draw, and everyone to paint who can. It's a part of necessary education. In the time when even a Baron couldn't spell, when a learned clerk was esteemed a sort of magician it might easily have been thought no good to teach anyone to write who couldn't write a good book. The number of people with imagination worth anything to the world generally is so small that an art would quite perish out of existence, if its practice were restricted to them

121

only. You wouldn't prevent every musician from playing that couldn't invent his own pieces.

MISTRESS: O, that's because the works of the great composers couldn't be heard unless other musicians played them.

E B-J: And the great works of painting are equally confined and locked up in the places where they were.

MISTRESS: Wouldn't it be better then for them to spend their time copying good pictures than doing quite worthless ones of their own?

E B-J: Most certainly it would. If I wanted to buy pictures and couldn't afford original ones of the proper valuable kind, I'd do nothing but buy copies. I'd buy every copy that Stanhope ever made, or Lady Lindsay – they're *quite* valuable . . .

16 December 1896

E B-J (*Grasses under Love's feet in* Love Leading the Pilgrim): Do you know a painter named [Steer]?[1] Is he a singularly great painter?

I: I heard him, if it's the same man, speak very well about Impressionists.

E B-J: What's in their minds? What do they do, those Impressionists?

I: They try to overlook minutiae and think of breadth and atmosphere.

E B-J: They do make atmosphere but they don't make anything else. They don't make beauty, they don't make design, they don't make idea, they don't make anything else but atmosphere and I don't think that's enough – I don't think it's very much. Do they sell their work?

I: Not very readily, people say.

E B-J: If it's good it's a great shame they can't live by it. He's done a picture which that fool of a [R-MS: space], I suppose it's he, someone in the *Spectator*, has been praising in such exaggerated and extravagant terms that Mr Hallé thought he might be doing an injustice in not seeing it – and what do you think it was when he did go to see it? A naked woman sitting up in bed with a black velvet ribbon round her throat. Perhaps it isn't a wonder altogether if they don't sell their pictures. I think the

suspicion people seem to have is a very just one, that they escape a great part of the difficulties of painting. They do get breadth and a pleasant sense of flatness it's true, but that's not by any means a new thing in the world; it's been done before, most distinctly, and of itself it's nothing to make a fuss about. They seem to *me* a set of inferior chaps who do next to nothing but talk about what they do. Other men are hard at it trying to do their work without making such a fuss. They've either got the press completely on their side or are perpetually writing and publishing in it about their own doings. They're *perpetually* gabbling. No people in the world make such a row as they do. I'm perfectly sick of it. Completely certain of it. When the Pre-Raphaelites began it was hard work for them to begin, and how quiet they were about it – how little jabber there was, wasn't there? They're a lot of young men setting out to take painting from its most agreeable side – to float out into the vague illimitable void. To have the least trouble over the work or getting things or ideas together for it. Well that may be all right. I've nothing whatever to say against that but it's been done before, there's nothing new in it. No need to make any fuss about it. But they express the human figure badly – never make a beautiful face or put the least atom of a desirable sentiment into it. What indeed do they do?

I: I suppose they don't want to go beyond the limits of Whistler's range of work.

E B-J: But Whistler's another matter – he's a perfect Raphael beside, the Angel Gabriel. But they're completely in the hands of their models, and there's no class so undesirable to be in the hands of. When they've got a model they don't know what to do with her but to clap her down on a bed, turn her round and paint her. I never saw any set of people so entirely destitute of ideas, who are so bent on making painting a stupid art – who constantly justify Byron's cruel saying of it that it is a stupid art.[2]

I: Did he say that?

E B-J: Indeed he did, and wasn't he quite justified? They want to make pictures that shall not be for the world at large but for artists only, for artists of their own degree – and naturally the world won't want them. A woman sitting up in

bed indeed, with a black ribbon round her neck. What a picture! Really by the side of these fellows Whistler's a kind of Van Eyck. They've got the pull all fools have over mankind that having no ideas they're not impeded by them. So they can keep up a perpetual meaningless babble without a pause and anyone that has something to say can't be heard. Bother it (*looking for something*), what a lot of things an oil painter has to do before he can set to work. What a happy art is water colour painting, and happier still the Black and White artist. But I wouldn't have Poynter's future before me for anything that could be said in this world. Not another hour of peace will he have in this life. Presently they'll all be baiting him you know.

I: I liked what he said at the prize giving about Leighton and Millais. And the critics, I think it was hardly worth his while to attack them.[3]

E B-J: It will bring the nest of hornets round him, and they'll have the last word of course, since it's their daily business that they're paid for to produce their rubbish. They've begun at it already. Morris' word about it was final. 'Imagine a set of fellows getting their living by selling their opinions about other men's work – and imagine a set of fools paying them to do it.' But really these critics are all at work cutting each other's throats; why not let them do it. The worst of it is that in a certain sort of a way these wretches are not so altogether wrong. I always thought Leighton's work to be theatrical, didn't you, or did you think better of it than I did? Not that it was ever vulgar, but I used to feel that his emotions were developed in just the same way as emotions are on the stage.[4] But there's never been but one critic in the world, and even he was constantly wrong. Only Ruskin that was ever worth listening to, and he was far from always right. Even his criticisms often did a world of mischief – but as to these creatures, O God! I think it's much better to do as I do and never read them . . .

(*To Phil*): Watts has written a most amazing preface to his catalogue – H[allé] brought it to me. It's so astonishingly bung-eyed. I don't suppose he means it, but it sounds almost as though he apologised for his pictures and when an artist takes to doing that, I do think he'd better not paint them[5] . . .

[1] Philip Wilson Steer (1860–1942) showed *Nude Seated on a Bed* (1896), now owned by Lord Ilford – an odalisque derived from Manet's *Olympia* (1863) and exhibited with the New English Art Club at the Dudley Gallery. The critic wrote that although some considered the N.E.A.C. custodian of the art of the future, and Steer its chief prophet, until he 'condescends to paint something rather more beautiful than *A Nude* (No. 68) many will prefer to remain outside the temple with the heathen'; see H. S., 'The Autumn Exhibitions', *The Spectator*, 77 (1896), 764.

[2] Byron to John Murray, 14 April 1817, from Venice: 'You must recollect however – that I know nothing of painting – & that I detest it – unless it reminds me of something I have seen or think it possible to see . . .'

[3] Poynter, presenting awards at the Royal Academy Schools on 10 December 1896, spoke of his friendships with Millais and Leighton, then defended Leighton against recent criticism; see 'Sir E. Poynter on Leighton and Millais', *The Times*, 11 December 1896, p. 10.

[4] Cf. above, p. 38.

[5] Preface (pp. 3–9) to the catalogue for his exhibition of 155 pictures at the New Gallery, January 1897. Watts wrote that his works must be regarded 'rather as hieroglyphs than anything else', that the purpose was 'frankly didactic, generally regarded as exasperating, . . .'

21 December 1896

E B-J (*Repainting Perseus with Athene*):[1] A young man called yesterday with his life studies to shew me. From the Westminster School where Brown was who's now at the Slade. They were the usual things that are brought to me now from drawing schools. The heads were bestial, horrid – the bellies were repulsive, the knees and the feet loathsome.

I: I suppose the Masters tell them to make the drawings exactly like the subject because a learner often hides bad work under attempts to make a thing look well.

E B-J: No doubt there's nothing more hopeless than empty prettiness, but if the drawings are like, why don't they get better models for these young chaps? These seem to be the ugliest they can pitch on. It's just the important time of a lad's life for receiving impressions of beauty. I asked him whether it didn't seem to him a very hideous thing, and he said it did – but

whether it was only to please me or not I couldn't tell. This boy seemed to take an especial delight in getting his horrid breasts enormous, heads enormous, feet enormous – and leaving all the rest to take care of itself and get in as well as it could. All which things are repulsive beyond degree. I wonder whether there isn't something half way between the slow stippling of the R. A. and this hurried sloppy way of making hideous things, done at such a rate as though it were in fear of their lives.

I: The antique drawing is given to produce a standard of good form and proportion.

E B-J: But it should come later. Rossetti used to say that if anyone could give the time it would be a good plan to draw for six years from life and a seventh from the antique, only no one thinks he can. But teaching's dreadful work, anyway.

I: I shouldn't like to have to teach drawing to boys at school.

E B-J: Especially now, when you can't knock boys about. A Master has a dreadful life with not being allowed to punch their heads and rap their knuckles and slap their bottoms. It's all over with Masters now-a-days.

[1] Study for *The Call of Perseus*, first in the series; see above, p. 96.

23 December 1896

E B-J (*Very dark. Standing before hot pipes*): What shall I do today? What on earth *can* I do? There's no seeing to do anything on a morning like this. I can't get anything more out than I have now, there isn't room for anything more, and what to do on any of these pictures I can't tell for my life. I must say Poynter is a happy man, he needn't paint any more. He can correspond just as well in this kind of weather as in any other. He can lift his eyebrows at complaints of the dark weather and say 'Oh as to that, it just seems to me that it's Winter, and what else is to be expected at this time of year?' He *is* a happy chap.

I: There's an engraving of a picture of his about everywhere just now, of a dance.

E B-J: I know, where the people are not dancing much – correctly, but not much. He first did a little one that was very

nice, but when he enlarged it to this one the design didn't bear it. Never looked as though it were meant for that scale. A most pretty thing the little one was – it was a panel in a piano that Tadema partly designed in a rather expensive manner. The whole piano cost about £8,000. It was done for a rich man in Liverpool named Marquand.[1] In that piano this little picture was the gem. A pretty dance with a pretty landscape background and trees and clipped hedges with rather dull ends, especially on the left hand side. I think it was a philosopher sitting down; something going on in other corners. Now a philosopher doesn't do in a picture, he's always such a bore. As Esculapius was in his other picture.[2] If Venus and the other little ladies were only just calling on him the little group would look so nice, just standing outside his house and knocking at his door: he's so dull. But Poynter's in a high state of [word omitted]. He needn't get anything done for exhibitions.

(*Unconscious exclamation of disgust from me.*)

E B-J: What is it?

I: I've left out all the fingers of a hand in my tracing.

E B-J: So you've to draw them in. My eye, there's an exercise for the mind – always so detrimental to an artist. (*About difficulty of teaching a moral by painting against vice: Watts.*) Dickens had the proper art – he could make a rich dinner party and shew how dull it all was. But that had no effect on the world; it only said it was exaggerated and untrue, though it wasn't a bit untrue. It wasn't exaggerated, it was painfully within the bounds of fact and what one sees every day. A dinner party at the Merdles is exactly like a Society Dinner.[3] Exactly!! They weren't exaggerated in the least. No, I think those things are best left to the Art that can do them best. The most powerful things that have been said against riches have been said by Ruskin, and all that ever he could do was to confirm those who already hated it. All that these things do is to confirm the faithful. He never was able to persuade the chap who liked to be rich or his wife who loved it beyond anything. He only made them read as much as they could get hold of on the opposite side. He makes us dislike a state of extreme riches all the more, doesn't he, and helps us to feel certain about it. And how could you depict the disgracefulness of Lust, so as to

make men stagger and pause before rushing into it. Some French pictures would be much more likely to do it – a picture such as I saw once, of a couple of lovers who had quarrelled and killed themselves. There was a beastly mess of a bed tousled and chairs knocked over and every sign of a row, done with great ability, so that it sticks in my memory to this day, though I wish it wouldn't.[4]

I: The materials for that wouldn't be hard to get together.

E B-J: No, he'd just have to go into his bedroom, pull his bed about and knock over some chairs, get a model, put her in a heap on the bed, and find a horrid man, a drunken wretch probably a friend of his, get him to lie with his back against the wall with his boots toward you, and the morning light breaking in on the room, and there he'd have it all ready. But for the sake of this very doubtful gain a man gives up his proper métier of creating beauty which ———— can do in a way that no one else can, at a time when there are very few other men even trying.

I: ———— told me he was reading the Morte d'Arthur in Tennyson, ought I to tell him to go to Malory for it?

E B-J: No, I wouldn't. It's always a pity to dry nurse anyone too much. It brings no great good about and only discourages him about his own way of coming at things.

I: He asked me about armour too.

E B-J: Armour is not what you can learn all about at once. It takes a very long time to find out about it. My own armour in early days was of a very inefficient kind.

I: I like it very much.

E B-J: I saw what was glorious in it, but didn't know the why and wherefore of it. Then I slowly learned about it, till now I can design it pretty well as I like. Whereas Morris seemed to be born knowing it completely. He seemed to be born knowing most things. I can't in the least tell how it was. One thing makes the hunting of it up so difficult – there's hardly any of the fine time [of armour-making] to be found; it used all to get beaten up and altered as the fashion of it changed. The best chance is of sometimes finding a boy's suit, because it's too small to be worth altering. Most lads had to wear their father's clothes, because when the armour was

altered the changes made it smaller and it had to be made up to a smaller size. In that picture of Paolo Ucello's there's the little chap riding into battle dressed just like his father only that he's holding his helmet in his hand. He's a dear little boy. He's carrying his helmet because it was so heavy he couldn't bear it on his head any longer, and his father said 'Oh well, take it off and carry it in your hand until the last moment, then clap it on and run into the thickest of it.'[5]

[1] Poynter, *Horae Serenae*, an oil shown at the Royal Academy in 1894, in the *Illustrated London News*, 109 (1896), 633. Present owner unknown. The 'little one': earlier version for the keyboard panel of the Steinway piano shipped to England in 1884 to be decorated as part of an extremely elaborate suite of furniture designed by Alma-Tadema for the music room in the New York mansion of Henry Gurdon Marquand (1819–1902), banker and real estate entrepreneur, President in the 1890s of the Metropolitan Museum. The piano, decorated by Johnson, Norman, and Co. of New Bond Street, is indeed a gorgeous concoction. Its ebony case is enriched by marquetry and inlays of cedar, box, ivory, mother-of-pearl, coral, rubies, and pearls. Alma-Tadema himself painted the lid, whose underside is decorated with a parchment that still bears the autographs of distinguished musicians who have played the instrument. At the Marquand Sale in 1903, the piano sold for only $260. That purchaser is unknown, but in the 1920s it was bought by the New York theatre impresario, Martin Beck, and at some point it migrated from his home to the mezzanine of the Martin Beck Theatre, where it became a resting place for orange-drink glasses. After refurbishment, it was described by *The New Yorker* (20 June 1977, pp. 26–28) as 'Broadway's biggest secret'. In 1980 it was sold at auction for $390,000, to a New York investment banker. Marquand was not a Liverpool man, but B-J is not far wrong about the cost, which then equalled about $40,000. On B-J's own influence on the Victorian piano-decorating vogue, see Michael I. Wilson, 'Burne-Jones and Piano Reform', *Apollo*, 102 (1975), 342–47.
[2] Poynter, *A Visit to Aesculapius* (1880), in the Tate Gallery.
[3] Dickens, *Little Dorrit*, Book I, Chapter 21: 'Society had everything it could want, and could not want, for dinner'; but Mr Merdle was 'mostly to be found against walls and behind doors'.
[4] Unidentified.
[5] Paolo Ucello, *The Battle of San Romano* (1460?).

The Conversations

2 January 1897

E B-J: Went to see Watts' pictures yesterday afternoon. Many things that bother me there. Every one of us must have his proportion of success and failure no doubt, but why don't one's friends prevent one from exhibiting disasters. They don't like to I dare say. Perhaps mine look on my *Love and the Pilgrim* in that light – only won't say so. I wish they would if they do. Most of the North Room is full of great weary things; there are 3 whacking Eves which I can't abide, and a huge desolate *Court of Death* begun a long time ago in that dreadful time when design in a picture was a thing unknown.[1] But he does men better than women. The shoulders and all the torso he does splendidly, knows all about it, and that seems to be all he cares for – the heads are never very good. The hands not made nearly as interesting as they might be, and the legs seem always too hard and rigid, standing with a strong cutting light from the thigh. There's the most beautiful of all his pictures there – the *Dream of Endymion*, that used to belong to William Graham, and his almost living portraits.[2] The Walter Crane is a marvellous piece of painting[3] . . .

[1] The '3 whacking Eves' in the Watts exhibition at the New Gallery were the trilogy, *She Shall Be Called Woman* (c. 1875–92), *Eve Tempted* (first exhibited 1884), and *Eve Repentent* (c. 1865–67); all now in the Tate Gallery.

[2] *The Dream of Endymion* (1869/70–1903), in the Watts Gallery.

[3] *Walter Crane* (1891), in the National Portrait Gallery, London. Crane (1845–1915), designer and illustrator, was a stalwart ally of Morris in campaigns to revivify the decorative arts.

18 January 1897

E B-J: Young men at drawing and painting schools get so conceited. They're so appallingly Cockney. Why are they so set up with themselves? (Re *changes in painting*.) No doubt at the end of one's life there's nothing for it but to see the world going a new way that we can't make up our minds to. Fra Angelico must have been deeply grieved to see Ghirlandajo doing his subjects very much in his manner but without any of his piety, for intensely pious he was in all his work. I've been reading *Woodstock* again. Some very good things in it, some

not so good. Cromwell's rum, but I should like to make Carlyle for his sins write a discriminating essay on the Cromwell of Scott and the Cromwell of Dumas. Not that his sins are so very great, but I should like to set him to study the documents. There's one thing for which I should like to push Scott. It's rather a shame to say I should like to shove Scott – but when he says that a portrait hung on the wall in that hard, meagre style we are accustomed to see in the world of Holbein, what doesn't he deserve? . . .

20 January 1897

. . . E B-J (*Birds and foreground in* Love and Pilgrim): Once I knew an old clergyman who painted, who was for his time an impressionist. David Cox was his hero.[1] No paper that was ever made was coarse enough for him. What he liked best was the paper that's at the bottom of hat boxes – it being made half of pulp and half of chips. But even that wasn't coarse enough, so he bought himself a pair of hobnailed boots, and then he swilled and soaked the paper all night in water, and when he got up in the morning he put on his hobnailed boots that he kept only for that purpose, and stamped and squirmed about on the paper and then put it in the sun to dry, and then it was just as he liked it and ready to paint on. Imagine a rather handsome and reverend looking old gentleman in hobnailed boots and perhaps nothing else on but his nightshirt dancing on the bottom of a hat box in the early morning. Must have been very nice to see. But as you see by this anecdote he was a very sensitive old gentleman – had a keen sense of touch ...

[1] English water colour artist (1783–1859) who used rough slightly tinted paper.

22 January 1897

E B-J: Were Prout's drawings *like* the places they were supposed to represent? I never liked his mechanical crumbly touch.[1] It wasn't like the tremblingly sensitive touch that gives the very texture of the object, but it seemed to me all the same whether applied to wood, stone, slate, brick, tile, or anything else. He was one of the old picturesque lot – they were never

pleased with anything but ruins. I hate ruins . . .

[1] Samuel Prout (1783–1852), English water colour artist.

3 February 1897

. . . E B-J (*looking at his* Magician *panel*): I hope it won't get horny. I've always longed in my life to do a picture like a Van Eyck and I've *never never* done it, and never shall. As a young man I've stood before that picture of the man and his wife and made up my mind to try and do something as deep and rich in colour and as beautifully finished in painting, and I've gone away and never done it, and now the time's gone by[1] . . .

[1] Jan Van Eyck, *The Marriage of Giovanni Arnolfini and Giovanna Cenami* (1434), in the National Gallery, London.

9 February 1897

(*Drawing sandals and painting joined hands in* Love Leading the Pilgrim.)

. . . I (*talking of Cook, of* Westminster Gazette, *who was one of Mr Ruskin's roadmakers at Oxford.*)[1]

E B-J: With Oscar Wilde. Poor fellow, I wonder what's happening to him.

I: He'll soon be out of prison.[2]

E B-J: If he isn't already. I should shake hands or bow to him if I saw him. Very likely he'll keep out of everyone's way – go abroad, perhaps – but there's no telling what state of mind he may be in, or what he has been turned into by this time. He may be mad. It wouldn't be surprising. If those noble warriors that England's so proud of couldn't stand two months' confinement in Holloway Gaol as 1st class misdemeanants, what must have happened to a man of his highly cultured mind in such a horrible place as Wormwood Scrubs, subjected to all the rigours of a criminal sentence. It's terribly severe there. He wasn't told even when his mother died; his wife had to come over from Italy, where she is staying, and get permission to tell him.[3]

[1] Sir Edward Tyas Cook (1857–1919), editor, *Westminster Gazette*, 1893–96. With the barrister Alexander Wedderburn (1854–1931),

co-editor of Ruskin's *Works*.

² Wilde was released at Pentonville on 18 May 1897 and left for France.

³ Wilde's mother died on 3 February 1896. Constance Wilde came from Geneva to Reading Gaol – the last meeting with her husband; see Wilde, *Letters*, p. 399. Probably on 22 February 1896, she came to borrow £150 from B-J; see *ibid*., p. 718, note 1. B-J wrote to Helen Mary Gaskell (postmark 22 February 1896. B-J:BL): ' – When there was announced a lady by the name of Constance Holland, and lo! it was poor desolate heartbroken Constance Wilde. I was glad to see the poor waif, and so was Georgie. And she had a warm welcome – she had come across from near Bodighera to tell her husband of his mother's death – which had not been told him – the poor lady had died three weeks ago – and it took ten days to get leave to see him, and four days to come – but she saw him and told him of it. She says he is changed beyond recognition but they give him work to do in the garden and the work he likes best is to cover books with brown paper – for at least it is books to hold in his hand: but presently the keeper made a sign with his finger, and like a dog he obeyed, and left the room. It was all inexpressibly dreadful – I wish they could see their way to let him go – but I had not heard she had changed her name her shameful name, poor thing. The younger child has quite forgotten him already, after the fashion of children, but the elder asks often for him and has heard from some one (who? good heaven!) that his father is in prison – but thinks it is for debt – alack for such a history.' The 'noble warriors' were Dr Jameson and six associates, who, in Holloway Gaol after being sentenced in July 1896, enjoyed special privileges with respect to food, clothing, and contacts with the outside world.

<div align="right">13 February 1897</div>

. . . E B-J (*painting birds round Love's head in* Love Leading the Pilgrim. *Referring to 'poor old Mr Caswell that I used to know when I was little'*): He used to say he was sure I should be a great historical painter – the finest historical painter the world ever saw – but his notion of a great historical painting was the signing of Magna Charta or the Landing of the Prince of Orange, or the Queen opening her first Parliament, and then I went and did the *Merciful Knight*, and what could he make of that?

I: He knew enough about painting to get as far as those ideas?

E B-J: He knew enough about it to buy a little oil picture of Turner's – it was of Boulogne Harbour I think with a calm blue sea, and he knew enough about it to paint white waves over it and make it into a storm. It wanted 'breaking up' he said. But he was deeply incensed at my courses when I painted the *Merciful Knight*. We couldn't expect him to be otherwise, could we? I suppose he was really rather an unusual man for Birmingham in that day though.

I: Was he your first purchaser you once gave me news of the death of?

E B-J: No, he never bought anything of me, but he used to be exceedingly kind to me – to lend me his colour box and have me to spend long days with him. He used to keep my funny little drawings, and he wrote on the back of them in a clear hand, 'This remarkable drawing was made by ———— on ————,' and they weren't remarkable at all, for I was then about 7. Kind he was to me always, and so was his wife. Dear old things they were. But it couldn't be expected he should see things in the later lights. He got old too by the time I began to paint. He used to be in very great dread of Ruskin.

I: Really, did he though?

E B-J: Oh, he thought he was terrible. Ruskin was anathema to him. It was such a long time ago. To shew what a very long time ago it was, I remember a gentleman coming there one night and bringing the news of the massacre in the Khyber Pass [6 January 1842]. I was a very little chap and was terrified at the idea of all the men shut in by the rocks and being shot down and killed from above without being able to do anything. Oh such a long time back. Past ages!

Mr Caswell's heroes in the art of painting (he had doubts about Turner) were Poussin and Claude Lorraine, I remember, in those days. And he was 'the possessor of' – a Guido and a Hobbema and to dwell on them and talk about them was his delight in life. It made him so happy. So you may think how little cheered he'd be with Ruskin.

I: No doubt those who like those things like them for some nice qualities in them.

E B-J: Yes, but it's wonderful people don't see what bad sentiment they are used on. There's no keeping mankind up to that. They're always expressing extreme delight and getting excited over what has no spiritual merit in it whatever. So you may guess how long ago it all was.

I: I had a Tory model on Thursday.

E B-J: Had she been sitting to the nobility?

I: No, she hinted that she had come down in the world.

E B-J: Ah, that's fatiguing. We have to work so very hard to make it up to them, and be so deferential. We know them. Simple the nature of life is after all. It seems complicated at first, but it's really so simple. You remember Miss Chalk. She'd come down. It was very trying. She had to be treated with such extreme respect. Very fatiguing, you know, Rookie, most excessively fatiguing. She was related to the Earl of Huntingdon, you should be made aware. I asked her if it was through an alliance formed with Maid Marion. That seemed to bewilder her. She didn't quite know what to make of it . . .

16 February 1897. Lunch

. . . E B-J (*coming in from an interview, quarter of an hour late – first course over. In reply to Phil's remark*): Yes, I *am* tired. Women ought to be locked up. In some place where we could have access to them but that they couldn't get out from. Yes they should. It's no use your sitting there, Rookie, and looking as if you were sorry for them – because if you are you'll catch it. Not from me but from them. She shewed me a rather nice little picture of a woman that she'd done without any background, and I said 'What's behind her, you can't leave it all fuzz – and what's she standing on? Don't you know? You must think. Go home and think about it.' And then she turned rather red, and I said, 'Well, I didn't ask you to paint the picture, and now you've undertaken to do it you must finish it yourself. Let us say now, that it might be out in the country.' And she said, 'Well, it couldn't be out in the country because I painted the figure in a studio light.' And I said, 'Studio light – what do I care about studio light – I never saw studio light in nature. What is it she's standing on – is it earth or bricks or stones or

boards or carpet? She must be standing on something, mustn't she? Can't be standing upon nothing, can she?' It's all such tiresome rubbish. Women have suddenly waked up to the idea that they can do something, and they can't. That's how it is, my Phil.

19 February 1897

E B-J (*paints copper vessel and tripod in* Magician – *too dark for* Love Leading the Pilgrim): Meeting yesterday afternoon was of the usual tiresome kind, such waste of time and such silly quarrels – absolutely nothing done. Should be so glad to be out of it [the Royal Water Colour Society]. It's just the same at the Academy I've no doubt. But before going to it I went into the National Gallery and refreshed myself with a look at the pictures. One impression I had was how much more important the tone of them is than the actual tint of any part of them. I looked close into the separate colours and they were all very lovely in their quality, but the whole colour effect of a picture then is not great. In fact I should say that sense of colour is not the strong point of the men who did them. It's the entire result of the picture that's so wonderful. I pried into the whites to see how they were made (*as to his own white figure*) and it's astonishing how little white there would be in a white dress – none at all in fact – and yet it looks white. I went again and looked at the Van Eyck [the Arnolfini], and saw how clearly the like of it is not to be done by me. I should think it's the finest picture in the world. But he had many advantages. For one thing he had all his objects in front of him to paint from. A nice clean neat floor of fair boards well scoured, pretty little dogs and everything. Nothing to bother about but making good portraits – dresses and all else of exactly the right colour and shade of colour. But the tone of it is simply marvellous, and the beautiful colour each little object has, and the skill of it all. He permits himself extreme darkness though. It's all very well to say it's a purple dress – very dark brown is more the colour of it. And the black, no words can describe the blackness of it. But the like of it's not for me to do – can't be – not to be thought of. As I walked about there I thought if I had my life all over again what would I best like to do in the way of

136

making a new start once more. It would be to try and paint more like the Italian painters. And that's rather happy for a man to feel in his last days, to find that he's still true to his first impulse and doesn't think he has wasted his life in wrong directions. So much happier than —————, who began by putting himself under me, and then thought he'd go over to Paris and add a little of modern French ability to what he got from me – but it didn't do. He ended by being so puzzled about it that he finally didn't know what to do and did nothing. It's no use, you can't combine opposites. Poussin is only too clear a case of it. Did you hear of that pretty old saying that Dr Evans said was used by a drawing master at the Birmingham School – 'Make your work sing to you, Sir, make your work sing.' I didn't see a sign of it among the candidates' works – they were in the terriblest of modern manners, most of them. But in the National Collection it was song after song – the pictures all sang. Instead of that in the modern exhibition it's bellow upon bellow, scream upon scream . . .

18 March 1897

E B-J (*Briars in* Love Leading the Pilgrim): A surprising piece of luck happened to me yesterday.

I: The tone of the announcement is dubious.

E B-J: Well it *was* a piece of good fortune. The Directors of the New Gallery came here and accepted my picture for their next Exhibition. There might be worse news than that. The Directors, who were so kind as to say they would exhibit my picture, and with the sole stipulation that it should have a frame (they even promised to hang it on the line which is an unexpected favour) say they expect a rather shady Exhibition. Can't get any picture anywhere of any consequence. No one seems to have got any done. The dark winter has been against us. They made it an essential point that it should have a frame, and I don't think they were wrong. They were also urgent with me on another point, that I should not send it in on varnishing day, and as I want to get rid of it as soon as ever it is finished I pretended to be very generous and promised they should have it by the 12th of April. It's strange how little I worry about not selling it. It would make such a difference to

my whole year.[1] But I can't think of that side of things some-
how. It's very likely indeed not to get sold – and I know why –
there's no woman in it. That's the reason why no one will have
Lucifer. In *Tit Bits* they've been publishing things about the
income of artists. They say Prinsep is the richest artist but that
his wealth comes from his wife, which is quite true. And then
they come on to Sir E. B-J. and they say his income is £15,000 a
year. I know how they come at it. From that mis-statement
that I had £15,000 for the *Briar Rose*. The worst of it is that after
anything like that is published, I'm inundated with begging
letters. The clergy write to me in shoals to ask me to build their
churches and vicarages and make them comfortable. The
clergy I said, Little Rooke, yes, the clergy.

Did I tell you that *Hope* has got safely to America? For a long
time I didn't know a word about it, and thought that as it had
been bought without having been seen by the purchasers they
were disappointed with it, and I was going to write to ask
them to send it back. But they're very pleased with it – and if
I'm very careful we can live a whole summer on the price of it
in case I don't sell this. They'll send the cheque soon. But they
say they've hung it up without a glass, to see it better, because
of reflections in it. They could manage that by sloping it or in
some way. I like a picture so much better under glass; it's like a
kind of aetherial varnish. It's wonderful to me how people
don't see that a picture under glass is so much more beautiful
than without it – they're so insensitive. But they must do as
they like with it. They can hang it upside down if they will.

I: Would you like to have someone with red hair to sit to
you?

E B-J: Well, I don't often paint red haired women some-
how. I like gold-coloured and oat-coloured hair. Rossetti used
to persuade me to paint from red-haired women and I did
some without anything particular happening. It doesn't quite
go with my kind of sentiment. There are two kinds of women
I like; the very good, the goldenhaired, and the exceedingly
mischievous, the sirens with oat-coloured hair. Perfect imps
they are. Not that I've any theory about it. When I see red hair I
like it. Rossetti's pictures of redhaired women I like exceed-
ingly but I don't think red hair does well with my own work.

¹ Charles Hallé and Comyns Carr were making their rounds of the
studios; see *Memorials*, II, 301. The Duchess of Sutherland bought
Love Leading the Pilgrim; in 1942 the Tate Gallery bought it 'for as
little as £94', but in 1973 a tapestry version sold for over forty-
seven times that, and the four pictures of *The Four Seasons*
(1869–71), originally created for Frederick Leyland's dining room,
which sold for £65 as late as 1965, brought $37,800 in 1973; see
John Christian, 'The Literature of Art', *The Burlington Magazine*,
117 (1975), 395–96. *The Four Seasons*, offered for sale in London in
1979, were purchased at an undisclosed price by a consortium of
British businessmen eager to keep the works in England.

3 April 1897

E B-J (*Last touches on* Love Leading the Pilgrim): Last night
we were at Holman Hunt's. He looked such a dear fine old
thing.

I: He must be rather old now.

E B-J: He's about 6 years older than I am. He's about 70.

I: Then perhaps it doesn't matter to him if he does no more
important work. Everyone can't be like Mr Watts and do a
Walter Crane portrait at 75.¹

E B-J: But Watts doesn't like to have that portrait praised.
He likes to think of his vast powers of mind. Of his powerful
intellect. He can't be pacified with anything else, so we're
obliged to mention it. I wonder he's not satisfied with being a
great painter, don't you? But he doesn't count it. He's not
content with any painting that he does. There's but one thing
that contents him. He wants to be known as the painter who
thought, not as the painter who painted.

And, would you think, Hunt took in my Missis to dinner as
his oldest friend. Only think – as his oldest friend – listen to
that. Little Georgie his oldest friend! We've got on so far in life.
I didn't know we had got on nearly so far. Isn't it tremendous?

I: But not altogether displeasing.

E B-J: No, it's got its pleasures. Arthur Hughes was there
too, and he reminded me of our first meeting which I'd forgot-
ten. It was when I brought him Mr Morris' cheque for his
April Love that Morris bought.²

I: Did he always have it afterwards?

E B-J: No, he sold it afterwards, when a time came that it no

longer fitted with his mind and his work. We all of us wished that the dear thing had never sold anything that he ever had or liked, but it was at a period when he was greatly distressed for want of money. So unworldly and strange Holman Hunt did look. Such a queer far off oaten colour he was all over him – his face, his flesh and his hair and everything . . .

<hr>

[1] On Watts's portrait of Walter Crane, see above, p. 130, note 3.

[2] Arthur Hughes (1832–1915), painter and illustrator, although never a member of the Pre-Raphaelite Brotherhood, was in their circle and one of the painters of the Oxford Union murals in 1857. His *April Love* (1856) was purchased by the Tate Gallery in 1909.

7 April 1897 . . . Lunch

E B-J (*of rejection of a candidate for a public office*): No use thinking a single thought about it. Only just exactly what was to be expected and the trouble he was taking was really quite out of proportion to what good he could do there. The wonder is we ever had any doubt about it. A crowd is always like that. It's been so from all time and will be. It always says not this man but Barabbas.

MISTRESS: If I thought things never would be any better than that I would throw up the sponge all round.

E B-J: You might as well commit suicide the moment you begin to think. I wouldn't say things would never be better, but there's no ground in the world's history for hurried hope.

MISTRESS: I wouldn't care so long as there was hope, even after a million years.

E B-J: Ah now we're coming to what I call practical politics – a million years is much more possible. For my part I'd keep out of it altogether, or if I fought I'd fight to win. If I were to be in the scrimmage I'd go on very different lines to what I would out of it. I'd stick at nothing.

13 April 1897

E B-J (Pilgrim *fetched away by New Gallery. Shewing me Joseph Southall's picture*): Very good, isn't it? I feel that Rossetti would have been so pleased to see it. It's all so tender and careful, as though he loved it – and what's such a good sign is

that the design and intention is in advance of the acquirement that will come afterwards.[1]

I: Is it in water colour?

E B-J: No, it's in tempera. He's found it hard to manage in the flesh. That's why I suppose the old Italian painters gave it up – they found it so much easier to round up the limbs and heads in oil painting. But I wish they hadn't. I wish they'd hammered away and worried at it till it came right. It would have in time . . .

[1] This picture is unidentified. Like Morris, the Yorkshire designer and painter Joseph Edward Southall (1861–1944) began as an architect. Much influenced by Ruskin, he discovered tempera painting in Italy in 1883 and devoted himself thereafter to revival of what he called 'true fresco', through the Society of Painters in Tempera, centred in Birmingham.

16 April 1897

E B-J (*finishing tall St George*):[1] I'm always having young chaps on my mind now. There's a friend's son who will inherit property who likes drawing and doesn't take to what's called learning, and I have suggested his going into an architect's office. I think it would be so good for him. The regular discipline of going to work every day would prevent his getting into habits of loafing about. You can't tell whether a lad works at painting or not. You can see after 6 or 12 months whether he's getting on, but you can't see whether he keeps steadily to work. You have to trust to an artist's honour. But the regular hours at an architect's office would do him good. That's what Mr Morris did, he articled himself to Street – paid £5, I think, for permission to go there for 5 to 7 years – I don't know exactly, though after two years he gave it up.

I: Did he regret that he had to change?

E B-J: Not in the least. Besides, he was never one to cry over spilt milk. But he (*the boy in question at the minute*) doesn't seem to like it (*the idea of architect's office*) and has certainly shewn talent at painting. He has been doing seas and skies that look pellucid and clear. I don't know what to say about his having lessons – it's so very easy, as you know, to be untaught what one has been naturally gifted with. I never had any lessons. His

mother of course was very polite and said Oh, that was very different – I was a man of genius, and of course I said oh, no. The lad is certainly not a genius either. But the only lesson I ever had was that Rossetti let me go several days and let me watch him paint a picture, and he began by drawing the design roughly in pencil and then went over it clearly and rather sharply in a colour called violet carmine. But I never saw him do any picture all the way through. Neither did I ever find I could do mine in the same way. The next time I came to him by appointment it would be 3 or 4 days afterwards perhaps, and what I had seen begun in that way would be nearly done, and I never saw how he had got it out of the hard stage and made it all soft and delicious. But I didn't know till long afterwards how he hated to be watched, nor how exceedingly generous and kind of him it consequently was to let me come and overlook him.

I: Dickens felt the difficulty of getting a rich clever young man to take to work.

E B-J: Didn't he know!

I: How exactly he describes the bad painter in *Little Dorrit*.

E B-J: Young Gowan? His hasty, impatient touches.

I: Surprising how he knew – a painter couldn't better describe it.

E B-J: He guessed at most things. Very few things he didn't get to the bottom of.

[1] A re-working of a stained-glass design; painted in 1896, purchased by the Duke of Hesse for his famous Art Nouveau Room.

21 April 1897. Afternoon

E B-J (*gold drawing*):[1] Have you read anything of Maeterlinck's?[2] People say his work is like mine, and I wonder what it is makes them say so. I like it very much; it's such beautiful poetry.

I: I suppose it's well known since there was a small piece of his in a Christmas annual.

E B-J: Oh, he's as well known as anyone – he's read all over Europe. The English call him morbid, but then we know what they mean by that. Everything that isn't roast beef they call morbid.

I: Perhaps if I were to read that piece again, though it was only a translation, I might see more in it.

E B-J: Oh no, I shouldn't do that – it's always a mistake to force a taste. One has an immediate instinct for what one really likes. But a translation is never any good. His French is curiously easy for me to read – I wonder if it is because of its being not very good French.

[1] Rooke writes 'figure', but the drawing is a girl's head in gouache and gold paint on purple paper (1897), now in the Fulham Public Library, London: see H/W, Plate 45.

[2] Maurice Maeterlinck (1862-1949), Belgian Symbolist playwright and poet, had a considerable vogue among the London avant-garde in the 1890s. B-J's medieval subjects perfectly complemented Maeterlinck's themes; Philippe Jullien writes that Maeterlinck's *Pelleas et Melisande* (1893) 'ought to have been produced with settings by Burne-Jones' (*Dreamers of Decadence: Symbolist Painters of the 1890's*, p. 63).

22 April 1897

. . . E B-J (*painting figure in gold on tinted paper*): I've smudged this thing. This gold work must be done very directly – it's an art of itself. I forget how I do it between one time and another, and it's always an experiment.

I: Mr Watts is very fond of experiments.

E B-J: Yes, he does amuse himself. At one time he used to paint with colours ground up in turpentine – and moistened with benzine. I wonder what became of those pictures, they can't last. A favourite idea he had at one time was to paint with the end of a piece of cork. He used it to put little dots of colour on the canvas. Why he couldn't have done that with a brush, which seems to me the thing of all others to do it with, I don't know. But he wouldn't be deprived of his cork, he loved it.

I: Hardly painting, was it?

E B-J: Well, you see, he is a sensitive artist, and like all sensitive artists he has an extreme dislike to the fat oily greasy smeariness of oil paints, and tries all sorts of ways to get rid of it. . .

The Conversations

30 April 1897

(starting again on Venus Concordia *in its frame.)*

... I: Something on the way home last night made me consider, after the success of the first Christian community and the Quakers, that nothing like it was tried in our time, and that the Socialists hadn't tried for something more like them.

E B-J: The Salvation Army is trying to do it, and they might win yet, those chaps – I rather wish they would. They might pull through, there's no knowing. They begin at the right end. They begin with enthusiasm and they begin at the poorest. The very name I like; it's a good one. It may all tail off into nothing, there's no telling. One thing they did I didn't like; they put outside their meeting house in Hammersmith in big letters 'Blood and Fire' – what did they mean, whose blood and what fire I should like to know. But you can get anything out of mankind by appealing to its sense of beauty and its enthusiasm – but in people's sense of right I have not the least belief. The Socialists will never do anything with it.

4 May 1897

E B-J (*working on* Venus Concordia): I had a model yesterday to try and make some drapery studies for that cartoon of the Nativity, but found that I'd quite lost the art of drawing drapery. Nothing at all could I do. It didn't go at all. Isn't it a shame?

I've started a new book to read and don't like to drop it having begun it, and yet I don't like going on with it.

I: Good morals?

E B-J: Couldn't be better, I know, and yet! And yet! And yet, and yet and yet and yet!! And yet and yet and yet!!! It's the life of Jowett. (*On my telling him, after an interruption, Harry's difficulties in Thackeray's* Virginians.) He's a great moralist. Would you believe me, there's not a single reference to Dickens or Thackeray in the whole life of Jowett. Nothing but dismal theology all the way through. Not that theology ought to be dismal, ought not to be the main subject of life – but there's so much of the inhuman side of it.[1]

I: Dean Stanley had a great deal to do with Dickens and Thackeray, though he's not much remembered now.[2]

144

E B-J: It's astonishing how little these chaps are remembered. He was very popular, he was a clever man and came at a very lucky time for himself. When people were beginning to weary of the vehement ardour of Newman. He brought a gentle kind of liberalism into religious questions that was very welcome to them. Though he and those who had similar views were liable to be asked why then did they stay in the Church. Carlyle said they ought to be shot as sentinels handing over their posts to the enemy. But there was something to be said on the other side too. They wanted to keep up the Church. Its downfall would be the signal of much mischief and they saw no good in handing it over to those who they thought would bring it to ruin by intolerance. Strange how a reputation like his becomes forgotten. Painters are luckier, they're remembered much longer. Dean Stanley was a clever man of course, though not anything like such a fine creature as Newman. No one makes a mark on his own time even without very considerable ability. He won his fame by his books, such as his *Syria and Palestine* – but the only poetical prose that is of any permanent value is Ruskin's.

[1] Evelyn Abbott and Lewis Campbell, *The Life and Letters of Benjamin Jowett, M.A., Master of Balliol College, Oxford* (1892). The authors, not Jowett, may have omitted Dickens. Swinburne recalled asking Jowett to name the first among living English writers: 'He hesitated for a moment or so, and then replied, "If Dickens were alive I shouldn't hesitate" ' (quoted by Geoffrey Faber in *Jowett: A Portrait with Background*, p. 368).

[2] Arthur Penrhyn Stanley (1815-81), Regius Professor of History, Oxford, 1856-63, and Dean of Westminster from 1863. He met Dickens only in the year of his death, 1870; of three meetings only one was private. It was at Stanley's instance that Dickens was buried in the Abbey.

25 May 1897. Garden studio

E B-J (*painting Morgan le Fay's white dress, who supports Arthur's head in* Avalon): How I did dislike being at Malvern.[1] I always dislike living in hotels – and the lives that people lead in them are so different to anything I can imagine. What do they do, what do they care about – what do they occupy themselves

with? After being there a few days I began to wonder if there were such an art as painting or whether it was a mistake of mine to suppose it ever existed. How can they be happy without painting – I don't know, or live without it or be happy. The two lives can't be both right, and which is the wrong one? But we are never happy. We can't enjoy any beautiful thing we see for wanting to paint it, and when we have time to paint it what miseries we get into. . .

[1] Georgie, worried about Ned's health, dragged him away from the studio for an alleged holiday.

26 May 1897

E B-J (*painting pink seated harper and green dulcimer player in front in* Avalon): Did you see in what a state of danger from fire South Kensington Museum is?

I: I like it so much more than the British Museum.

E B-J: So do I. But there are always the painted books there, any one of which if all the other art of the world were destroyed would, properly used, suffice to revive it.

I: No one seems to be able to use them as you have.

E B-J: No, they're not understood. There are two arts which others don't care for that Mr Morris and I have found our greatest delight in – painted books and beautiful taestry.

27 May 1897

. . .E B-J (*red dulcimer player and Fay with Arthur's feet in* Avalon): Do you hear that 30 millions is to be spent over the Jubilee and none of that comes to us? No wonder we can't sell any pictures.

I: We ought to have turned Jubilee artists.

E B-J: Walter Crane has lost a splendid opportunity. It's terribly didactic, that idea of his of improving mankind by his pictures. It's preaching, invading the province of the parson. Poor parson, what's he to do with his province invaded! . . .

29 May 1897

E B-J (*rest of shrine roof in* Avalon): A pity it is I was not born in the middle ages.

I: It would have suited you exactly.

E B-J: People then would have known how to use me – now they don't know what on earth to do with me. 'The time is out of joint: O cursed spite, that ever I was born to set it right.' Rossetti couldn't set it right, and Morris couldn't set it right, and who the devil am I? Who the devil am I, Rookie?

Swinburne saying 'When three men hold together the kingdoms are less by three' was splendid – but to say 'When one man holds himself together in a very shakey way, the kingdoms are less by one' doesn't sound so well, does it?[1] Well, what does that matter, even then? I've learned to know Beauty when I see it, and that's the best thing.

I: And to shew it to us.

[1] Swinburne, 'A Song in Time of Order' (1852), his undergraduate attack upon Napoleon III: 'While three men stand together,/The kingdoms are less by three.'

2 June 1897

E B-J (*painting shield in* Avalon): I wonder what Rossetti would have said to this. I have never done anything without saying that to myself. Over every bit of work that's been always my thought. Always wondered whether he'd approve it and be pleased with it or whether he'd say it was rubbish. Lucky thing it is for Morris that he has Mackail to write his life – he will do it so well.

I: Couldn't he do one of Rossetti with your help?

E B-J: I don't know enough of it; it can't be done at this date, it's too late. . .

8 June 1897

E B-J (*walking down the garden*): I'm not in good spirits about *Avalon* – it looks as though it might turn out no more than a piece of decoration with no meaning in it at all, and what's the good of that. I shall have to pull myself together over it and go at it with more fury. (*Painting Fairy with white horn in palace and white harper-draperies.*) The shield's begun to have the swagger taken out of it now – but I begin to feel as though it would never all get done, or that if it does, it won't be worth anything when it does.

I told you about Mr De Morgan's joke of a fruitful crop of hot water. He came on Sunday – and where do you think he got it from? *Mrs Lirriper's Lodgings* that we ought to read again – and he repeated another fine thing out of it.[1] When she tells of her lodger getting better she says that in three days he was another man, and in a week after he was himself again. They don't do it after that manner now-a-days, do they?

Legros fetched me on Saturday to see a thing he's done for the Bank of England for Jubilee Day – it's wonderfully done. It seems such a shame that it's all to be knocked to pieces after all's over. He's painted and gilded it so as to give it an extraordinary look of relief. Of course it's only about Britain and all that, but the technique of it's so wonderful. Of course it's only 'Britannia and Law and Prosperity', and they can't be otherwise than Britannia and Law and Prosperity – but they are so astonishingly projected.[2] And the babies, though they're not like M. Angelo's and Mantegna's babies, and too much rolls of fat instead of articulate limbs, are better than Rubens. Damn Rubens! Or, in the words of Rossetti as they occur in his copy of Mrs Jameson's *Sacred and Legendary Art* wherever the name of Rubens turns up – 'Spit here'. It was one of the things that I saw in my early days with Rossetti – when I took up the book that was lying about in his painting room. And there were the words written in little pencil notes all through the book after the name of Rubens.

[1] Long monologue in Dickens' best sentimental style, by Mrs Emma Lirriper, Islington landlady: 'And then what the gentlemen like in girls the ladies don't, which is fruitful hot water for all parties, . . .' (*Christmas Stories*, Gadshill Edition, II, 3-42).

[2] Alphonse Legros (1837-1911), French realist painter in the Courbet tradition; settled in London in 1863 at Whistler's suggestion; followed Poynter as Slade Professor of Fine Art at University College. University of London, 1876-92.

12 June 1897

E B-J (*painting grass and King Arthur's gold covering in Avalon*): I went to see a lady's pictures yesterday. They were wonderfully painted and only extreme talent could have enabled her even to put them together as they are. They're a

kind of eclectic mixture of Mr Watts and me and old Floren-
tine work. They look like some undiscovered bad 15th-
century painting of Florence, if such a thing was possible. The
colours of some of them are extremely beautiful if you look
close in at them, yet at a distance the whole has no beauty of
colour at all. The faces are so pretty with such nice expressions,
but the figures are so badly drawn. Then there's that tiresome
thing about them that's always happening to the inexperi-
enced, that a little way off you can't make out the shape of
anything – it's all a hopeless confusion, though close to it's all
elaborately drawn and finished.

I: The question of originality to an artist is almost as cruel as
the one of a divine call to Evangelistic religion.

E B-J: There's always salvation for the humble minded,
none for the ambitious. If this girl had left figure painting alone
and had gone about the world modestly and happily doing
pretty views, cities, flowers, and every beautiful thing she
came across in nature, with a cheerful mind, and if she'd
rigidly left all figures out, she would have done admirable and
useful work that would have been a pleasure to everybody.
But these pictures are only a bore and an anomaly – nobody
wants them or knows what to do with them.

I: That's a serious lesson to us all.

E B-J: Unto him who shall consent to be admonished. A
very essential qualification which the wise narrator of the
Arabian Nights puts in. Hardly anything is a lesson to anyone.
Like many more this one is not content with anything less than
the highest thing, so she has to help herself all round from
everyone within reach. And yet that's no good to her. But the
beautiful way in which she has covered great spaces of ground
with forget-me-nots and all sorts of flowers that a little way
off look only like patches of bad effectless colour, is wonderful
and distressing. It's almost beyond belief how she has man-
aged to get so much highly elaborated work done, if one didn't
know how if you stick steadily to work things swim along.
There's a fig tree in one picture, with every leaf perfectly
drawn and shaded, and of a most beautiful colour, and yet at a
little way off the whole tree is not of a good colour – it's too
green to be good colour, and the tree is not like a fig tree yet it

149

is a fig tree, for there are the fig leaves. And that style of work must lead to reaction, to impressionism inevitably. So on the whole I had a hard time of it to know what to say to her.

I: You couldn't tell her all this?

E B-J: Oh, quite impossible, and quite useless. She must go on. Some things I couldn't let pass though. There was one knock-kneed impotent creature that I would have out. He was a knight with a lady in an Allegory; they were nearly all allegories. Life and Aspiration I think it was called – such a wretched ———— he was, a regular ————. They were coming out of a cave and meeting reason – you know those circles with ladies in them that she's seen done over and over again. But what could I say to it all – what could I? But the kind of painting I should like would be what would look lovely under a magnifying glass and yet cover an acre in extent and be quite right on that scale too – and that's what I never do – do I?

I: Is it even possible?

E B-J: The other day I saw a most lovely piece of colour of Rossetti's – like a jewel it was for strength and beauty which yet when I went up to it was hardly what I should call nice painting; it was so rough and unfinished, careless looking. But it was only a piece of decoration on the panel of a piece of furniture.

18 June 1897

(Painting heads of Morgan le Fay and purple Harper in Avalon).

. . . I: I pleased the people of Chiswick yesterday.

E B-J: By painting their city?[1]

I: Yes. One man said to another, 'Now Jack, if you could do the likes o' that you wouldn't need to do no more plastering.'

E B-J: And that is quite true.

I: And the other one answered, 'My 'and ain't steady enough and I'm too thick in the head, so I'm done for always.'

E B-J: Poor fellow! Quite done for, was he? But there's one way in which he'll have the better of us – he'll have a high place in heaven for humble-mindedness when we shall come off very badly. We artists are not going to have it all our own way, I can tell you. We've persuaded people that it's to their advantage that we should play with paints and mix blue and red, and

we've got a fine time of it just now – but that's not the end of it. So he was no good, was he? I'm so sorry for him.

¹ Unidentified, and whereabouts unknown.

22 June 1897. In afternoon of Jubilee procession
E B-J (*re-designing drapery of Fairy supporting Arthur's feet, and Sea*):¹ It was all surprisingly successful – but all the boasting of the papers is so dreadful; it makes one wonder that a thunder-bolt doesn't fall upon London. They're so silly as not to know that the gods do not love [R-MS and R-TS: space here].

I: *What?*

E B-J: The pride of cockiness. And all this enthusiasm spent over one little unimportant old lady in the one effort of imagi-nation of the English race. It's curious, but rather pretty. There was one set of men near where we were, that won great favour. It was a regiment that kept the ground in front of Downing Street – the Seaforth Highlanders. They were in the highest good humour with everybody, and the pipers puffed away and kept walking backwards and forwards swelling with such pride and excitement that their naked calves seemed to turn upwards – making such a beastly row that I loathe and detest above all others – till I nearly went mad – for as you know the noise of Scotch bagpipes is the one sound I can't bear. Such savage, barbarous people they looked. Excellent people no doubt and in the best of tempers they were, but in that dress with tight plaid trousers and huge headdress of ostrich feathers they looked like South Sea Islanders altogether. There was an old boy on horseback who kept riding up and down and screaming at them and you could see his ridiculous bottom as he sat on his saddle. And he had brass-coloured eyebrows and moustaches and a pink face. Literally brass-coloured his hair was. He was a sight! It is said she (the poor old Queen) was very pleased with it all and wanted to go and see the illuminations, but Radford wouldn't let her.

I: Fancy the Queen of London to be under the command of her head policeman!

E B-J: Oh, he wouldn't hear of it – wasn't it rather a shame.

There was a great German in the procession with an eagle on his helmet.

I: A white one?

E B-J: No, it was a metal one and I instantly hated him. He was a louring looking devil. He was such an overbearing huge ironmade wretch that the few moments' sight of him put me in a fury. (*Organ in the street.*) Ah, that feels as though life were beginning to take its old place, the organs beginning again in the street; now we can go to work quietly once more – once in a lifetime's enough for a Jubilee.

I'm going on slowly with the Nelson life.[2] The poor writer is very much bothered about Lady Hamilton; and in a way it is a pity. It's a blot on an otherwise stainless history. But people have long been curiously wrong about such matters – for centuries past (perhaps however that's too much to say) in this country at least. On the Continent they've always been well understood. I think that some day the world will have to set itself right about these matters. I mean there will have to be a separation of things that a man does because of a woman from other faults he may have. Of course he was in love, poor chap, and what else is to be said. And it isn't fair to dwell – as the writer does – on the faults and shortcomings of the lady – what's that to do with it if he didn't see them? . . .

[1] Again, from the discarded version of *Avalon*; see above, p. 38, note 1.

[2] Captain A.T. Mahan, *The Life of Nelson, The Embodiment of the Sea Power of Great Britain*. The Captain, an American who here combined snobbery, prudery, and authorial bias, was also much bothered by Lady Hamilton's humble antecedents; see p. 373.

24 June 1897. Lunch

. . . E B-J: You see we have the French flag at the door besides ours. If I were Heaven, which I'm not, I'd certainly drop down on the English pretty smartly just now. It would do them good, it would be blest to them. But there's an arrogance that's even worse than theirs. When you put it to them they do see the comic side of it and will own to it with a good humoured smile – but for downright insufferable arro-

gance and tyranny there's nothing like the Germans, and who's going to take it out of them I don't know. I should like to have a try, but the English and Germans couldn't get at each other even if they wanted. They've got no fleet, and if we were to go over there we should simply be eaten up in no time. But I'm afraid now nations don't get punished for their pride. I used to believe they did, because the Bible said so, but now I don't. I'm afraid the only thing they get punished for is for not keeping themselves strong.

26 June 1897

E B-J (*painting curtain etc. at Arthur's feet in* Avalon): I've bought a picture.

I: I saw it in the hall.

E B-J: By a painter named Deverell – a poor handsome young fellow who died very young. Rossetti made a very handsome drawing of him. He occurs in several Preraphaelite pictures and I think he's in that Isabella picture of Millais's with the man kicking the dog. A fine looking brown-headed youth he was. He died of consumption. I never saw him. He only painted two pictures and this is one of them. I heard of its having gone at a sale for only £5 and would have tried to run it up if I had known of it. So Phil wrote to the purchaser to ask if he'd sell it, and he's let me have it at what he gave for it. Deverell died at the rooms Mr Morris and I afterwards lived in, at No. 17 Red Lion Square.[1]

I: Did you go to them because Rossetti had lived in them?

E B-J: Well, it was because he was sorry to see us living in expensive and inconvenient furnished lodgings when we first came to London not knowing how to help ourselves, and he told us what he'd done when he began and advised us to go and see if the rooms he'd had were to be let. He and Deverell lived and painted there together till Deverell got so ill he had to go to bed in the back room while Rossetti painted on in the front – and a kind doctor used to come to see him – a sort of Goodenough he must have been – for one day as he passed out of the back room he put his hands on Rossetti's head as he sat painting, and said 'Poor boys! Poor boys!' The front window was cut up to give a higher light, which was much in those

days when the luxurious studio didn't exist.

I'm distinctly working at this picture under the discouragement of popular opinion. None of the ladies that come to see my things will look at it. They like the *Nativity* and the *Car of Love* very much – but this they won't take the least notice of.[2]

I: And that's puzzling after the excitement people have shewn about your work.

E B-J: Yes, they've got me into the way of expecting their approval and when they don't give it I can't help wondering if there isn't something wrong. I wonder where it is. For one thing they always like drama more than beauty. When there's something going on in a picture they can make it out – but when all is the beauty of repose they feel it is dull.

I: Except it is a single head or figure.

E B-J: Ah yes, they understand penny pictures.

[1] Walter Howell Deverell (1827-54), who met Rossetti in 1845 and became an assistant master at the Government School of Design, died probably of Bright's Disease. 'Goodenough': the kind doctor in Thackeray's *Pendennis* (II, Chapter 13). On Rossetti's drawing of Deverell, now owned by Lady Mander, see Surtees 314, 315. Millais' *Lorenzo and Isabella* (1849) is in the Walker Art Gallery, Liverpool. B-J had bought Deverell's oil, *The Pet,* or *Lady Feeding a Bird* (1852-53) for £6.00 at the Leathart Sale in 1896; the Tate Gallery bought it in 1911.

[2] The *Nativity* (1898), B-J's last glass design, was for windows in St David's Church, Hawarden, the Gladstone children's gift in honour of their parents. See *Memorials*, II, 317; Sewter, pp. 91-92.

29 June 1897

E B-J (*3 Amazons in* Avalon): I did not even see the Queen yesterday afternoon; I wanted to be back to *Avalon* all the time. I was obliged to go – it is esteemed a great rudeness to refuse a royal invitation and I don't want ever to be peculiar – I want to keep as quiet and unobserved as possible.

I: Except in art.

E B-J: Yes, one eccentricity is enough for any life.

I: Did you see Maclise's frescoes in the summer house you once told me about?

E B-J: Ah, I forgot all about that. They were about Arthur, I think. I used to like his things when I was little – he had a sense of line that pleased me and didn't draw badly, though we won't say much about his painting. I don't think any life of him was ever published.[1] He was famous once, but his glory was eclipsed by that of Herbert who was a tiresome eclectic made up of all styles absorbed into his. His design is in the grand Historical Manner, with a real Mount Horeb which he went out to study, and all that rubbish.[2]

Agnew is to have the little panel Sorcerer. Mr Graham used to say it was always well to let him have some small pictures to play with – they helped him to sell the big ones.

I: People get to know that they can find things of yours with him, but they might come to you first hand.

E B-J: Ah, they like to have him to deal with – they're a bit afraid of me. They can chaffer with him, which is a thing they love doing. A man goes to him for something of mine and says 'I've got a Creswick now – one of the finest known. I had a critic to dine with me the other day and he said he'd never seen a finer. I'll let you have that, and a Newton and a Powell (I say those names at a venture – I don't know if there are any artists called by them – but if there are I don't mean them any discourtesy – but those names will do) for this Burne-Jones.' And then Agnew would answer 'Ah, that's quite impossible – the Newton and the Powell I could do absolutely nothing with, and as for the Creswick I know all about that – had it in my hands long before it ever passed into yours. This is, on the other hand, one of the finest things Burne-Jones has ever turned out. Like all other men he is not always equal to his reputation, but this is decidedly the finest work of his that has ever been through his hands.' Then the purchaser would say, 'I'll tell you what I'll do – I'll give you £50 and the Creswick.' And Agnew would say, 'Oh, quite out of the question, I couldn't do that,' and then the man would say 'Well, a hundred then,' and to his surprise Agnew would suddenly say 'Done.'

[1] Daniel Maclise (1806-70), Irish historical painter, settled in London in 1827 and was one of eight artists asked in 1843 to paint frescoes of scenes from Milton's *Comus* in the Garden Pavilion (now pulled

down) at Buckingham Palace, as a trial for frescoes for the House
of Lords. B-J had attended a Royal Garden Party.
[2] John Rogers Herbert (1810-90), portrait and history painter and
Royal Academician, painted nine subjects, all Biblical, for the
Peers' Robing Room at Westminster; in all, he spent fourteen years
on one painting, *Moses Descending with the Law to the Israelites*. In
later years his work declined to the point of actual public protest
about his pictures being too prominently hung at the Academy.

17 July 1897. Garden studio
. . . E B-J (*working on* Avalon. *Speaking of twin boys interested
in painting*): They know what colour is too, for they stopped
before the only hollyhock whose colour went well with the
green of the leaves and admired the harmony of it – a thing that
rarely happens even among flowers. Nature's so stupid that
she doesn't know how to harmonise the colours of leaves and
flowers, and it takes all one's time looking for it when she does
manage it. The garden's so full of hollyhocks it's never been so
gay before. Georgie's going to give a garden party on purpose
because of them – 'to admire the hollyhocks'. One of these
little chaps is a naturalist, the other a designer.[1] They do crabs
and all sorts of things that are given to them. One of their
drawings was a very beautiful one of a starling, with all the
delicate markings of the feathers done, and all the spots and
crumples about the beak. And another was of a brass pot, and
all the room reflected in it, and the little chap himself drawing
at the table and very like him too. The one that designs has yet
to learn what the good school of design is. All he knows is
Japanese things that are given him, and Japanese ornament
can't be said to exist. A Japanese puts a crab in one corner, a
spider's web in another and 3 leaves, but it's all about nothing
at all and these scattered objects are quite unconnected – well
placed but no more. Sense of architecture and construction
absolutely nil. So his ideas of ornament are very bad at present.
The one merit of Japanese ornament, its splendid drawing, is
of course beyond him as yet. But the making of patterns is no
trifle – it's a rare gift to be able to do it. For ten young men that
can design a picture there isn't one will turn up that can really
imitate a pattern. Gothic is the first school of ornament; it has
what is so essential – it has made fetters for itself, knows the

value of limits and boundaries. It transgresses them sometimes and plays about in its fetters, but it always wears them and consciousness of them is never lost.

[1] Charles Maurice (1883-1908) and Edward Julius (1883-1957) Detmold, both water-colour painters, etchers, illustrators. Edward first exhibited at the Royal Academy in 1897, a work called *From Far Japan*. In later years he illustrated, in naive, faintly Japanese style, works of Aesop, Kipling, and Maeterlinck.

26 July 1897

E B-J (*repainting blue cloak of furthest trumpeter to right, rocks and grass in* Avalon): I've had a very sad letter from Mrs Morris at Kelmscott. No doubt she'll have to give it up. She was always used to be managed for, and is only now learning what it is she's lost. What a magnificent kind of Peerage Death is to give to a man. A rank that at once puts him on such a pinnacle. (*To Mistress coming in.*) Poor Lady Salisbury looked only half her size.

Mistress: She was rather a portly lady.

E B-J: She had a yellow satin covering over her as she lay on the sofa. Splendid yellow it was, covered all over with delicate Chinese embroidery. And she asked me if I knew what it was, and when I said no, she told me it was the envelope that had come round the Emperor of China's letter to the Queen – which must have been a great piece of parchment, or silk paper more likely, that was wrapped up in this and fastened and sealed in many places. And when Lord Salisbury took the letter to that Royal Lady, after it was opened she gave him this beautiful piece of stuff to take to his old woman.

Lunch

MISS NORTON: Mrs Humphry Ward is writing another novel, and she didn't object to reading some chapters of it to us.

MISTRESS: Quite naturally. What was this one about?

MISS NORTON: Well, some of it was about Roman Catholics, and the factory difficulties were in it too.

E B-J: Oh, my dear, do you know I like a duel in a novel so

much better than factory trouble, because when factory troubles come in my spirits fall at once. Isn't there a duel in it?[1]
. . .

[1] Mrs Ward was writing *Helbeck of Bannisdale* (1898), which has no duel with weapons, but a duel of wills on the ground of conversion to Catholicism.

Interlude: Summer 1897

The Rookes left for France late in July 1897 and settled near Loches, where Rooke began two commissioned drawings for the Birmingham City Museum and Art Gallery. In France the fragmentation of the past year faded a little into the background; by August Rooke could write that 'that peaceful happiness that you used to congratulate me on the approach of has set in and we are the better for it. Leonora's face has a look of quiet content and elasticity has returned to my steps.'[1]

Quiet content eluded Burne-Jones. One cause was that the critics were beginning to say publicly what he had been saying privately. In 1896, when *Aurora* and *The Dream of Launcelot* were shown at the New Gallery, the *Times* writer had said that 'there is little else in the Gallery that in any way suggests Sir Eward Burne-Jones or his influence; a curious contrast with the days, not so many years ago, when here or at the Grosvenor one used to see his followers and Rossetti's on every wall.'[2] However stoutly Burne-Jones resolved to ignore such judgments, they contributed to fits of discouragement, which brought on bouts of influenza, and it became impossible to say which had begun the vicious circle. He had had a bad spell in March 1897. 'Caught chill, in bed, chill turned to influenza, influenza to melancholy, melancholy to despair, despair to coming back and beginning work again, the only remedy for all ills, Little Rookie, the only remedy,' he wrote. 'Now – will you come and play with me at work on Monday. Do if you can, and so all care shall be forgotten.' He added a postscript: 'To have taken a holiday, Rookie – it's all nonsense – the most horrible dull hard work.'[3] It had ended with the 'holiday' at the detested Malvern hotel, followed by that other kind of upheaval that he regarded with abject horror: the papering and painting of the Grange. He fled to Rottingdean, which brought on still another kind of upheaval. 'I look across to France often,' he wrote to Rooke, 'and long to run over and

159

see some splendid church for which I pine – but it isn't easy for me to travel – and it ends only with longing.'[4]

Avalon, too, had been moved, from the Kensington garden studio to the larger, lighter St Paul's Studios. 'Avalon has travelled safely,' Burne-Jones wrote to Helen Mary Gaskell, 'but after infinite trouble and I am worn out with fidget and anxiety, but there it is – set up in its new home and not looking near as well as it did here. Pictures have a way of growing into the atmosphere in which they are painted – and they fade away in new surroundings – I long to be at it. And this afternoon I go into town to buy new brushes – new paints – new everything.'[5]

Avalon, a part of his life since 1881, when he had begun to design it for George Howard's library at Naworth Castle, now became the summing up of all that he had ever been or had expected to be. In a long letter summarising problems connected with the picture, he had written to Howard: 'Then why did I begin it you say. Ah! Why was *I* begun – who am not really as much worth finishing.'[6] His energies were collected and directed toward the completion of this picture, and yet he felt that, being finished, *Avalon* would be his own ending.

In the summer of 1897 time seemed somehow to have slipped out of its frame. Toward the close of the warm weather, Burne-Jones wrote that he could not even remember how many weeks it had been since Rooke had left England, and that he longed for his return so that they could begin to work again. 'Other effects of Time, too we are feeling,' Rooke replied, 'and know that a new and more serious epoch opens when we get back – one for the production of your crowning work and for a last chance for a firm footing in life for me and that we may pass it near and sometimes by [i.e. beside] you is one of our many earnest hopes. Kind of Br'er Rabbit's Last Ack and the dignified folding of the mantle.'[7]

8 October 1897 — 20 June 1898

E B-J: Come and look at the very last drawing that will ever be done for the Kelmscott Press. (*Burning of Atli's house.*) Do you like it? Tell me if you see anything to better in it.[1]

(*Enter Phil.*)

I: Wouldn't it be better if the torch were less straight in her hand?

PHILIP BURNE-JONES: No, I think it's all right.

I: Then two to one settles it.

E B-J: Like Rossetti used to consider. He'd say to Morris as he came in of a morning, 'What do you think about that?' and Morris would say, 'Well, old chap, mightn't it be put up a bit?' That would be Rossetti's chance, and he'd answer, 'Do you know, I've been thinking that if anything it ought to be a little lower – so there can't be much the matter with it, and it must be just right.' That's the use of criticism. It was so funny to see them together. I used to wonder how Morris dared to say such things to Rossetti.

(*Top of Road. 5 p.m. Poster*, 'Subsidence of the Mansion House Buildings.')

I: What *would* you do if the Mansion House were to tumble down?

E B-J: I'd bear up. I'd do my best to bear up. But it isn't true – don't you be alarmed – it's too good to be true.

[1] On the *Sigurd* drawings, see above, p. 76. After lunch at the Grange on 7 October 1897, Cockerell wrote: 'He was working on the picture of Gudrun for the *Sigurd* which bids fair to be as fine as anything he has done for the Kelmscott Press – a fitting conclusion. He promised that I should have the drawing! and arranged to meet me at the British Museum on Saturday to look at MSS.' The drawing is in the Morris Gallery.

26 October 1897

E B-J: I've been reading in Tennyson's *Life* lately, and it's very sad the numbers of conversations there are about death in it. There's one he had with Rogers the Banker, who talked about his death when he was over 90, with his eyes streaming with tears. It's so sad to hear of anyone weeping at the idea of his own death; about some one else's that's all very well, but at his own, O my word. There's no telling of course – it might be the same with me if I were only to live long enough – who's to say what he might come to, and it's so much a matter of mood. But now it seems as if it would be such infinite rest to be no more worried about doing a picture. It begins to seem almost useless to keep on trying at it any longer. People get tired of one; they've had all you can give them, and begin to feel about you as they would about a discarded mistress. You may break your heart trying to invent new charms for them, but it won't do.

I: But he had all the cream of existence, others the skim milk and the dregs, and all the fun of thinking himself a man of genius.

E B-J: No doubt he was very conceited, we're all that. He did that unfair thing, he entertained a great deal, which gained him reputation at the moment, though it only lasted for a time. He got much talked about because he gave charming break-fasts to famous people so that they might meet each other, and so that no famous person after that liked to say a detracting thing about his work. He got Turner to illustrate his poems. It wasn't fair to get Turner to illustrate his poems.[1] Let us pray, Rookie, that when the time comes for us to go, we may go without pain. You see it's going to be all right. We've had great happiness and we've had unhappiness in life.

It was funny for Ruskin to say, 'Jones, you're gigantic.' I didn't hear the last of that joke for a long time. Tennyson would say it every time he came into the same room with me. He loved that joke very much.

[1] See Hallam Lord Tennyson, *Alfred Lord Tennyson: A Memoir by His Son*, I, 269; II, 71-72. Samuel Rogers (1763-1855), banker, art collector and poet, published anonymously and at his own risk his

poems, *Italy* (1822, 1828). When it failed to sell, he destroyed unsold copies, engaged Turner and the painter Thomas Stothard (1775-1834) as illustrators, and issued a handsome revised edition (1830). The plates assured its success and introduced Ruskin to Turner's work. The literary breakfasts resulted in *Recollections of the Table Talk* of *Samuel Rogers*, ed. Alexander Dyce (1856).

27 October 1897

. . . E B-J (*dragging pale blue over background of Graiae in Perseus series*): But how they used to go on in Birmingham. They'd talk of people who'd never been heard of in the world and never could be (not that that matters exactly) as if they were of eternal importance, and say 'There's a bit of Newton' or 'reminds me of the manner of Powell, doesn't it you?' And when I was little, old Mr Caswell would point at me and say 'There's the boy that will beat them all at his historical painting.' And if I'd painted a picture of the landing of William of Orange, O how proud he'd have been of me. And then when I went on and fell into the Preraphaelite ways, he stared – as you may well think. But I don't know what made him think so much of my drawing – I wasn't clever, and other boys could do better than I.

I: Perhaps because at least you did draw.

E B-J: Well, he saw I was thinking about it when other boys thought of anything but that. The Khyber Pass I must have drawn 40 times, and Lady Sale always. A terrible guy she turned out under my management. Her bonnet never did her any credit.[1] I knew she was a failure and took away the romance of it. Corbould used to paint her with a riding whip. But I used not to draw women in those days; I drew warriors. I drew Mucius Scaevola in the tent of King Porsena at Clusium. Tent? I never saw such a tent. I had never seen one. It wasn't a tent at all, a nice round thing, but drawingroom curtains with great thick cords and tassells and an urn overturned. Don't know where I got it from. Suppose I'd seen one in some horrible Rubens or other. It meant Rome.[2] There was one thing I didn't like. Mr Caswell made me draw Tasso, Mrs Caswell's King Charles Spaniel, and that wasn't at all to my mind. In one thing he was like some people I know now – he

didn't like me to make comic drawings. When I'd drawn a coffee pot and made all the reflections and brought out all the high lights upon it, and lid that would lift up, which he was pleased with (and no doubt it wasn't a bad thing to do) he didn't like my having done a lot of little imps coming out of the inside which you saw when you lifted up the lid. So all alone I was in my mind and untaught away there in Birmingham, with nothing for it to fasten on but details of the dowdiest existence. . .

[1] Lady Florentia Sale (1780-1853), wife of Sir Robert Sale (1782-1845), who fought in the First Afghan War in 1838 and defended Kabul in 1841 and Allahabad in 1842. Lady Sale's journal (1843) is available in a modern edition, *Lady Sale: The First Afghan War*, ed. Patrick Macrory. This portrait by Edward-Henry Corbould (1815-1905), who was art master to Queen Victoria's children, is unidentified.

[2] On this drawing, see John Christian, 'Burne-Jones Studies', *The Burlington Magazine*, 115 (1973), 92-111.

19 November 1897

E B-J (*re-touching* Dawn (Aurora), *by the river-street*): Sir G. Lewis was very pleased with his daughter's portrait that I sent him the other day. Vowed it was exactly like her now, tho' it isn't. For she is a young lady of 22, and when it was 'done' she was only a child of 8.[1] He didn't know what to do to thank me. His wife did it quite successfully, but he couldn't. All he could do was to make me take away as many boxes of cigars as he could lay hands on. He fidgetted about the room to try and find something to give me that I would like and couldn't satisfy himself at all. Rather pathetic, wasn't it, to see a man in that state who is the terror of the aristocracy of England and knows enough to hang half the Dukes and Duchesses in the Kingdom . . .

[1] *Portrait of Katie Lewis* (1882), oil on canvas, now in a private collection, see H/W, Plate 38. B-J's illustrated letters to her (Department of Prints and Drawings, British Museum) were published as *Letters to Katie* (1925). She was the daughter of Sir George Henry Lewis (1833-1911), head of the firm of Lewis and Lewis,

solicitors, who was totally discreet about the private and legal affairs of the fashionable and influential. He was a canny art collector and a friend of both Morris and B-J.

17 December 1897

. . . E B-J (*last touches to* Atli's Palace *burning*):[1] But artists don't even know what books there are – I mean even for their own purposes. It comes of their having no book education. They think for instance that if they've got *Hamilton's Vases* they've got all they want in that way, but they haven't – *Hamilton's Vases* being quite a bad book.[2] Artists it's true have no call to be learned, but they have no call to be ignorant. When they attempt anything they're bound to be accurate so far as it's possible. Until Tadema's arrival Greek and Roman scenes were shocking things in the hands of the Academy. About mediaeval life artists haven't the least notion. Their only idea of it is tights – with one leg red and the other yellow. All the armour they can get hold of, poor things, is what is to be had out of Wardour Street. An artist has no call to do mediaeval things, nothing obliges him to. He is quite at liberty to do modern subjects if he sees what amuses him in them – but if he does do mediaeval things he's bound to do them fairly well. . .

[1] Cockerell, having lunch at the Grange, 'found the drawing of Gudrun setting fire to Atli's Palace framed by Guerant, in my place – "that is your dinner," said E B-J' (diary, 7 December 1897. CP:BL). See above, p. 161, note 1.

[2] *Outlines from the Figures and Compositions upon the Greek, Roman, and Etruscan Vases of the late Sir William Hamilton, with Engraved Borders, drawn and enlarged by the late Mr Kirk* (1804). Sir William (1730-1803), diplomat, early and knowledgeable collector of antiquities, and the husband of Lord Nelson's Lady Hamilton.

31 December 1897

E B-J (*re-paints Frances Graham's head in* Nereids. *To Catterson-Smith*): Do you still pursue Socialism?

CATTERSON-SMITH: Well, I feel I've given all the time to it I can afford. I gave a great deal.

E B-J: No doubt. I'm sadly afraid that what made me have

doubts of it from the very first was that no one had devotion enough for the cause to be prepared to ruin himself for it.

CATTERSON-SMITH: Well, you see there were so many ins and outs in it and things were so mixed up that I daresay people didn't see their way.

E B-J: Very likely. It was no more clear than any other plan is of improvement – that's the difficulty with most of us. I really believe that if Lord Salisbury and Mr Balfour thought it would benefit the world they would give in to it. They're men of culture and not besotted to their little interests and views. They've got quite as much interest in others as I have when the course is clear for them. All that I felt at the only time when I failed Mr Morris, the one thing upon which he and I did not stand together. I used to tell him that if a number of people were moved to throw themselves entirely into it that would give it a different aspect to me. And even as I said it I was afraid he might do it, and it would have been such an injury to him and to his work and to us all and to the world. Yet what the Socialists don't do the Christians have done a thousand times over and Christianity will lick Socialists into nothing if only by the beauty of it.

CATTERSON-SMITH: But it's ineffectual.

E B-J: Ineffectual? Its triumphs are the biggest the world has ever seen. . .

7 January 1898 . . . Before lunch, in studio
PHILIP BURNE-JONES: Uncle Edward [Poynter] was so cross last night – he said he'd never go to such a thing again; but I took him to dine at that restaurant and then he forgot it altogether and was quite happy.[1] And then when we came out, he was pursued into his vehicle by two Regent Street ladies. I should have thought they wouldn't have gone after a man of his age.

E B-J: Oh, the older you are the better for them – the more money they hope to get out of you. That wretch ———— once gave a woman 5/- to go after me – one night as I was going quietly to my 'bus. He told her I was very timid and shy, and wanted her to speak to me. I saw him talking to her as I looked back and then she came after me and I couldn't get rid of her. I

said no, my dear, I'm just going home – for I'm never haughty with those poor things – but it was no use. She wouldn't go, and there we marched arm in arm down Regent Street. I don't know what any of my friends would have thought if he'd caught sight of me. He'd have thought it fine fun, as ——— did, of course.

Lunch

(Conversation turns to sun dials.)

E B-J: Do you remember Hogarth's funny motto in the election picture – 'We shall,' 'We shall,' 'We shall,' written on all the dials.[2]

MR JOSEPH JACOBS: Are there pictures of all his engravings?

E B-J: Of all the coarse brutality? Fortunately not – but of the principal ones, such as the *Rake's Progress* and the *Harlot's Progress* and the *Marriage à la Mode*.[3] But though they're all three well done, the last is far and away the best set, and the best of his work. The colour's so good, isn't it Phil, and the perfection of the painting is absolute. I remember after my stay in Venice, when I came back thinking there could be no painting in the world but Carpaccio's and the other Venetians, there was nothing whatever wanting in Hogarth's to my eyes when I saw the *Marriage à la Mode* again. . .

[1] Poynter spoke at the opening of the South London Art Gallery and Institute, Camberwell. B-J castigated the materialist emphasis of such occasions, and Poynter's speech, he said, 'can't be said to have cast a chill over the proceedings – he literally scattered dust and ashes of death and the charnel house on them. I think it must have been that he was in a fury at having to go there at all. Said nothing to smarten anyone up – seemed almost ashamed of being an artist' (R-MS).

[2] Hogarth's four engravings, *An Election Entertainment* (1754-58). In the fourth, 'Chairing the Member', the sundial bears the motto 'WE MUST', but the inscription is different in the oil versions, *Four Pictures of an Election* (1753-54), in Sir John Soane's Museum, London.

30 January 1898. Morning

E B-J *(finishing Chapel of Holy Grail for Dr Evans' book.[1] To*

Mr Mackail, answering question about Mr Morris): I don't suppose
he was ever so excited as with *Love Is Enough*, except with
Sigurd.[2] He was pleased with the name, he was pleased with the
————, he was pleased with all those things. Not that he was
so very much disappointed with its unpopularity, or ever
talked about the public and himself. But he was hurt with
them for not liking *Sigurd*. He loved it – thought it was a shame
they should neglect the absolutely best thing he had made. I
never heard him say one word about the *Death of Jason* – the
only one of his poems that got noticed at all, that ever got into
anything like editions, while *Sigurd* was not noticed at all.[3] It's
funny, but I suppose the day for epics is over. I can go back to it
over and over again, and not feel tired of it at any time, for the
splendid kind of interest and humanity of it all. (*To a question as
to W.M.'s painting*:) He hadn't time with his other undertak-
ings. You can write poetry in a train or on an omnibus, or
anywhere – but to paint a picture you need to sit down so
seriously and get so many things together to do it with, that
it's quite another matter, so far as time goes. But about *Love Is
Enough* he wasn't surprised. It's splendid when the King gives
up his Kingdom for Love's sake, but when at the end it comes
to nothing more than a mere matrimonial existence, that's
poor. I wanted him to stop it before it came to that, when the
Kingdom was given up, but he wouldn't. He couldn't bear
anything in the nature of a fragment – must have it all. It was
part of that splendid sternness that was in him – was one of his
ways – he would do it. If he ever could have felt that the half
was greater than the whole, but he never would. I suppose if
he'd painted he would never have hidden things with dark-
ness. That was Top, so clear.[4] That was Top, so out in the
sunlight. Never wanted to snatch at anything.

I remember the day he first came across the [Elder] Edda,
and would have gone to Greenland only for one of them, and
my asking him 'Is there really a Greenland Saga?' and he said
'Yes, you may be sure of that, and I suppose you'd expect a
Greenland Saga to begin with "Once upon a time there was a
whale" – but it doesn't, as it happens.'[5] I remember that quite
the last moment before they went off to Iceland from Edin-
burgh, at Granton, that place near, Faulkner went into a shop

to get some of that long tinder stuff for lighting pipes, and while he was expecting the bell to sound on the boat every moment, the man was quietly cutting it up into lengths. So Charley said, 'Look here, I'd better take it as it is or I'll lose the boat.' But the man went on without taking any notice of him except saying 'Ye'll be having it in foot lengths.' And then Charley said, 'But you must give me or I shall either lose the boat or the stuff,' but the only answer he got was, 'Ye'll be having it in foot lengths' – and in foot lengths he did. Dreadful man, eh?

The voyage to Italy wasn't much of a success. He was rheumatic and out of sorts. Not in a Southern humour but in a Northern humour. We stayed a little while in Paris on the way there. We tried everywhere. We went to Fiesole and he didn't like that, though I should have thought he would. Then we went to Siena, and he liked that a great deal better. But he wasn't really at all in a mind for it and was very angry at all the things that were being done to the old work. He liked the outside of the Duomo at Florence but when we went inside, the bareness of it and late attempts at furnishing it up were too much for him. He really was Northern, not Southern in his nature. The one thing he liked extremely in Florence was the Baptistery with its pillars all in one piece, and the little trees let into them in metal. At Venice there were splendid scenes, such as when he smashed up George Howard's hat, thinking it was his own, in his rage and fury at what they were doing to St Mark's. He was sorry it was ruined, would have liked it all fresh, just done yesterday. He was sorry for that and sorrier as it gets on.[6]

But he didn't want me to be too happy with the South, for fear I should be unfaithful to the North – so he tried all he could to diminish my satisfaction with it, and I must say he succeeded. He would have liked the little painted chapel in the wood that Rookie did last summer near Loches better than all that he brings drawings to shew.[7]

[1] See above, p. 36, note 1.

[2] Morris's *Love Is Enough, or the Freeing of Pharamond: A Morality* was first published in 1873. Of two illustrations by B-J, that on the last

page was to have been frontispiece to a projected edition of Morris's work. The Tate Gallery has one unfinished oil on this subject; Carlisle City Art Gallery, a pen-and-ink drawing. The Morris Gallery has two drawings and a proof of B-J's frontispiece, *Azalaid and King Pharamond* (c. 1896).

3 Morris's *The Life and Death of Jason: A Poem*, first published 1867, reached a ninth edition by 1897; see H. Buxton Forman, *The Books of William Morris*, pp. 45-51.

4 Topsy: Morris's nickname.

5 As translated by Gudbrand Vigfusson and F. York Powell, in *Corpus Poeticum Boreale* (1883), the first line (p. 45) reads: 'In the olden days Atli sent one of his trusty warriors, whose name was Knefred, to Gunnar.'

6 This was the trip in 1873; see *Letters*, pp. 55-57, in which Morris writes that he is 'not at all disappointed with Italy, but a good deal with myself: . . . cannot bring my mind up to the proper pitch and tune for taking in these marvels; . . . I daren't whisper this to Ned who is horribly jealous of the least sign of depression in me here, thinking that Florence ought to make a sick man well, or a stupid one bright.' Morris could not forget the dark side of Italian history: 'change and ruin and recklessness and folly and forgetfulness of "great men and our fathers who begat us" . . .'

7 See above, p. 159.

16 February 1898

(*Working on* Magician.)

I: I've been to see Millais' pictures [at the Royal Academy].

E B-J: I haven't yet – I must go. I know them all very well but should like to see them again. Did you go to see Rossetti's [at the New Gallery]?

I: Yes, and saw very clearly how quite truly you say that his early watercolour is his most valuable work.

E B-J: Yes, the oil ones don't count. Why they don't and where they fail is hard to say.

I: Perhaps he aimed at enjoying the painting.

E B-J: Aim doesn't exist in them; the Romance by that time was over with him. He got to love nothing else in the world but a woman's face. Sometimes he'd force himself to draw the hands well, which he could do very beautifully, but sometimes he failed in it. . .

4 March 1898

E B-J (*painting Perseus' armour, helmet*): Any history today?

I: (*speaking of Quilp's return.*)[1]

E B-J: Sweet for him! This we may say is the acme of his life, the zenith of it, Rookie! How happy for him! Now comes that beautiful expression, 'Aquiline, you hag!' We love Quilp, don't we? But I'm afraid that naughty Dickens instead of letting him die comfortably and honourably in his bed, is going to kill him off. How can he?

When I was little I knew a Mrs Quilp. When she married she was a handsome and very charming woman, and in about 20 years her husband had worried her into a mere rag, tho' still quite ready to be pleased and appreciate anything tolerable. And then he died, having worn himself out with every sort of intemperance and gone bankrupt over and over again and ruined himself and everyone he could. And then a very nice fellow exceedingly well off took pity on her and married her. But the funny thing was that after that she was always regretting her first husband. She used to say of the second, 'Ah, but he hadn't anything like the powers of mind of my poor Henry.' She made a deal more fuss of his memory than she did of her good husband. I remember one of the things I heard he used to do to her was to make his spoon burning hot in his tea when it was just poured out and suddenly press it into the back of her hand in pretence that he wanted to call her attention to something. Miss Sampson's gossips used to come in full of tales about him and I used to listen to them all without its being supposed that I was taking any notice – and I used to wonder how anyone could live through such treatment; I had such a gentle, kind Papa.[2]

[1] Daniel Quilp, villain of *The Old Curiosity Shop*, while addressing his wife with excruciating courtesy, savoured his sadistic treatment of her, which she received with abject humility.

[2] Miss Sampson, who seems to have no first name in the accounts of B-J's life, came as housekeeper after B-J's mother died. She had never known the mother, could not understand Mr Jones's inability to 'rejoice in his own son', but 'the child she fostered tenderly' (*Memorials*, I, 2).

5 March 1898. Rottingdean

E B-J (*looking about for something which doesn't appear. With deliberation*): I hate swearing and I can't abear violent language. Nor can I think of anything more ungracious in a man just recovered from a serious illness than the utterance of blasphemy, but where the —— what the —— has become of that thing? (*Settling to work both of us; Annie comes in with something.*) Have you brought a little picture to do, Rookie? Do you see that little chap, Annie? How good he is drawing there. He'll go to heaven some day, you'll see him (as sure as you're born) sitting on a cloud, harping with a golden harp, while I go to the other place.

ANNIE: I see *two* good people.

E B-J: Then you're in luck's way, that's all I can say, in luck's way you are today. . .

9 March 1898. Rottingdean. Supper

I: Do you know Louis Davis made Associate of the Royal Watercolour Society? Edward Hughes wanted him very much.[1]

E B-J: Edward Hughes has done another of those Italian story books and had more fun. But as for the stories I don't care for them. There's one splendid Italian story book and that's the *Decameron* – but as for your *Pentameron* and —— I don't care a rap for them. The later Italians are no good at it. The Arabs beat them out and out at story telling, but then that may be said of any people.

I: The motive of Italian poetry after Dante hasn't seemed fine to me. Petrarch hasn't.

E B-J: No, I never cared about him a bit.

I: All those splendid things of early poets that Rossetti translated people don't seem to notice.[2]

E B-J: They're choked with the quantity of things they have to read; what they want is a little starvation. Everybody's got too much of everything. A little starvation would do a world of good. Never looked on the Raleigh picture as a very interesting feat, but he [Millais] might have got it right since it would only have taken 10 minutes to get it right. I never minded about the correctness of detail in poetical subjects, the

poetry of them was so fine it was quite enough, but when he took to those quasi-historical pictures he ought to have the details beyond question. In that one of King Charlie's time where the drummer boy's fifing, his drum is just a Lowther Arcade drum. But I never minded that the dress in the Huguenots is of rather a ramshackle kind, or that in *St Agnes' Eve* it's a modern pair of stays she's lacing up – the whole thing is such a piece of splendid gloom and deep colour and masterly painting.[3] I never did a piece of historical correctness, but I know so much about it as to have a right to play with the subject. What I like most is to make a dress in a picture that has never existed at all. My nearest approach to archaeology is in the Sleeping Beauty, where I took the pains to make the armour of the Knight [R-TS: many centuries?] later than the palace and ornaments and caskets and things and dresses of the ladies and courtiers.

Annie, can we get this poor little fellow off by half past seven tomorrow morning? You'll have to get us breakfast by seven, and in half an hour he ought to be able to put enough into himself to last him up to London. Mr Aurelian Ridsdale goes up by the same train every Monday, and the discipline of this house is as good as his I hope, my lass. And then you know he can get out at every station and get a glass of brandy and water and say a few words to the young woman, and poke her in the ribs and chuck her under the chin. No harm you know, no harm in a gentleman like him as is used to that sort of thing.[4]

Rossetti once used to design wonderfully in pen and ink, and I used to do it because I saw him do it, as a pupil does – though I don't know if it is right for him and I never satisfied myself in it. Not that I've done it in anything – I've been always greedy! In colour it's never been possible to get what I've always wanted. It seemed to me that if glorious colour and deep shade could be combined, which is impossible, that would be what I've dreamed of. I could have been a chiaroscurist if it hadn't been for my wanting colour too. . .

[1] Louis B. Davis (1861-1941), illustrator and stained-glass artist. Edward Robert Hughes (1832-1903), nephew of Alfred Hughes,

and a portrait painter excelling at idealised portraits of women. B-J, who particularly liked him, wrote (n.d.CH) to Rosalind Howard: 'I am glad you like that bright Edward Hughes – to be as young I would almost consent to be as attractive –. . . years ago he painted a most beautiful little picture called "A Wet Sunday Morning" [*A Rainy Sunday* (1872)]. I then expected famous things to follow – but private troubles I fancy took it out of him – they do play the very devil with one's work . . .'

² *The Early Italian Poets from Ciullo d'Alcamo to Dante Alighieri (1100-1200-1300) in the Original Metres Together with Dante's Vita Nuova Translated by D.G. Rossetti*, published 1861; a second edition, 1874, is called simply *Dante and His Circle*. For Rossetti's early comments on these, see his *Letters . . . to William Allingham*.

³ Millais' *The Boyhood of Raleigh* (1870), in the Tate Gallery. The 'picture of King Charlie's time': *An Idyll of 1745* (1884), owned in 1899 by Sir F. Wigan, Bart. Lowther Arcade: G. B-J's note in R-TS: 'Lowther Arcade now Coutts Bank guarding the secrets of Georgian Royalties'. On *St Agnes' Eve*, see above, p. 80, note 9.

⁴ On the Ridsdales, who lived at The Dene, Rottingdean, see Angela Thirkell, *Three Houses*, pp. 105-10, 125.

18 March 1898

(Returned from Rottingdean. 3 [Nereids'?] dresses. E B-J has caught another cold.)

. . . E B-J (*re pupil*): A boy is always terrible to me, isn't he to you?

I: Well, I think of him as he's going to be.

E B-J: Yes, but as he *is*.

I: Last night's memento of Aubrey Beardsley.

E B-J: Yes, he's dead.¹ He's quickly run his course. Did you ever see him?

I: The back of him, going out at the door last time he called on you, when you weren't pleased with him.

E B-J: That was the day he was so stupid and conceited, and I let him see pretty plainly that I wasn't anxious to be troubled with him any more.² You know they're impeccable, the young, as I suppose you've found out. I asked him how he was getting on with the book he was decorating – King Arthur that was – and he said he'd be precious glad when it was done, he hated it so. So I asked him, why did he do it, and he said because he'd been asked. He hated the story and he hated all

174

medieval things – and I said, how could it be successful work then. I never saw such a pitiful exhibition of vanity in my life.[3] I wondered why it was he took the trouble to come and see me, unless it was to shew off and let me know my influence with him was over. As if it mattered in the least whether it was or not. Then he got into all that horrid set of semi-sodomites, and after Oscar Wilde's disappearance had almost to disappear himself. Damned young fool. In one season he was suddenly marched into that ridiculous position of his that was entirely invented by critics, and he believed it all. Ought to have known better. He had a little healthy looking affectionate sister who used to come with him. I wonder what's become of her.

I: Have you never seen her since?

E B-J: Yes, I saw her once at Victoria Station by chance. She came up to me with her simple, straightforward looking face with a saddish look on it, as though to say, I'm sorry you don't like what my Brother is doing any longer – at least that's what I thought it looked like.[4] But is there no history today?

I: Only a little.

E B-J: Ah, the historians are so very few. There's Dumas, there's Scott, there's Thackeray and there's Dickens, and no more – after you've said them, there's an end.

Lunch

E B-J (*Mrs Busk and Mistress, of a country church*): On a Sunday afternoon once, when I was at Oxford, I went a long walk till I came to a church in a meadow, the ancient church you can imagine – and the sound of the drone of a sermon was coming out of it so I didn't go in but went and sat in the porch, and there I heard this: The land of Edom is composed for the most part of old red sandstone to a depth of about 35 feet, and that rests on a base of silicate of magnesia – or something of that sort, and the whole sermon was made up of that kind of valuable spiritual information. So I waited till the end for the congregation to come out so that I might see what kind of audience this was addressed to – and when it was all over there came out about 6 old men (and perhaps a woman or two) dressed in smock-frocks and nice fluffy hats, with pretty

embroidery on the smock-frocks. And that's what they had to last them through the week.

MRS BUSK: Been reading about Newman's conversion.

E B-J: Newman was an unusually splendid character, a more unworldly couldn't be. He never wanted *any* distinction. Wherever they chose to put him there he would be. Manning was just the opposite – I don't say he had any ulterior object in becoming Catholic, but having changed his church he laid himself out for what chances of ambition it gave him. Newman was so humble minded. He had to put up with a great deal of snubbing after his conversion, which he took in the prettiest way.[5] The Catholics very rightly when they've made a convert from another church don't at once go and make a great fuss over him and make much of him, but they stow him away in the background somewhere and keep him in the dark for a long time till they've disciplined him. . .

[1] Beardsley, born in 1872, died at Mentone on 16 (or 15) March 1898; see Malcolm Easton, *Aubrey and the Dying Lady: A Beardsley Riddle*, p. xxiv. The *Times* notice (18 March 1898, p. 10), spitefully Philistine, connects lung disease and morbid imagination.

[2] Beardsley recorded his first visit (12 July 1891) with a dated portrait sketch of B-J; see illustration above. There is no doubt that B-J helped to launch Beardsley's career. In 1891 B-J sent him a four-page letter of advice (see Beardsley, *Letters*, pp. 23-24). In Paris Puvis de Chavannes introduced Beardsley to William Rothenstein, who wrote (*MM*, pp. 61, 82-83) that Beardsley then thought B-J too remote from life, but inimitable as a designer. Although he may have intended it as sarcasm, Beardsley himself wrote that 'I still cling to the best principles of the P.R.B. and am still the beloved of Burne-Jones' (*Letters*, p. 45). He had begun to burlesque the P.R.B. influence: see the medallion caricatures in *The Early Work of Aubrey Beardsley*, Plate 141, where B-J appears as a Pre-Raphaelite Britannia. Late in 1894, however, Beardsley still gave B-J credit for directing him to art as a career (*Letters*, p. 76).

[3] Beardsley made 300 illustrations for Malory's *Le Morte D'arthur*, published in parts, 1893-94; see Brian Reade, *Beardsley*, notes 55-163. Easton suggests (*Aubrey and the Dying Lady*, p. 126) that Beardsley disliked Malory because by 1892 'Malory had been so flattened out by Burne-Jones and the soft-furnishing trade, that the sex of the knights and ladies of the Table Round was no longer

substantial matter for discussion.'
4 On Mabel Beardsley (1871-1916), see Easton, pp. 156-253. Yeats's
 seven poems, 'Upon a Dying Lady', included in *The Wild Swans at
 Coole* (1919), are addressed to her. Fitzgerald (p. 249) transcribes
 Rooke's text as 'I'm sorry I don't like what my brother is doing any
 longer . . .'
5 Newman's writings had profoundly affected the undergraduate
 B-J. He became disappointed with Oxford, where he had intended
 to take Holy Orders, because 'he had thought to find the place still
 warm from the fervour of the learned and pious men who had
 shaken the whole land by their cry of danger within and without
 the Church. To him it was like a room from which some one he
 loved had just gone out, . . .' (*Memorials*, I, 71).

23 March 1898

. . . E B-J (*Prioress' Tale*):[1] Vanity and egotism are great
perils to artists.

I (*not hearing*): Jealousy?

E B-J: And jealousy. But jealousy is in a way a more grace-
ful fault in an artist, though it doesn't seem so at first sight. It's,
to say the least, a tribute to merit in another. But vanity is
without any relief. It comes out in all forms. I see it strongly in
the young men and women who bring their work to me. They
won't stand the slightest rebuking. I can hardly tell them of a
fault. There was a young woman who came the other day – it
was quite painful to watch her expression as I found any fault –
flushing in evident misery as she was. I often think of Ros-
setti's terrible classification of our lot for vanity. How he put
Morris in a place all by himself in the first class. I had a very
high place too in the first class of the vain. When I remon-
strated with him for putting me there, he said, 'Now, Ned,
you know nothing at all about it. You're so vain that you think
even *your* pictures are not good enough for you to do.' Which
was not a way of lessening my vanity. He put himself also in
the first class for the same weakness. . .

1 See Arts Council 194, which calls this 'perhaps the most remark-
 able example of Burne-Jones's tendency to work on his pictures
 over many years'. Cockerell wrote (diary, 28 March 1898. CP:BL)
 that he saw 'B-J's most beautiful Prioress' Tale picture, begun 35
 years ago and just taken up again and finished'.

The Conversations

6 April 1898

E B-J: I've missed my chance of selling my picture, Rookie. I can't say that there'll not be another, but it isn't likely that there will. But it's not an unexpected thing, I've been looking forward to its happening. This is the third year now that my things haven't sold, and if it's to go on I must arrange my life accordingly. I must paint only little pictures and sell them cheap. Not but that the *Prioress' Tale* is small enough. I shall send it to the New Gallery of course, but don't expect to sell it there. I don't think I've ever sold a picture at a gallery in my life. Doesn't affect my spirits at all, it's just what I've been expecting. Even Millais didn't sell a picture for the last four years of his life, and he was 50 times more popular than ever I've been. It's just that I've lived too long, you see – not for my own purposes, but for the public, who've got tired of me, as I long ago said they would. Shall never be able to sell a big picture any more, shall have to finish *Avalon* and the *Car of Love* without any expectation of selling them. Shall have to finish all my big pictures without selling them. . .

13 April 1898

. . . E B-J (*last touches to* Prioress' Tale): Little bits of colour are not the least good in this large picture, they don't tell in the general effect one bit. So it's no use putting them in, only a waste of means. Holman Hunt has done it a great deal, quite uselessly. There are little spaces of the most brilliant colour that can be imagined in his large things, yet the result in the whole is almost grey colourlessness.

I: He likes to peer into his work so much, perhaps ought to do only small pictures.

E B-J: I think so. His smaller things are such treasures that once seen can never be got out of the mind again.

I: Like his *Ponte Vecchio*.

E B-J: And his *Valley of Esdraelon* and *Jerusalem in the Feast of Ramadan by Moonlight*. They won't leave the memory they're so beautiful. . .[1]

[1] Hunt, watercolours: *The Ponte Vecchio, Florence* (c. 1868?), in the Victoria and Albert Museum; *The Mosque As Sakreh, Jerusalem,*

during Ramazan (c. 1854?), in the Whitworth Art Gallery, University of Manchester; oil, *The Plain of Esdraelon from the Heights above Nazareth* (begun 1870, completed 1875-77), shown at the Grosvenor Gallery in 1877 and now in the Ashmolean Museum. See Mary Bennett, *William Holman Hunt*, 215, 151, 47. In general, Hunt's prolonged travels and long periods of work make his pictures difficult to date.

29 April 1898

E B-J (Avalon. *Irises*): You must be glad you've got your teaching over – such a bore, isn't it, that it's nice to be free of.

I: It's an anxiety. But it recalls beginning and makes me feel younger. It seems good to be learning to paint. In a picture there's no chance for painting.

E B-J: Except in the things that Sargent and that dreadful Melville does, which are more like painting studies than pictures.[1]

I: Even Velasquez painted the heads properly. It was only the dresses that he dashed in so hurriedly.

E B-J: That was all right, he did quite enough to them. But the Spaniards didn't get out of their barbarism till too late, till pictures were over – there was nothing but painting left for them to come into. And the world now very much wants to go back into barbarism. It's sick and tired of all the arts, it's tired of beauty, it's tired of taking care, it's tired of a great many things. If it weren't that I'm engaged in producing, I might be tired of them too. I *am* tired. We've all been living a great deal too fast, that's the truth. The world's worn itself out and pretty nigh every thing in it. No doubt about that. What's your boy going to be?

I: He'd think it a come down not to be an artist like his father.

E B-J: That's serious for him. There's no guessing what the future of Art's going to be. All the critics just now seem to be impressionists. What that means I don't know. Whether it's only that they all belong to a clique or whether it's the general feeling in the world, who's to tell!

[1] B-J disliked the delicacy of touch, which to him seemed overly impressionistic, therefore unfinished, in work by Arthur Melville (1855-1904), Scottish painter.

6 May 1898

. . . E B-J (Avalon. *Arthur's armour*): Yesterday I went to see Hawarden Window – it looked very well done. At Hawarden they're very anxious to have them, though I should have thought they couldn't think of them at such a sad time as it is now for them.[1]

I: So they'll be as good as the Rottingdean ones?

E B-J: They look even better, but there's no telling till they're in place. There's always the risk of that to be run. But there's no helping it. All modern work has to be done under that disadvantage. The only right way is to do it at the place, and then if there needs to be any trying, it can be done in situ. But it's a heavy business going to Merton Abbey now.[2]

I: Did you go often in Mr Morris's lifetime?

E B-J: No, but I never went without him, and he did love it so.

I: Are they the pale blue and gold colours you first designed them?

E B-J: No, they're much stronger than that; the colour is very good. Mr Dearle who looks after the doing of them is competent, but he is peculiar. He has to be dealt with very carefully.[3] You have to find everything well done. If I give an opinion I have to be cautious about it and say 'Don't you think' before all my remarks. I can see he wouldn't stand any rebuke. He's extremely sensitive. He's that much of an artist – you know we're all like that. Don't you remember how sulky ——— used to be, if I didn't say every touch he put on was magnificent. You remember how I've told you we used to be with regard to that in our early days – and how Rossetti used to take advice? If Mr Morris would say to the Great One, 'Don't you think that hand's too large?' Rossetti would answer, 'Now I'm glad you've said that, for I was thinking it was too small – so it must be just the right size – and that's all right.' But Mr Morris was much more direct; Rossetti would say to him, 'Neck's too long, old fellow –' and Mr Morris would catch him up at once and say, 'Too short you mean – all right, I'll alter it.' But I was more leery than that when they told me something was out. I'd say, 'Out, is it – then I'll set it right,' but never touched it again.[4]

¹ Gladstone died on 19 May 1898. The Nativity window for St David's Church, Hawarden, became a memorial as well as a thanksgiving window; see above, p. 95, note 4.
² In 1881 Morris moved the Firm's works to Merton Abbey, Surrey. B-J went there about 1 May 1898, but he now went as seldom as possible, since it revived all his memories of Morris.
³ J.H. Dearle (1860-1932) became Morris's assistant in 1878 and was increasingly responsible thereafter for design of stained glass and tapestries.
⁴ Cf. above, p. 161.

10 May 1898

(*Re-painting spoilt head of girl in* Love in the Ruins, *from tall model*):¹

. . . I (*on Kipling's Arctic life*): The Eskimos live upon the seals and spare the bears that live upon the seals.

E B-J: I hate this world, want it to end. Wish the Day of Judgment would come.

I: In a bad hunting season they die of hunger.

E B-J: I wonder if they feel as miserable as I do now, when I've just got a brushful of ox-gall in my mouth. Yesterday some fiend sent me a circular (how dare anyone send me circulars) asking me to go to Somaliland and make a 'bag'. To kill 5 elephants and 7 lions and ever so many tigers and have 30 camels and 5 or 6 horses and 10 servants and pay £600. I'm *not going*. Nasty creatures! Very few Englishmen who go out to S. Africa are as good to look at as a fine lion. Nasty creatures. This wretch is the son of a bishop. . .

───────

¹ In 1893 the Goupil Gallery sent B-J's gouache, *Love among the Ruins* (1870-73), now in a private collection, to Paris to be photographed. Thinking that it was an oil, the photographer used egg-white to add highlights and when removing this, ruined the picture. Rothenstein was present when the distressed photographer arrived to consult Whistler, who crowed in malicious glee: 'Didn't I always say the man knew nothing about painting, what? They take his oils for water-colours, and his water-colours for oils' (quoted in *MM*, pp. 56-57).

One of the last days

E B-J: Do you remember how beautiful the 'Judge and Jury'

[*Trial by Jury*] was when that Usher said 'Behold the great Judge comes', and then came on the tiniest and neatest little gentleman ever seen – and when he blew a kiss so daintily to the Complainant, and when the Jury sang 'We hush, we hush, we hush', in a long Handel-like chorus at first very soft, then getting louder, and at last bursting out into a regular roar? And the operas that came after weren't nearly so good – it was such a mistake to make them longer and to spread them out into two acts. The fun got to be too long drawn out. When there was but one short act you had no time to think of anything but how funny it was. But when you had to wait between the two acts and couldn't prevent your mind running on it, you began to doubt whether it mightn't be all nonsense.

11 May 1898

. . . E B-J (*arriving at St Paul's Studio 9.15*): Sargent is a most detestable painter. A very bad painter indeed. Amid all the praise of him I wonder some one doesn't, or if they ever will get up, like the child in Anderson's story of the Emperor's new clothes, and say, 'but it's very badly done'. It's thoroughly dreary work. Faces you wouldn't look at twice, such horrible expressions, so ugly. So badly designed, such inferior drapery. Dreadfully drawn extremities and horrid background. Nothing but technique. The world's gone mad about it – such rubbish as it is when it's all done. Comes of the curse of all this public talk and writing about painting. Critics can never say anything really to the point about it. The subject eludes them. All the language employed upon it only obscured the reality. . .

Have you ever read Chesterfield's letters? I'll lend them to you. Taking his point of view, they're really a quite perfect performance. The funny thing is that at the very times they were written his son was secretly married to a poor girl and he never knew it. – There are some days when I can't work; this is one. – You know Johnson's sarcastic letter. He [Chesterfield] kept it to shew to his friends – was very proud of it. Said it was the very finest specimen of Johnson's style that existed – of course a little injured by want of balance at the moment and the spirit of mind in which he wrote – but in spite of that quite

a wonderful piece of literature, absolutely perfect. So you see what a fine gentleman he was.

12 May 1898. Morning, at door
(*We arrive at St Paul's Studio at 9.5, he in a cab.*)

. . . E B-J: I went last night to see an exhibition of Lombard paintings in Savile Row – a great many Leonardos there, though perhaps they may be some of them only of his school.

I: I thought there were but two or three large ones and half a dozen smaller.

E B-J: There are more than that, a great many about the world. A lot may have been destroyed. That's always happening. If a painter wants his reputation to last and to be represented in the future, he must count upon destruction. He must do an enormous amount of work, three hundred pictures at least he ought to leave behind him to take their chance of surviving. Then he'd be almost as safe as anyone can hope to be in this world. Some unfinished ones there are, so delightful to see. He's laid them in in black. He seems to have underlaid everything with black – even the shadows of red drapery. It's hard to think how he could have managed to get red over it.

I: Has the blackness of his pictures seemed to you a fault? It rather prevented me from being attracted to them.

E B-J: No, I just thought it was Leonardo da Vinci and was glad all pictures were not alike. No doubt some of the colour has faded out of them. What I love most of all is extremely dark shadow with light shining in it. When he gets that smile that he's so fond of it's exceedingly delightful – though there is at least one face there where it's gone amiss, and then I must say it's horrid. Of course that one may have been injured and botched by some one, there's no knowing. Beautifully the Lombards draw hands. . .

13 May 1898
(*I arrive at St Paul's Studio at 9.15, and disdaining to ask if the Master has arrived, go up and opening the door, see him sitting low down, as quiet and motionless as he can make himself – painting Irises at bottom of* Avalon.)

E B-J (*with simulated surprise*): Who is that? Oh, come in, you

won't disturb me much. Hope you enjoyed yourself last night? (*Relaxing*.) Isn't that a very nice joke, Rookie? Haven't I had the best of it? As I came along I wondered if I should be here first, and when I found you weren't here I said 'I must try and get my palette set before he comes' – and then, when that was done and you still hadn't come, I made haste and mixed my varnish and turpentine, and then I got to work. So it was all very successful. But I had a very agitated time, I was so afraid I shouldn't manage it before you were down upon me.

(*Then we sat side by side painting Irises, so I could make no note of a word and had to remember what follows, and only put something down after he was out of the room.*)

E B-J: I'm afraid there's no history today?

I: No. I went to anti-restoration Committee.

E B-J: Then you saw Philip Webb, I suppose – how was he? It always pleases me to hear about him.

I: Very well and young looking.

E B-J: He must be about 70.

I: So much?

E B-J: Well, at least 6 years older than I am.[1] When I first heard of him it was from Mr Morris, who was articled to Mr Street in Oxford and said there was a very fine old fellow in the office who was very kind to him and shewed him everything – and I naturally imagined someone about fifty, so that you may judge of my surprise when I saw someone looking just about of my own age – for I always looked old for my age, and I suppose he must have been somewhere about 30 then. Rossetti thought a great deal of him; he was very pleased with him when he saw him.

I: Aren't his drawings of animals very good?

E B-J: Yes, Rossetti praised them above everything, he said they were the finest beasts that had ever been done in the world – said he ought to be a painter: 'You'd make your fortune at it.' Poor fellow, how far he was from ever making his own fortune.

I: I saw in his letters to Allingham how poor he was – repeated promiees to pay thirty shillings.[2]

E B-J: He was dreadfully poor. But I have been not a bit better off at times, with this additional difficulty, that I would

never borrow – very soon made up my mind never to try and do that again. Rossetti asked Webb what he wanted to build red brick houses for, what was the good of that. He'd a great contempt for architects, thought they were only a kind of tradesman. Understood an artist who should be painter, sculptor and architect and perhaps a poet too.

I: Not that a sculptor now-a-days is anything but a modeller.

E B-J: No, there can't be a greater difference than between the old way of a sculptor carving an image out of stone and the modern way of a man modelling a hideous putty wretch and then getting someone to point it out for him into marble.

I: Perhaps Rossetti's seeing so much dreary architecture in London, his interest in it was not brought out.

E B-J: Partly, he hadn't very much sympathy with architecture. He'd make beautiful little buildings in his pictures, though rather of a slight kind – but he wanted everyone to be a painter. So horrible of him, wasn't it? When I first told him of Morris he said, 'What's he going to be – he's going to be a painter isn't he?' – and the first time he saw Morris he said to him, 'Of course you must be a painter,' and so Morris set to work and very soon produced that little picture that was shown with the Rossettis so nicely at that New Gallery this Winter – and it was a very wonderful production to start off with.[3]

I: Did he do it very soon?

E B-J: Oh yes. There were no bounds to the excessive praise Rossetti would pour out upon you. It was so exciting that he set everyone going with it. I don't believe I should have had the courage to be a painter if it hadn't been for that. It was so late in life for me to begin. Though I don't know what else was open to me. Perhaps it wasn't, so I might have been that anyhow. But whatever hope and confidence I had in it I had to thank him for. He'd say, 'Painting's not difficult, it's quite easy, there's no difficulty in it. The difficulty is to bring intelligence into it' – and there I can't say he was wrong. For until then English painting had been extraordinarily unintelligent and stupid – nothing but portraits and landscapes. Reynolds was a good portrait painter, but as soon as he

attempted a subject the ignominy of his failure can't be exaggerated. Though I can't conceal from myself that the Great One had a secret pleasure in setting all his friends about attempting with difficulty what was so easy to himself. So Philip Webb was upset by him to that degree – though I should hardly say 'upset' – that he got a model and began to make drawings of her. Then he did what you'd expect an architect to do – he took accurate measurements of her all over, though as she was but a chance model there's but small likelihood of her having been well proportioned – and I saw the drawings afterwards and I can't say they had any excellence – were very stiff and hard as an architect's would be. So that was all that came of that. Then there was an old friend, Mr Dixon, who's now a Canon of Carlisle and a man of great ability.

I: Which didn't develop into results?

E B-J: Oh, he has written poems that are very good. Mr Mackail thinks most highly of them. So Dixon was also persuaded to be a painter, and what did he do but set up a heap of fine old books, and begin to draw them in pen and ink with great sternness and severity – so that he made works of theology in wrought iron with steel leaves.[4]

I: You Oxford band of young men must have been a great accession to Rossetti.

E B-J: It was in a way.

I: And how nice for you all to have transplanted yourselves together in London.

E B-J: We got separated in no time. That was life you know, and inevitable. . .

[1] Webb was born in 1831, thus was only two years B-J's senior.

[2] See D.G. Rossetti, *Letters . . . to Allingham*, p. 12.

[3] Morris was painting *Sir Tristram after His Illness in the Garden of King Mark's Palace, recognised by the Dog he had given to Iseult* (1857), whereabouts unknown.

[4] Richard Watson Dixon (1833-1900), educated, like B-J, at King Edward's School, Birmingham, met him at Oxford. The novelist Hall Caine, in his *Recollections of Rossetti* (pp. 37-39) writes that 'it is not surprising that Dixon succumbed to his [Rossetti's] spell just as the less impressible Jones and Morris had done . . . for some months during 1857 Dixon was given instruction in painting by

Rossetti . . . for a month or two in the winter of 1857-58 Dixon was living in the little Bohemia of Jones and Morris's lodgings at 17 Red Lion Square.' Dixon dropped painting because his family was not wealthy and he doubted his own talent. By Easter Term 1858 he had returned to Oxford to prepare for ordination. He provided Georgie with useful notes for her *Memorials*; see, for example, I, 48-53.

20 May 1898

I: Have you the brushes you want?

E B-J (*about to darken water and continue changing rocks into grassy mounds in* Avalon): I shan't want any small brushes today, only thumpers and whackers. Thumpers and whackers we may term them.

So that great creature [Gladstone] is gone. The window isn't at Hawarden yet. Stephen Gladstone wrote to say there was no hurry – it was only wanted for Whitsuntide – now of course it can't go. But perhaps it won't be amiss that they should have it to amuse them in that dreadful dull time there will be when the funeral's all over. . .

24 May 1898

(*Side trees,* Avalon.)

. . . I: Strange to see Beardsley's will proved.

E B-J: I always wondered what people saw in his drawings.

I: His brilliant line.

E B-J: But other artists draw as well and better. The drawings were as stupid as they could be. Empty of any great quality and detestable. I was looking at some the other day, and they were more lustful than any I've seen – not that I've seen many such. There was a woman with breasts each larger than her head, which was quite tiny and features insignificant, so that she looked like a mere lustful animal.¹ Lust does frighten me, I must say. It looks like such despair – despair of any happiness and search for it in new degradation.

I: You were cross with Leighton for liking them.

E B-J: I was excessively angry with him. I couldn't understand his liking them. I don't know why I've such a dread of lust. Whether it is the fear of what might happen to me if I were

to lose all fortitude and sanity and strength of mind – let myself rush down hill without any self-restraint. . .

[1] Beardsley, *The Fat Woman* (1894), pen, ink and wash; in the Tate Gallery. It is both a drawing of a procuress and a caricature of Whistler's wife Beatrix. Beardsley intended to call it *A Study in Major Lines*, to parody Whistler's titles for his paintings. John Lane (1854-1925), publisher of *The Yellow Book*, refused it; for Beardsley's defence of it, see his *Letters*, pp. 65-66.

9 June 1898

(Last thing. Dr Evans there. E B-J with mixed asthmatic coughing fit and deprecating laugh.)

(The last sight: he comes back, up some stairs again.)

E B-J: You will be able to bring some sandwiches for yourself on Saturday?

I: Oh yes, thank you.

E B-J: You're quite sure – if not, Pendry shall bring you some over.

(Probably same last day.)

E B-J: I've heard from Mrs Drew. The Hawarden window is put up and she's very pleased with it, so that's all well.

Death. Morning of Friday, 17 June 1898

20 June 1898

(Round the corner of little one side street opposite against the Grange garden wall.)

FIRST WOMAN: Come to draw the funeral, Sir? *(Calling out:)* There *is* some flowers, Mrs ———, come and see! Beautiful flowers. But I did hear as his wish was to be that there was to be no flowers.

(Exclamations of astonishment, as Annie appears carrying flowers to put in hearse.)

SECOND WOMAN: Servant hasn't got no mourning on! *(Neighbour aghast.)* A Blue dress!

FIRST WOMAN: There's a lovely wreath – how beautiful. Lilies of the valley! Look!

✎ Conclusion: June 1898

Sir Edward Burne-Jones died in the very early morning of June 17. The heart whose 'banging about' he had resolved to disregard, gave up, with a final clutching protest, in the spasms of *angina pectoris*. He had worked all the previous day on *Avalon*, then had spent a pleasant evening with guests. He had written a letter to his nephew Rudyard Kipling, had read for a time, then had gone to bed, and when he called out in the night, there was nothing that Georgie could do for him, and he was soon gone.

Cockerell recorded June 17 as 'a very fine day – the first day of summer', but 'BURNE-JONES died early in the morning suddenly.' Cockerell was just starting to the Grange for a previously planned lunch, when he saw the announcement: 'I went on to Kensington and met Sara Anderson outside the house waiting to tell me.'[1]

On June 20 the ashes were interred in a corner formed by the outside wall of the small church at Rottingdean, near windows that he had designed and Morris had created, with only the tiny village green to separate the church from North End House. Cobden-Sanderson recalled that Georgie had once told him how she and Edward had long ago chosen the spot, 'a little corner, visible from the windows of the house, and she had said to him, "If you die first, you know, we shall still be near to one another, and I can still say 'How do'you do?' to you from my window which just looks out on you," and so now, from the window, she can look forth upon the quiet spot and say "How d'you do?" and then round upon the little village, and the quiet downs, and see how they will look down upon them when she, too, is gone.'[2]

On June 23 there was a memorial service, crowded with eminent personages, at Westminster Abbey, the first ever held there for an artist; it had been requested by 'an influentially signed memorial', which had the approval of the Prince of

189

Wales.[3] Cockerell saw Georgie there; she 'had that air of determined resignation that she wore after W.M.'s death. She was very well, she said, and very thankful to have known those two men as she had known them – and "we must pay for the wine that we have drunk." '[4]

Rooke, who began this record, shall have the last word here. On June 18 Cockerell had written to him: 'I am so grieved by the terrible news, which I know will be more painful to you than to almost anyone. It is some comfort, though I feel not much, that the death was sudden and painless, as he would have wished, and that it came, as with Morris, when so much of his work had been rounded off, though so much must have remained undone in any case – I hope it will not affect your own painting, the loss of his sympathy and encouragement – but that you will feel it even more necessary than before to contribute to the beautiful things in the world, now that the chief maker of beauty is no more. How one's heart goes out to Webb – how we ought to cherish him – the only one of those great heroes that remains to us.'[5]

'A great piece of our sky has indeed fallen in,' Rooke replied, 'and we can't tell how much but I hope thankfulness will grow with time at its having been bright so long. . .' He, too, thought of Webb as 'the last of the assembly of Goodliest Knights (as Malory says) that ever was; and I am writing to salute him in that capacity, as a beginning.'[6] He wrote, therefore, as follows:

Carlie Cockerell very rightly reminds me of our duty to you as the one remaining of the ever famous circle that Rossetti had about him, with whom we are privileged to be in any way intimate, and my own emotion confirms him and me in it. And in making this submission I think you would not dislike to know how often and with what affection your Friend through whom I came to the pleasure of knowing you talked to me about you.

My seeing you was always, at my next following meeting with him, the occasion of enquiry about you and eulogy and long talks about your old friendship together and with the other intimates of the golden epoch. And my last appearance at a Thursday Committee [of Anti-Scrape]

resulted in one of the longest of those.

May we to the end of our need have you to help and guide us and to confirm and bring up a younger generation to carry on your work, such as I rejoice to see gathering around at those Committees and may the joint efforts of us weaklings make up as far as they may to you for the mighty strokes of the giants who no longer dwell in the land.[7]

✎ Acknowledgements

In the five years during which this edition has been in progress, the list of those to whom I am indebted for assistance of many kinds became very long. I am grateful to all of them, although it is not possible here to mention all by name.

I wish most particularly to thank Mr and Mrs Lance Thirkell, and Mrs Celia Rooke, not only for their permission to publish Thomas Matthews Rooke's journals of Burne-Jones's conversations, but for generous and sustained interest and hospitality. Through them, as much as through the written record, I have come to feel that I enjoy a warm and rewarding acquaintance with Rooke and with his Master.

Among the many others who have helped in so many ways are Lady Abdy, Wendy Baron, Margaret Belcher, Richard Dorment, Mr and Mrs William Dockar-Drysdale, Malcolm Easton, Lord Faringdon, Penelope Fitzgerald, Mr and Mrs T.A. Greeves, Mr and Mrs Arthur Grogan, Norman Kelvin, Mary Links, Margaret Mac-Donald, Lady Mander, Ronald Parkinson, Mr and Mrs David Pirie, Orna Raz, Godfrey Rubens, Mary Oliphant, Frances Spalding, Virginia Surtees, and Michael I. Wilson.

Work of this kind would be difficult, if not impossible, without the cooperation of archivists, librarians, and museum curators. I am especially indebted to B.K. Bilton (The Ruskin Museum, Coniston), Wilfrid Blunt (G.F. Watts Gallery, Compton), David Brooke (Sterling and Francine Clark Art Institute, Williamstown, Massachusetts), Jeaneice Brewer and her staff (Ellis Library, University of Missouri-Columbia), Peter Cormack (William Morris Gallery, Walthamstow), J.D. Dearden (Ruskin Galleries, Bembridge School, Isle of Wight), Ellen Dunlap (Humanities Research Center, University of Texas at Austin), Katherine Lochnan (Art Gallery of Ontario), Virginia Mauck (Lilly Library, Indiana University), Paul Needham (J. Pierpont Morgan Library), Judith Oppenheimer (Castle Howard Archives), Richard Ormond (National Portrait Gallery, London), Patricia Pellegrini (Metropolitan Museum Archives), Peyton Skipwith (The Fine Art Society, London), Julian Spalding

Acknowledgements

(Sheffield City Art Galleries), John Woudhuysen (Fitzwilliam Museum).

In addition, I have had invaluable assistance from the Birmingham City Museum and Art Gallery, Bodleian Library, The British Library, The British Museum (Prints and Drawings), Durham County Council, The Foundation Custodia (Institut Néerlandais, Paris), Glasgow University Special Collections, Houghton Library at Harvard University, Martin Beck Theatre in New York City, University of Reading Art Collections, Tate Gallery Archives, and the Victoria and Albert Museum Library.

For permission to quote from unpublished materials, in addition to Lance Thirkell and Celia Rooke, I wish to thank Sir Christopher Cockerell (diaries and letters of Sir Sydney Carlyle Cockerell), George Allen and Unwin (letters of John Ruskin), The Society of Antiquaries (diaries of William Morris). In a very few cases I have been unsuccessful in tracing the present copyright owners; I ask their indulgence for any failure on my part, in my efforts to find them. I wish, as well, to thank all of those individuals, art galleries, libraries, and other institutions, as identified in my annotations and captions, for their kindness in allowing me to quote from manuscript materials in their keeping and in permitting reproduction for illustration.

The University of Missouri–Columbia allowed me to arrange my teaching schedule so that I might have a year's leave of absence in 1977-78, during which a major part of this work was done. The University's Research Council contributed a travel grant to the support of the project. I am grateful for its continued interest and consideration. And finally, I am grateful to the kind Fate that led me to this very satisfying project. I hope that it may be the means of helping others to a sympathetic view of two appealing personalities and to a new view of the 1890s.

๑ Abbreviations

Album	T.M. Rooke's album, photographs of his works: Private Collection
Art of the Book	The Pierpont Morgan Library, *William Morris and the Art of the Book*
Arts Council	The Arts Council of Great Britain, Catalogue: *Burne-Jones: The Paintings, Graphic and Decorative Work of Sir Edward Burne-Jones, 1833-98.*
B-J: BL	Burne-Jones Papers: British Library
CH	Castle Howard Archives
CP:BL	Sydney Cockerell Papers: British Library
Fitzgerald	Penelope Fitzgerald, *Edward Burne-Jones: A Biography*
Fitzwilliam	Burne-Jones Papers: Fitzwilliam Museum, Cambridge University
MG:BL	Mary Gladstone Papers: British Library
Henderson	Philip Henderson, *William Morris: His Life, Work and Friends*
HRC	Humanities Research Center, University of Texas, Austin
H/W	Martin Harrison and Bill Waters, *Burne-Jones*
IN	Institut Néerlandais, Paris
Letters	*The Letters of William Morris to His Family and Friends*, ed. Philip Henderson
Mackail	J.W. Mackail, *The Life of William Morris*
Memorials	G[eorgiana] B[urne]-J[ones], *Memorials of Edward Burne-Jones*
MM	William Rothenstein, *Men and Memories*, abridged and annotated by Mary Lago
PC	Private Collection
R-MS	Thomas M. Rooke Manuscript (Lance Thirkell Collection), transcription by Lady Burne-Jones
R-TS	Thomas M. Rooke Typescript (Celia Rooke Collection and [copy] Victoria and Albert Museum Library)
Sewter	A. Charles Sewter, *The Stained Glass of William Morris and His Circle – A Catalogue*
SHL	*Some Hawarden Letters 1878-1913, Written to Mrs Drew (Miss Mary Gladstone) Before and After Her Marriage*, comp. and ed. Lisle March-Phillipps and Bertram Christian
Surtees	Virginia Surtees, *The Paintings and Drawings of Dante Gabriel Rossetti (1828-1882): A Catalogue Raisonné*

Abbreviations

WG G.F. Watts Gallery, Compton, Surrey
WM:BL William Morris Papers: British Library
WMG William Morris Gallery, Walthamstow, London
Works *The Works of John Ruskin*, ed. E.T. Cook and Alexander Wedderburn. Library Edition.
V&A Victoria and Albert Museum Library

Notes

INTRODUCTION *pp. 1–18.*

1 For a history of the MacDonald family, see A.W. Baldwin, *The Mac-Donald Sisters*. For a personal, affectionate account of The Grange and of North End House (Rottingdean), see Angela Thirkell, *Three Houses*.

2 H/W, p. 95.

3 I am indebted to Mr Ronald Parkinson for a copy of this undated document (Tate Gallery Archives).

4 George James Howard, 9th Earl of Carlisle (1843–1911), Liberal M.P., amateur painter, friend and pupil of the Italian artist Giovanni Costa (1833–1903).

5 B-J to Mary Gladstone [1 November 1879]. MG:BL.

6 *Works*, XXIV, 191–400. The proof copy was sold at Sotheby's in 1978.

7 *Works*, XXX, lvi.

8 *Works*, XXIV, 308, note 132.

9 Rooke to B-J, 27 July 1879. IN.

10 Ruskin to Rooke, 23 November 1879. HRC. John Wharlton Bunney (1826–82), resident of Venice, known for paintings of Venetian scenes; Royal Academy exhibitor, 1873–79, 1881.

11 Ruskin to Rooke, 14 October 1884; 17 January 1886; 24 February [1887]; 18 June [1887]. All letters, HRC. 'Large view of Brieg': in Album, captioned 'Brieg 1884 Jesuit Church, Glys Church, and house of Stock Alpens [for] (Sheffield).' Now at Reading University.

12 B-J to Helen Mary Gaskell, postmark 17 April 1895. B-J:BL.

13 Thomas Carlyle, *On Heroes, Hero-Worship, and the Heroic in History*, Lecture I (1840).

14 B-J to Rooke, n.d. PC. A formula repeated with variations in many letters to Rooke. Also, a reflection of B-J's conviction, particularly strong when he was forced to take a holiday, that for him there was no difference between work and play.

15 B-J to Mary Gladstone [13 September 1879]. MG:BL. Stopford A. Brooke (1832–1916), liberal Irish clergyman who seceded from the Church of England in 1880, then continued to preach and to lecture on English literature at Bedford Chapel, Bloomsbury; poet, and author of books on the English poets and on English literary history.

16 B-J to Mary Gladstone [October 1879]. MG:BL.

17 Fitzgerald, p. 132.

18 *Phyllis and Demophoön* (1870), gouache, now in the Birmingham City Museum and Art Gallery. A second version, *The Tree of Forgiveness* (1881–82), oil, is in the Lady Lever Art Gallery, Port Sunlight.

19 B-J to Rooke, 24 June 1879. IN.

Notes

20 R-MS, p. 5.

21 R-MS, p. 90; R-TS, p. 121.

22 B-J to Helen Mary Gaskell, postmark 26 April [1895?]. B-J:BL. Mrs Gaskell (1857-1940), daughter of Canon Melville of Worcester, wife of Captain Gaskell of the Ninth Lancers, was a friend of another of B-J's younger friends, Frances Graham, later Lady Horner (d. 1940), daughter of B-J's faithful patron, William Graham (1817-85).

23 *The Golden Stairs* (1880), oil, Tate Gallery. See Arts Council 138.

24 For a comprehensive study of this project, see Richard Dorment, 'Burne-Jones and the Decoration of St Paul's American Church, Rome' (unpub. diss., Columbia University, 1975); 'Burne-Jones's Roman Mosaics', *The Burlington Magazine*, 120 (1978), 58, 72-82.

25 B-J to Helen Mary Gaskell [25 March 1893]. B-J:BL. Four large panels on the Sleeping Beauty theme, one of B-J's favourites (and a legend of ageing arrested), William Graham's last commission. He paid £15,000 for the set and stipulated before his death that it be exhibited at Agnew's. It was bought by Alexander Henderson, later 1st Lord Faringdon (1850-1934) for the saloon at Buscot Park, Buckinghamshire.

26 Charles E. Hallé (1846-1919), son of the famous conductor, Sir Charles Hallé, and Joseph Comyns Carr (1849-1916) joined Sir Coutts Lindsay (1824-1913) to found the Grosvenor; for *Punch*'s comments, see Leonée Ormond, *George Du Maurier*, pp. 258-66. The Grosvenor collapsed along with Sir Coutts' marriage. Hallé and Carr objected to his plan to make the gallery a popular gathering place with musical entertainment.

27 For B-J's letter of resignation, see Sidney C. Hutchison, *The History of the Royal Academy 1768-1968*; also, *Memorials*, II, 233-34.

28 B-J to G.F. Watts [12 February 1893]. WG.

29 David Cecil, *Visionary and Dreamer: Two Poetic Painters: Samuel Palmer and Edward Burne-Jones*, pp. 63, 65.

30 B-J to Helen Mary Gaskell, postmark 27 March 1895. B-J:BL.

31 W.L. Seaman and S.C. Newman, 'A Burne-Jones Discovery', *The Burlington Magazine*, 107 (1965), 632-33. The letter ([21 August 1895], Durham County Records Office) is one of four to Sir Sidney Colvin and Mrs A.H. Sitwell (later Lady Colvin).

32 See *Memorials*, I, 10.

33 Catterson-Smith (1853-1938) became Inspector of Art Schools and Classes for the London County Council, Head of the Victoria Street School in Birmingham, and until retirement in 1920 Head of the Birmingham School of Art. Cockerell (1867-1962), was with the Kelmscott Press from 1892 until it closed in 1898.

T.M. ROOKE'S APOLOGY *pp. 19–24.*

1 Rooke's 'Apology on Presenting the Conversations' (R-TS) and an additional 'note' (R-MS) are here combined, with some deletions and some silent corrections that eliminate repetitions and some digressions.

2 See p. 117, however, for a discussion of an American purchaser. Simply

197

Notes

ignoring them seems to have been B-J's method of baffling 'improper enquiries' about technique.

³ *A Sibyl* (1874), an oil, described by Malcolm Bell (*Sir Edward Burne-Jones: A Record and a Review*, p. 57) as shown in 'a dark purple dress'; exhibited at the Grosvenor Gallery's opening in 1877; acquired by Sir William Agnew; present owner unknown

⁴ At the end of Dickens's *Barnaby Rudge* John Willett, wits unsettled by the sacking of his Maypole Inn during the Gordon Riots of 1780, dies peacefully at home in 1787.

⁵ In Dickens, *Dombey and Son* (1847-48): Captain Jack Bunsby, Master of the *Cautious Clara*; Captain Edward Cuttle, protector of Florence Dombey.

INTERLUDE: SUMMER 1895 *pp. 39–43*

¹ Cockerell to Rooke, 16 July 1895. CP:BL.

² Rooke to B-J, 20 July 1895. PC. This painting (Album), 'Rouen 1895 (Birmingham)' is still owned by the Birmingham City Museum and Art Gallery.

³ *Ibid.*

⁴ *Letters*, p. 124.

⁵ Rooke to B-J, 20 July 1895. PC.

⁶ *Ibid.*

⁷ Blunt, 'England's Michelangelo'', p. 214.

⁸ B-J to Helen Mary Gaskell [3 April 1895]. B-J:BL.

⁹ B-J to Helen Mary Gaskell, postmark 4 April 1895. B-J:BL.

¹⁰ B-J to Helen Mary Gaskell [25 May 1895]. B-J:BL.

¹¹ *MM*, p. 100. Charles Ricketts (1866-1931), painter, stage designer; and Charles Shannon (1863-1937), painter, lithographer, designer; noted connoisseurs who lived in The Vale, Chelsea.

¹² B-J to Helen Mary Gaskell [11 July? 1895]. B-J:BL. Earlier, he had told her (postmark 20 September 1894. B-J:BL): 'Yes, digitalis is for the heart, but I think only for weakness – it does trouble too much I know and starts are bad for it. . .'

¹³ See Henderson, pp. 334-35.

¹⁴ *Memorials*, II, 221.

INTERLUDE: SUMMER 1896 *pp. 112–14*

¹ B-J to Helen Mary Gaskell, postmark 14 August 1896. B-J:BL.

² Carruthers to Cockerell, 19 July, 2 August 1896. CP:BL.

³ Cockerell to Webb, 18 August 1896. CP:BL.

⁴ B-J to Howard [20 August 1896]. CH.

⁵ Diary, 30 August 1896. CP:BL. Emery Walker (1851-1933), distinguished typographer and printer; in 1890, helped Morris to set up the Kelmscott Press; partner, 1900-1904, with Cobden-Sanderson in the Doves Press.

Notes

[6] Frederic William Farrar (1831–1903), Dean of Canterbury, author of a phenomenally popular *Life of Christ* (1874), and *Eric, or Little By Little*.

[7] Cockerell to Webb, 17 September 1896. CP:BL.

[8] Diary, 3 October 1896. CP:BL.

[9] Mackail notebook, WMG.

[10] B-J to Helen Mary Gaskell, postmark 9 October 1896. B-J:BL.

INTERLUDE: SUMMER 1897 *pp. 159–60*

[1] Rooke to B-J, 24 August 1897. PC. Rooke's 1897 drawings, still owned by the Birmingham City Museum and Art Gallery: *The Carthusian Chapel of St Jean du Liget in the Forest of Loches* and *Wall Paintings in the Chapel of St Jean du Liget*.

[2] Unsigned review, 'The New Gallery', *The Times*, 18 May 1894, p. 6.

[3] B-J to Rooke, postmark 8 March 1897. IN.

[4] B-J to Rooke, 17 June 1897. IN.

[5] B-J to Helen Mary Gaskell [September 1897]. B-J:BL.

[6] B-J to George Howard [1 January 1885]. CH.

[7] Rooke to B-J [August? 1897]. PC.

CONCLUSION: JUNE 1898 *pp. 189–91*

[1] Diary, 17 June 1898. CP:BL.

[2] Cobden-Sanderson, *Journal*, I, 376.

[3] Court Circular, *The Times*, 23 June 1898, p. 9. On the burial at Rottingdean, *The Times*, 22 June, p. 12.

[4] Diary, 23 June 1898. CP:BL.

[5] Cockerell to Rooke, 18 June 1898. CP:BL.

[6] Rooke to Cockerell, 18 June 1898. CP:BL.

[7] Rooke to Philip Webb, 18 June 1898. Editor's collection.

❧ Bibliography

Abbott, Evelyn, and Lewis Campbell. *The Life and Letters of Benjamin Jowett, M.A., Master of Balliol College, Oxford*. 2 vols. New York: E.P. Dutton, 1892; London: John Murray, 1897.

Allingham, William. *Day and Night Songs*. London: Bell and Daldy, 1860.

Arts Council of Great Britain. *Burne-Jones: The Paintings, Graphic and Decorative Work of Sir Edward Burne-Jones, 1833-98*. London, 1975.

Baldwin, Alfred W. *The MacDonald Sisters*. London: Peter Davies, 1960.

Barrington, Mrs Russell. *G.F. Watts: Reminiscences*. London: George Allen, 1905.

Beardsley, Aubrey. *The Early Work of Aubrey Beardsley*. London and New York: John Lane, The Bodley Head, 1899.

— *The Letters of Aubrey Beardsley*. Henry Maas, *et al.*, eds. Rutherford, N.J.: Fairleigh Dickinson University Press [1970].

Bell, Malcolm. *Sir Edward Burne-Jones: A Record and Review*. London: G. Bell, 1898.

Bennett, Mary. *William Holman Hunt: An Exhibition*. Liverpool: Walker Art Gallery/Arts Council of Great Britain, 1969.

Blunt, Wilfrid. *'England's Michelangelo': A Biography of George Frederic Watts. O.M., R.A.* London: Hamish Hamilton [1975].

Burne-Jones, Sir Edward Coley. *Letters to Katie*. London: Macmillan, 1925.

B[urne]-J[ones], G[eorgiana], *Memorials of Edward Coley Burne-Jones*. 2 vols. London: Macmillan, 1904.

Byron, Lord. *Letters and Journals of Lord Byron with Notices of His Life*. 3 vols. 3rd edn. London: John Murray, 1833.

— *'So late into the night'*, Vol. 5 of *Byron's Letters and Journals*, ed. Leslie Marchand. London: John Murray; Cambridge, Mass.: The Belknap Press of Harvard University Press, 1976.

Caine, Hall. *Recollections of Rossetti*. London, etc.: Cassell, 1928.

Carlyle, Jane Welsh. *Letters and Memorials of Jane Welsh Carlyle, Prepared for Publication by Thomas Carlyle*. James Anthony Froude, ed. 3 vols. London: Longmans, Green, and Co., 1883.

Cecil, Lord David. *Visionary and Dreamer: Two Poetic Painters: Samuel Palmer and Edward Burne-Jones*. London: Academy Editions, 1977.

Chaucer, Geoffrey. *The Complete Works of Geoffrey Chaucer, Edited from Numerous Manuscripts by the Rev. Walter W. Skeat*. 6 vols. Oxford: The Clarendon Press, 1894-1900.

— *The Works of Geoffrey Chaucer*. London: The Kelmscott Press, 1896.

— *The Works of Geoffrey Chaucer* [facsimile of Kelmscott Press edition]. With *A Companion Volume to the Kelmscott Chaucer*. 2 vols. London: The Basilisk Press, 1975.

200

Bibliography

Cobden-Sanderson, Thomas James. *The Journals of Thomas James Cobden-Sanderson, 1879-1922*. 2 vols. London: Richard Cobden-Sanderson, 1926.

Collins, L.C. *Life and Memoirs of John Churton Collins*. London: John Lane, The Bodley Head; New York: John Lane Company, 1912.

Dalziel, George and Edward. *The Brothers Dalziel: A Record of Fifty Years' Work in Conjunction with Many of the Most Distinguished Artists of the Period...* London: Methuen, 1901.

Dickens, Charles. *The Letters of Charles Dickens*. Madeline House and Graham Storey, eds. The Pilgrim Edition. 4 vols. Oxford: The Clarendon Press, 1965-

— *The Works of Charles Dickens*. 34 vols. London: Chapman and Hall; New York; Charles Scribner's Sons, 1897-99.

Didron, A[dolphe] N[apoleon]. *Christian Iconography; or, the History of Christian Art in the Middle Ages*. K.J. Millington, trans. 2 vols. Bohn's Illustrated Library. London: Henry G. Bohn, 1851.

Dorment, Richard Gerard. 'Burne-Jones and the Decoration of St Paul's American Church, Rome'. Unpublished dissertation, Columbia University, 1976.

Du Maurier, George. *Trilby*. 3 vols. London: Osgood, McIlvaine, 1894; New York: (1 vol.) Harper [1894].

Easton, Malcolm. *Aubrey and the Dying Lady: A Beardsley Riddle*. London: Secker and Warburg; Boston: David Godine, 1972.

Faber, Geoffrey. *Jowett: A Portrait with Background*. London: Faber & Faber [1957].

Farrar, Frederic William. *The Life of Christ*. 2 vols. 2nd edn. London: Cassell, Petter & Company, 1874.

Fitzgerald, Penelope. *Edward Burne-Jones: A Biography*. London: Michael Joseph, 1975.

Forman, Buxton. *The Books of William Morris. Described, with Some Account of His Doings in Literature and in the Allied Crafts*. London: Hollings, 1897.

Forster, John. *The Life and Times of Oliver Goldsmith*. 2 vols. 2nd edn. London: Bradbury and Evans, 1854.

Froude, James Anthony. *Thomas Carlyle: A History of the First Forty Years of His Life, 1795-1835*. 2 vols. London: Longmans, Green, and Company; New York: Charles Scribner's Sons, 1882.

— *Thomas Carlyle: A History of His Life in London, 1834-1881*. 2 vols. London: Longmans, Green; New York: Harper Brothers 1884.

— *Froude's Life of Carlyle*. Abridged and edited by John Clubbe. London: John Murray; Columbus: Ohio State University, 1979.

Gilchrist, Alexander. *Life of William Blake, 'Pictor Ignotus'*. 2 vols. London and Cambridge: Macmillan, 1862.

Gladstone, W.E.G. *Gladstone's Speeches: Descriptive Index and Bibliography*. Arthur Tilney Bassett, ed. London: Methuen, 1916.

[Hamilton, Sir William] *Outlines from the Figures and Compositions upon the Greek, Roman and Etruscan Vases of the late Sir William Hamilton, with Engraved Borders, drawn and enlarged by the late Mr Kirk*. 2nd edn. London: T. McLean, 1814.

Bibliography

Harrison, Martin, and Bill Waters. *Burne-Jones*. New York: Putnam [1973]; London: Barrie and Jenkins [1973].

Henderson, Philip. *William Morris: His Life, Work and Friends*. New York: McGraw-Hill, 1967. London: Hamish Hamilton, 1969.

Hutchison, Sidney C. *The History of the Royal Academy 1768-1968*. New York: Taplinger Publishing Company, 1968.

Ingram, John Henry. *Edgar Allan Poe: His Life, Letters and Opinions*. 2 vols. London: J. Hogg, 1880.

Ironside, R[obin], and John Gere. *Pre-Raphaelite Painters*. British Artists, John Rothenstein, ed. London: The Phaidon Press, 1948.

Jameson, Mrs [Anna B.] *Sacred and Legendary Art*. 2 vols. London: Longmans, Brown, Green, and Longmans, 1848.

Jullian, Philippe. *Dreamers of Decadence: Symbolist Painters of the 1890's*. London: Phaidon Press [1971].

Löcher, Dr Kurt. *Der Perseus-Zyklus von Edward Burne-Jones*. Stuttgart: Staatsgalery, 1973.

Mackail, John William. *The Life of William Morris*. 2 vols. London: Longmans, Green & Company, 1899.

MacLaren, Archibald. *The Fairy Family: A Series of Ballads and Metrical Tales Illustrating the Fairy Mythology of Europe*. London: Longman, 1852.

McMullen, Roy. *Victorian Outsider: A Biography of J.A.M. Whistler*. New York: Dutton, 1973.

Mahan, Captain A.T. *The Life of Nelson, The Embodiment of the Sea Power of Great Britain*. 2 vols. London: Sampson Low, Marston, & Company, 1898.

Malory, Sir Thomas. *The Birth, Life and Acts of King Arthur[,] of His Noble Knights of the Round Table[,] . . . and in the End Le Morte Darthur with the Dolourous Death and Departing Out of This World of Them All . . . With an Introduction by Professor [John] Rhys and embellished with many original designs by Aubrey Beardsley*. London: J.M. Dent, 1893.

March-Phillipps, Lisle, and Bertram Christian, eds. *Some Hawarden Letters 1878-1913, Written to Mrs Drew (Miss Mary Gladstone) before and after Her Marriage*. London: Nisbet & Company, 1917.

Menpes, Mortimer. *Venice*. Text by Dorothy Menpes. London: A. and C. Black [1904].

Merriam, Harold G. *Edward Moxon: Publisher of Poets*. New York: Columbia University Press, 1939.

[Morgan, J.P.] *Pictures in the Collection of J. Pierpont Morgan At Prince's Gate & Dover House, London*. 3 vols. London: Privately printed, 1907.

Morris, William. *The Letters of William Morris to His Family and Friends*. Philip Henderson, ed. London: Longmans, Green & Co., 1950.

— *The Life and Death of Jason, A Poem*. London: Bell and Daldy, 1867.

— *Love Is Enough, or the Freeing of Pharamond: A Morality*. London: Ellis & White, 1873.

— *The Story of Sigurd the Volsung and the Fall of the Nibelungs*. London: Ellis & White [1876].

Bibliography

Ormond, Leonée. *George Du Maurier*. London: Routledge and Kegan Paul, 1969.

— and Richard Ormond. *Lord Leighton*. New Haven and London: Yale University Press, 1975.

Panofsky, Erwin. *The Life and Art of Albrecht Dürer*. Princeton, N.J.: Princeton University Press, 1955.

Pierpont Morgan Library. *William Morris and the Art of the Book, with Essays on William Morris as Book Collector by Paul Needham, as Calligrapher by Joseph Dunlap, and as Typographer by John Dreyfus*. New York: Pierpont Morgan Library, 1976.

Poe, Edgar Allan. *The Works of the Late Edgar Allan Poe. With a Memoir by Rufus Wilmot Griswold and Notices of His Life and Genius by N.P. Willis and J.R. Lowell*. 4 vols. New York: J.S. Redfield, 1853-56.

Portland, 7th Duke of. *Men, Women and Things: Memories of the Duke of Portland*. London: Faber and Faber, 1937.

Quinn, Arthur Hobson. *Edgar Allan Poe: A Critical Biography*. New York: Cooper Square Publishers, 1969.

Reade, Brian. *Beardsley*. London: Studio Vista Limited, 1967.

Robertson, W. Graham. *Letters from Graham Robertson*. Kerison Preston, ed. London: Hamish Hamilton, 1953.

Robinson, Duncan. *A Companion Volume to the Kelmscott Chaucer*. See Chaucer, *The Works of Geoffrey Chaucer*.

Rogers, Samuel. *Italy. A Poem*. London: Printed for Longman, Hurst, Rees, Orme and Brown, 1822.

— *Recollections of the Table Talk of Samuel Rogers*. Alexander Dyce, ed. London: Moxon, 1856.

Ross, Robert. *Aubrey Beardsley*. London: John Lane, The Bodley Head, 1909.

Rossetti, Dante Gabriel, trans. *The Early Italian Poets from Ciullo d'Alcamo to Dante Alighieri (1100-1200-1300) in the Original Metres Together with Dante's Vita Nuova Translated by D.G. Rossetti*. London: Smith Elder, 1861.

— *Dante Gabriel Rossetti and Jane Morris: Their Correspondence*. John Bryson, ed., in association with Janet Camp Troxell. Oxford: The Clarendon Press, 1976.

— *Dante Gabriel Rossetti: His Family-Letters*. William Michael Rossetti, ed. 2 vols. London: Ellis and Elvey, 1895.

— *Letters of Dante Gabriel Rossetti to William Allingham*. London: T. Fisher Unwin, 1897; New York: Frederick A. Stokes Company [1897].

Rossetti, William Michael. *D.G. Rossetti as Designer and Writer*. London, Paris, etc.: Cassell and Company, 1889.

Rothenstein, William. *Men and Memories: Recollections of William Rothenstein, 1872-1938*. Abridged and annotated by Mary Lago. London: Chatto and Windus; Columbia, Missouri: University of Missouri Press, 1978.

Ruskin, John. *Works*. E.T. Cook and Alexander Wedderburn, eds. Library Edition. 39 vols. London: George Allen, 1907.

— *Stray Letters from Professor Ruskin to a London Bibliophile*. [Frederick Startridge Ellis, ed.] London: Privately printed, 1892.

Bibliography

Sale, Lady Florentia. *A Journal of the Disaster in Afghanistan, 1841-2*. London: John Murray, 1843. Re-issued as *Lady Sale: The First Afghan War*. Patrick Macrory, ed. Military Memoirs Series. London: Longmans [1969].

Sewter, A. Charles. *The Stained Glass of William Morris and His Circle – A Catalogue*. 2 vols. New Haven and London: Yale University Press, 1975.

Sizeranne, Robert de la. *La Peinture Anglaise Contemporaine*. Paris: Hachette, 1895.

Skeat, Walter W. *An Etymological Dictionary of the English Language*. In four parts. Oxford: The Clarendon Press, 1879-82.

Sketchley, Rose Esther Dorothea. *English Book-Illustration of To-Day; Appreciations of the Work of Living English Illustrators with Lists of Their Books*. London: K. Paul, Trench, Trübner and Company, 1903.

Swinburne, A.C. *Atalanta in Calydon: A Tragedy*. London: E. Moxon & Company, 1865.

— *The Swinburne Letters*. Cecil Y. Lang, ed. 6 vols. New Haven: Yale University Press; London: Oxford University Press, 1959-62.

Surtees, Virginia. *The Paintings and Drawings of Dante Gabriel Rossetti (1828-1882): A Catalogue Raisonné*. 2 vols. Oxford: The Clarendon Press, 1971.

Tennyson, Alfred Lord. *Poems*. London: Edward Moxon, 1857.

Tennyson, Hallam Lord. *Alfred Lord Tennyson: A Memoir by His Son*. 2 vols. London: Macmillan, 1897.

Thackeray, W.M. *The Works of William Makepeace Thackeray with biographical introductions by his daughter, Anne Ritchie*. The Biographical Edition. 13 vols. New York and London: Harper, 1899.

Thirkell, Angela, *Three Houses*. London: Humphrey Milford for Oxford University Press, 1931.

Thompson, Edward P. *William Morris: Romantic to Revolutionary*. Rev. edn. New York: Pantheon Books, 1977.

Thompson, Paul. *The Work of William Morris*. London: William Heinemann, 1967.

Thompson, Susan Otis. *American Book Design and William Morris*. New York and London: R.K. Bowker, 1977.

Tissot, J. James. *The Life of Our Saviour Jesus Christ. Three Hundred and Sixty-Five Compositions from the Four Gospels with Notes and Explanatory Drawings*. 2 vols. London: Sampson Low, Marston & Company; Paris: Lemercier & Cie, 1897.

Trevelyan, Raleigh. *A Pre-Raphaelite Circle*. London: Chatto and Windus, 1978.

Vigfusson, Gudebrand, and F. York Powell, trans. and eds. *Corpus Poeticam Boreale: The Poetry of the Old Northern Tongue from the Earliest Times to the Thirteenth Century*. Oxford: The Clarendon Press, 1883.

Ward, Mrs Humphry. *Helbeck of Bannisdale*. London: Macmillan, 1898; New York: Macmillan, 1899.

Wentworth, Michael Justin. *James Tissot: Catalogue Raisonné of His Prints*. Minneapolis: The Minneapolis Institute of Arts, 1978.

Bibliography

Whistler, James M. *The Gentle Art of Making Enemies*. London: William Heinemann, 1890.

Wilde, Oscar. *The Letters of Oscar Wilde*. Rupert Hart-Davis, ed. London: Rupert Hart-Davis, 1962.

Yeats, William Butler. *The Wild Swans at Coole*. London: Macmillan, 1919.

◥ Index

206

Index

207

Index

Index

Index

Index

Journal extracts © Mrs. Noel Rooke 1981
Editorial matter © Mary M. Lago 1981
The author's moral right has been asserted

First published in 1982 by John Murray
This edition published 2012 and reprinted 2015 and 2018 by
Pallas Athene (Publishers) Ltd,
Studio 11A, Archway Studios
25-27 Bickerton Road
London N19 5JT

www.pallasathene.co.uk

 pallasathenebooks PallasAtheneBooks

 Pallas_books Pallasathene0
ISSUU

ISBN 978 1 84368 089 5

Printed in England